Photographic Printing

RALPH HATTERSLEY, one of the leading figures in the world of modern photography, has written numerous articles for *Popular Photography* and other well-known photography magazines and journals. He is also the author of *Discover Your Self Through Photography, Beginner's Guide to Photography, and Beginner's Guide to Darkroom Technique.*

RALPH HATTERSLEY

Photographic Printing

A SPECTRUM BOOK

PRENTICE-HALL, INC., Englewood Cliffs, New Jersey 07632
AMPHOTO, Garden City, New York 11530

Library of Congress Cataloging in Publication Data

HATTERSLEY, RALPH.
 Photographic printing.

 (A Spectrum Book)
 Includes index.
 1. Photography—Printing processes. I. Title.
TR330.H37 770'.28 77-2835
ISBN 0-13-665299-9
ISBN 0-13-665281-6 pbk.

Photographs courtesy *Popular Photography*, © Ziff-Davis Publishing Co.

©1977 by Prentice-Hall, Inc.
Englewood Cliffs, New Jersey 07632

A SPECTRUM BOOK

10 9 8 7 6 5 4 3 2

Printed in the United States of America

Prentice-Hall International, Inc., *London*
Prentice-Hall of Australia Pty. Limited, *Sydney*
Prentice-Hall of Canada, Ltd., *Toronto*
Prentice-Hall of India Private Limited, *New Delhi*
Prentice-Hall of Japan, Inc., *Tokyo*
Prentice-Hall of Southeast Asia Pte. Ltd., *Singapore*
Whitehall Books Limited, *Wellington, New Zealand*

To Andreas Feininger and Terence Knight,
two of my favorite people. They have both taught
me much, for which I thank them.

Contents

Preface

This book is for beginning, intermediate, and advanced photographers; there is an abundance of material for all of them. Though photography is a technical subject, the writing here is as nontechnical as I could make it. I did this so that people oriented more toward art than science would be able to understand it. However, scientific minds should find it a satisfying introduction to photographic printing on the level of craftsmanship. Furthermore, the material presented here is scientifically accurate, even though it avoids the concepts and equations of science in favor of language that nearly everyone understands.

Acknowledgment

I wish to thank the Ziff-Davis Publishing Company for permission to reprint numerous pictures and ideas that were originally created for *Popular Photography* magazine and the Ziff-Davis photography annuals.

1 A Review of Basic Printing

HOW TO MAKE AN ENLARGEMENT PRINT

Even from the beginning, photographic printing is quite easy—if you can keep track of what you are doing. By spelling it all out in detail, this chapter will provide a good starting point for beginners and a good review of basic printing for more advanced students.

You must do your printing in an area in which white light (daylight, tungsten, fluorescent, etc.) has been totally blocked out, though you can work under certain colored lights (safelights) made especially for printing. You see, white light will fog (darken) photographic printing papers, while safelights will affect them relatively little.

The easiest way to get a darkened room is to wait for sunset and refrain from turning on the lights in your home. Then you can conveniently work in a kitchen, bathroom, utility room, or bedroom. For daytime work, however, you will probably have to lightproof some windows and doors, which you can do with light-impervious materials such as cardboard, wallboard, black plastic sheeting, heavy

1

Fig. 1.1 An effective darkroom made from a small sewing room. The window is light-trapped with roofing paper. The sink is a shallow box with splash boards on three sides, painted with epoxy paint, the bottom lined with roofing paper. The box sits on an old kitchen table. Chemicals and water are carried to and from the sink with a plastic bucket. Not as convenient as having running water, but it works very well.

black felt, roofing paper, or black Con-Tact paper. You can easily cut these materials into appropriate sizes and hold them in position—permanently or temporarily—with staples or black tape (Con-Tact paper is self-adhesive, of course).

You need work surfaces for your enlarger, paper, negatives, paper trimmer, chemical trays, and so on. Kitchen counters are especially handy, but you can make do with card tables, benches, chairs, bureaus, plywood panels laid across sawhorses, or even an ironing board (for trays). The work surface for your enlarger should be sturdy, so that you won't get fuzzy pictures due to vibration, but sturdiness is not so critical elsewhere in the darkroom. However, you don't want things so flimsy that they come crashing down in a heap.

The surface on which you put your trays should be protected from chemicals with plastic sheeting (e.g., a discarded plastic table cloth), roofing paper, or some other waterproof material. Photographic chemicals will damage many kinds of surfaces, especially if puddles are left standing for an hour or more. Since there is also a possibility of damaging the floor, spilled chemicals—even a few drops—should be mopped up immediately. If you do this you will have no trouble with linoleum, vinyl, or wood flooring.

2

If convenient, divide your work area into a wet side and a dry side, so that your enlarger and photographic materials are well separated from the chemicals. This is a simple precautionary measure, because dribbled or splashed chemicals (or even water) will wreak havoc with everything else in your darkroom. To keep your hands dry, have several turkish towels located in convenient places.

It is best to arrange chemical trays in a row—developer, stop bath, first hypo, second hypo, and water bath. However, if you have to use two rows or scatter the trays around the room, it is all right, though unhandy. You can control dripping by moving your prints around in a dry tray.

We will continue this review with an outline describing briefly how to make an enlargement print, then expand the outline to fill in the necessary details.

1. Set up the chemical trays.
2. Clean your negative.
3. Put your negative and negative carrier into the enlarger.
4. Turn on the safelight and turn off the white light.
5. Put a piece of focusing paper in the printing easel.
6. Adjust the enlarger head and easel positions to get the desired image size and cropping.
7. Focus the image.
8. Cut strips of enlarging paper for test strips.
9. Expose a test strip.
10. Process the test strip.
11. Analyze the test strip for exposure and image contrast.
12. If necessary, make another test strip.
13. Expose the final print.
14. Process the final print.
15. Wash and dry the final print.

The following expansion of the basic outline will tell you nearly all you need to know concerning how to make a finished print; additional material will be given in the following two chapters.

1. *Set up the chemical trays:* You will need five 8 x 10 or 11 x 14-inch trays to contain the following: print developer, stop bath, first hypo bath, second hypo bath, and water. The developer, an alkaline solution, makes the image visible. By acidifying the print, the stop bath stops the developing action so that the image won't get darker. This also protects the hypo baths (also called fixers) from the developer alkali. The first hypo makes the image permanent by changing undeveloped silver compounds into hypo-silver compounds, which are not darkened by light. The latter must be washed away in water. The second hypo makes them more water-soluble, so that they can be washed away more easily. The water tray is a "holding bath" in which prints are kept until the final wash.

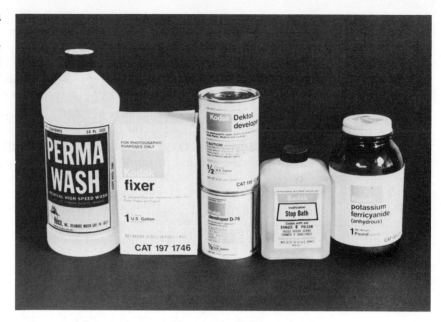

Fig. 1.2 Some chemicals used in photography: washing aid (Perma Wash), fixer, print developer (Dektol), film developer (D-76), stop bath, and bleach (potassium ferricyanide).

Recommended chemicals are Kodak Dektol Developer and Indicator Stop Bath. Any brand of regular (not rapid) acid hardening fix bath (hypo bath) will do. Instructions for use are clearly and simply stated on the labels. Read them carefully.

2. *Clean your negative:* Any dust, lint, or hair on a negative will make ugly white marks on a print. They generally cling to a negative, especially the back (shiny) side, due to a magnetic static charge, which can be removed with an anitstatic cloth. Gently draw the whole negative through a fold in the cloth two or three times. Any other dust on the negative can be picked off with a small sable brush that has been made slightly oily by rubbing it in the laugh crease at the side of the nose.

A negative should always been cleaned afresh just before enlargement, even if you have already cleaned it a short time before. However, once it is in the enlarger it needn't be cleaned again.

3. *Put your negative and negative carrier in the enlarger:* The negative should go in the carrier with its emulsion side (dull side) down. The emulsion is a dried gelatin layer containing the silver that makes up the image. If your enlarger head is the kind that raises up or tips back, turn on the enlarger light after the carrier is in place. Then any dust remaining on the negative will be clearly visible and can be easily lifted off with the lightly oiled brush. The small amount of nose oil that gets on the negative won't affect the picture.

4. *Turn on the safelight and turn off the white light:* A photographic enlarging paper must be handled only under a special colored light, the Kodak OC type usually being recommended. However, a $7\frac{1}{2}$-watt round red General Electric (G.E.) bulb works just as well and is a lot cheaper. You should have a safelight positioned near your enlarger and another over the developer tray.

5. *Put a piece of focusing paper in the printing easel:* The easel is a special frame made for holding printing paper flat and in a preselected position on the enlarger baseboard. It may also have a provision for making white borders, so that you can crop (proportion) the image in a variety of ways. The best paper for focusing is the kind you are making prints on; use the back (dull side).

6. *Adjust the enlarger head and easel positions to get the desired image size and cropping:* The higher the enlarger head on its standard, the larger the image, and vice versa. The image cropping can be changed by moving the easel around on the enlarger baseboard. This step is always done in close conjunction with the next one.

7. *Focus the image:* Your enlarger has a provision for gradually changing the distance between the lens and the negative, and it is used for focusing the image on the focusing paper. The lens aperture (a variable-size hole) should be set at the wide-open position for best visibility while focusing, for the image is then at its brightest. You may focus either with the unaided eye, which is usually satisfactory, or with a device called a grain focuser, which guarantees that you will get really sharp focus. If you have poor vision, you may need one.

8. *Cut strips of enlarging paper for test strips:* Use 8 x 10-inch double-weight regular paper or medium-weight resin-coated (RC) paper. Be sure you get an enlarging paper, not contact paper. The latter is too "slow" (insensitive to light). With scissors or a paper trimmer, cut one sheet into 1 x 8-inch strips and return all but one to the lightproof paper package.

9. *Expose a test strip:* Position the 1 x 8-inch strip of printing paper on the easel in such a way that it will overlap an important part of the image—for example, the face in a picture with a person in it. Stop down (make smaller—the larger the *f*-number the smaller the aperture) the lens aperture either two or three *f*-stops (settings). Now turn on the enlarger light for exactly 5 seconds. Then cover up 1 inch of the strip with a sheet of cardboard or the paper package and give another 5-second exposure. Continue progressively covering up the paper and making 5-second exposures until there is no more paper left to expose. Then turn off the enlarger.

You can time your exposures by counting under your breath, using a cheap metronome, or using an electronic interval timer made specially for photography. The latter two are most accurate, of course, and are thus highly recommended. However, for many

purposes counting is accurate enough. For high-quality work get an interval timer.

10. *Process the test strip:* Put the exposed test strip through the developer, stop bath, first hypo, and second hypo in that order, then into the water holding bath.

Develop for exactly $1\frac{1}{2}$ minutes, all the while gently moving the test strip by nudging it with the fingertips, which is called "agitation." Don't hold it with your fingers, for that will make a brown stain caused by your body heat.

Next put the strip into the stop bath for 30 seconds (or 5 seconds for a resin-coated—RC—paper). Regular papers should then spend about 4 minutes in each hypo bath, RC papers 1 minute in each. Too long in the hypo (fixer) will cause bleaching. Not enough time will lead to brown stains later on, after a few days or weeks. RC papers are especially prone to bleaching, so you have to watch them.

After 1 minute in the first hypo a test strip or print can be viewed in white light. However, turning it on before that may lead to fog (an overall darkening) or stains.

11. *Analyze the test strip for exposure and image contrast:* A test strip consists of a series of toned areas ranging from light to dark, each one representing a different amount of exposure to the enlarger light—for example, 5, 10, 15, 20 seconds, and so on. The idea is to pick the area that looks best in terms of how dark it is and use the same exposure for a full-size print. Some sections will be too light, of course, and some too dark. If the best exposure would fall between two sections, average their exposure times. For example, if the 5-second section is a hair too light and the 10-second section a little too dark, we would use a $7\frac{1}{2}$-second exposure for the final print.

The test-strip method is a very easy and accurate way for determining the best exposure for a print. To do it mathematically, which is possible, would be quite a complicated and disheartening procedure.

The images in these different sections also have contrast, or tonal difference, but the only area in which the contrast really matters is in the section you judge to have the best exposure. The contrast may be too high, just right, or too low. If it is just right, it means that you should make your full-size print on the same-contrast paper as you used for the test strip. If it is too high, use a lower-contrast paper, if too low, use a higher-contrast paper. Make a fresh test strip on the paper you change to, because different contrast grades of the same type of paper vary in their sensitivity to light, so you would need a different amount of exposure. The available contrast grades are 1 through 6, with 6 being the highest.

With variable-contrast papers you control contrast with colored printing filters under the enlarger lens. Thus one package of printing paper will yield four distinct degrees of contrast. So to change

contrast you change filters. You should also make a fresh test strip, because the paper speed (its light sensitivity) varies with the filter used.

12. *If necessary, make another test strip:* You have learned that you should make a new test strip if you change your paper contrast or printing filter. You should also make a new test strip if the sections of the strip are either all too light or all too dark to include the exposure time that would look good for a final (full-size) print. If they are all too light, on the next test strip increase all the exposure times to 10 or 20 seconds. If they are too dark, stop down the lens one or two more times. That is, make the hole smaller.

13. *Expose the final print:* After examing the test strip under a bright light (a 150-watt bulb at a distance of 3 feet is about right), choose the best exposure time and use that time for exposing the full-size print—at the same *f*-stop and lens-to-easel distance.

14. *Process the final print:* Final prints and test strips should be processed in the same way—and with great care. Agitate the print in the developer by pushing it with the pads of your fingers (not the fingernails, which may mark the image) or by gently tipping the tray. If your exposure calculations are correct, the print will look just right after $1\frac{1}{2}$ minutes. If not, the time may be cut to 1 minute for a print that is getting too dark (overexposed), or pushed to $2\frac{1}{2}$ minutes for one that is too light (underexposed).

In either case, however, it would be best to adjust the exposure time somewhat and make a new print. The reason is that prints developed 1 minute or less tend to lose contrast and to get mottled, or splotchy, and ones developed for much longer than 2 minutes begin to fog. The manufacturers of photographic papers generally recommend $1\frac{1}{2}$ minutes as the ideal time, but many teachers of photography like 2 or $2\frac{1}{4}$ minutes best. So take your pick.

Agitate your print constantly in the stop bath, taking great care not to get any of it in the developer (the acid will knock out the developer, which is alkaline). For the first 30 seconds in the first hypo, agitate constantly; then agitate intermittently thereafter. Agitate intermittently in the second hypo and don't let prints sit on top of each other for long, or the ones underneath will show edges of demarcation due to bleaching.

Lift your print from the second hypo and drain it thoroughly, then put it in the water holding bath. If you don't have water running into the holding bath, prints should be agitated there every now and then. Enough hypo gets carried over into it to cause bleaching, especially with resin-coated papers. The water should be changed every hour or two.

15. *Wash and dry the final print:* Though hypo (fixer) serves the important function of making the image permanent, it must be completely eliminated from the print in order to prevent it from even-

tually bleaching or turning brown. This is done by washing in running water, agitating almost constantly by pulling out the bottom prints and putting them on top. Because the hypo-silver compounds that must be washed out aren't very water-soluble, this process should take about 1 hour with ordinary papers, which is a tediously long time.

By using a washing aid such as Heico Perma Wash you can cut this time to about 6 minutes, for it makes the hypo-silver compounds much more water-soluble. Many people use it just to reduce the tedium of a long wash time. Instructions for use are clearly stated on the bottle.

With resin-coated (RC) papers washing is less of a problem, and you don't need a washing aid like Perma Wash. The problem with ordinary papers is that the hypo compounds get imbedded in the paper fibers, where they are very difficult to wash out. However, an RC paper is waterproofed with a resin before the emulsion is put on so that the hypo can't get into its fibers. The emulsion (the gelatin layer that contains the image) and the paper itself will wash clean in 4 minutes in running water with constant agitation.

For a print washer you can use a sink, wash basin, or bathtub. The bottom drain should be partly open to let the hypo, which is heavier than water, drain out. Better yet is a large tray with a tray siphon attached. Then the hypo gets siphoned out from the bottom.

Prints on ordinary printing paper can be conveniently dried in a blotter roll, in a blotter book, or between sheets of blotter paper. Only photographic blotter should be used, because the ordinary kind (and papers in general) will cause stains. This is because they contain hypo as a preservative. With a clean sponge, wipe off a print on both sides before putting it to dry.

Resin-coated prints can be dried by wiping them off and laying them out face up on blotters, towels, bedspreads, or tablecloths. They shouldn't be covered with anything but simply exposed to air.

THE THEORY IN BRIEF

A photographic paper consists of a paper base, resin-coated or not, on which is coated a thin emulsion made up primarily of gelatin containing many thousands of tiny crystals of silver halides—silver chloride, silver bromide, or a combination of both. These crystals are sensitive to white light, which means that they can be chemically changed by it. There are numerous other ingredients in an emulsion, but the main ones have been listed.

When photographic paper is exposed to a projected light image from an enlarger the change in the crystals takes the form of a "latent image," an imagelike electrochemical configuration that is en-

tirely invisible at that point. One could call it "an image that is capable of becoming visible." If a given crystal has received sufficient exposure to light to permit it to contribute to the latent image, it will be affected by the developer, which will convert it from a silver compound into pure metallic silver, which is visible and happens to look black. Crystals receiving insufficient exposure will not be affected during normal developing times, though at longer times they will eventually break down into metallic silver, forming "fog."

After development the emulsion still contains numerous crystals of the silver compound(s) that are still light-sensitive and that would, therefore, turn dark on exposure to light. Thus the entire image would disappear in darkness. The hypo (fixer) takes care of this by changing them into entirely different compounds. Sometimes called hypo-silver salts, these new compounds are entirely insensitive to light and fairly soluble in water, so that they can be washed away. Once this has been done the only thing that remains in the gelatin is metallic silver in thousands of tiny particles, or grains. These particles make up the image.

When a print has been properly washed and dried the gelatin forms a protective coating around the silver particles, though they will eventually be deteriorated by the sulfides in polluted air, combined with heat and humidity. Otherwise, they will remain unchanged almost indefinitely.

2 Test Strips, Simple and Two-Way

As you have probably gathered, there is nothing whatever difficult about making straightforward photographic enlargements, though getting the exposures right would be an onerous task without test strips. Unless you had an electronic printing exposure meter or a well-developed talent for guessing exposure times, here are some of the things that would have to enter into your calculations, which would have to be mainly mathematical: the intensity of the light coming through the negative, paper speed, light bulb wattage, bulb color temperature, and voltage variations in the electrical line into which the enlarger is plugged. As you can imagine, exposure determination would be quite a hassle. However, using a test strip makes it as easy as falling off a log. For this reason alone you should have a high respect for test strips and make them with great care.

EXPOSURE

At this point it would be good for you to understand just what the word *exposure* means in photography. Basically, it means to subject

a photosensitive material to radiant energy, usually light, such a material being one that can be chemically or physically changed by radiation. For just exposure as such, any amount of light will do, but *correct* exposure is something else: in order to have correct exposure you must use exactly the right amount of light for a particular purpose.

Usually, this means the amount of light that will make an image look just the way you want it to, neither too light nor too dark. Thus the final judge in the rightness of a printing exposure is your personal taste in the way two-dimensional images look on photographic paper. This puts the burden squarely on you, but you will find that it is a light one to carry. This is because you have already spent thousands of hours deciding whether things were too dark or too light—for example, in different room illuminations or on the TV tube. More than anything else, your experience with television has adequately prepared you for an adventure in photography. You see, TV *is* photography, pure and simple, so you already know much more about photography than you think.

What exposure means can be expressed by a little formula that you ought to know about, because it is the equation that underlies all of photography and is well known to all photographers. It expresses the *law of reciprocity*, which you also ought to know. Stated nonmathematically it says: exposure (an amount of light) equals light intensity multiplied by time. Or we could say that *an* exposure consists of light of a certain intensity falling on a photographic material for a certain amount of time. Mathematically, the law is stated: $E = I \times T$, where E stands for exposure, I for light intensity, and T for time.

This is called the law of reciprocity because light intensity and time have a reciprocal relationship, but don't let that throw you. It simply means that if you want a specific exposure (amount, or quantity, of light), you can get it in more than one way by varying either the light intensity or the time or both. For example, you might use a low-intensity (dim) light and a lot of time, or a high-intensity (bright) light and little time and still end up with the same exposure (the same total quantity of light).

It is analogous to filling a bucket with water from a faucet: you can fill it with just a dribble and a lot of time or with a fast flow and little time. Of course, you could also fill it with a medium flow in a medium amount of time. In any case you end up with the same total quantity.

At this point you should try to remember that *exposure* may mean "quantity of light" and that it is a result of light intensity and time working together. Do not confuse *exposure* with *light intensity*, which is only part of the formula. You must remember that time also contributes to the light quantity, or exposure.

LENS APERTURE AND TIMER

In your enlarger the light intensity is controlled by the wattage of the bulb, which remains constant, and the lens aperture, which may be varied. The aperture is carefully calibrated so that each time you stop down you decrease the area of the hole by one-half, so that just half as much light can get through it in a given time interval. Conversely, each time you open up the aperture you double the aperture area and the amount of light that can get through in that interval.

Though this is very simple stuff, I am spelling it out carefully, because very many people are confused by it. Simple things seem to throw people just as badly as fairly complicated ones.

Now, your timer is also calibrated—in seconds. Thus you can double or halve a time without difficulty. In terms of the exposure (light quantity) you get, doubling the time is the exact equivalent of opening the aperture one stop. Conversely, halving the time will give you exactly the same exposure as stopping down one stop.

Thus quadrupling the time is equivalent to opening up twice. And using one-quarter of the time is equivalent to stopping down twice. And so on. The important thing to remember here is that the lens is calibrated so that the hole size is progressively doubled as you twist the ring in one direction, halved as you twist in the opposite direction. This will help you remember the things you have just read.

By now it should be fairly obvious that the aperture and timer work together to control the exposure, or total light quantity. One controls the light intensity, the other the time. Though this is idiotically simple when you think about it, it has badly confused many a photographer in the beginning.

Since the functions of the aperture and timer have the relationship just described in controlling the exposure, the thing to do is juggle their settings around to get the ones most desirable. You are somewhat limited in aperture selections, because your lens is at its sharpest only when stopped down two or three times from its maximum opening. However, the image is reasonably sharp (except at the very edges) when the lens is stopped down once and passably sharp when it is wide open.

You are not so limited by timer settings, except that those under 5 seconds aren't usually very accurate. On the long end of the scale, you can go to 5 minutes or more if you have to, though the enlarger should be turned off to cool down after each minute.

The most desirable setting for the aperture is down two stops or more. The best timer setting is between 10 and 20 seconds. As for the juggling, say your test strip tells you that 40 seconds would be the best time: you can open up a stop and give 20 seconds instead.

Say the strip says 5 seconds; then stop down one more stop and give 10 seconds, or two more stops and give 20.

The reason the 10-20-second range is desirable is that it gives you time for dodging (Chapter 3) and yet isn't interminably long. Furthermore, it helps insure that burning-in times won't be too awfully long.

THE SIMPLE 5-SECOND TEST STRIP

You have already been told how to make this kind of a test strip, but I will repeat the instructions to refresh your memory. You stop down the enlarger lens two or three stops and give a 1 x 8-inch strip of printing paper a 5-second exposure. Then you start covering it up an inch at a time, giving another 5 seconds at each step. This gives you a test strip with exposures totaling 5, 10, 15, 20, 25, 30, 35, and 40 seconds, one of which will probably be the *correct* exposure. That is, its tone will look as you think it should.

This type of test strip is very commonly used and is the one you will probably find yourself making most frequently. As you see,

Fig. 2.1 You make a test strip by progressively covering up a strip of printing paper with a sheet of cardboard while it is being exposed to the enlarger light. Exposures are usually given in 5-second increments.

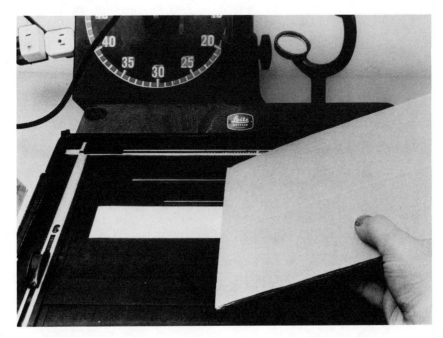

it is absurdly easy to make. To find the exposure for a given section you merely count up by 5s from the bottom (lightest) section. Selecting the best exposure is also dead easy: you just pick the section where the tone looks best for the particular kind of picture you are printing. When you try it for the first time you will probably be successful. This being so, there is no reason why your very first full-size print shouldn't be a good one.

Incidentally, you will encounter photographers who will tell you to expose test strips by progressively *uncovering* the paper, but don't listen to them. Using the covering-up method will help you keep things straighter in your mind, especially when you use the next exposure method.

THE 5-5-10-20 TEST STRIP

Though the simple 5-second test strip is very, very good, there are several things that it doesn't do. It doesn't embody a very great exposure range, doesn't show you the total possible range of tones of the particular paper you are using, and doesn't give you a very clear quantitative idea of the effects of exposure increases and decreases.

Because of its relatively short exposure range, the 5-second method doesn't provide a very good test strip to use with an unfamiliar sensitized material of unknown speed (paper speed can vary quite considerably). In using it you may miss the correct exposure so far that you can't figure out what is going on.

In using the 5-second method you may never see the blackest black that a paper is capable of producing, which is something you should know. Producing tones is basically all that printing consists of, so you should always be aware of all the tonal capabilities of whatever paper you are using. That is, you should know its built-in tonal range. Tonal ranges vary somewhat from one brand or type of paper to another.

Finally, the 5-second method gives you a strip in which the percentage of exposure increase constantly varies as you go progressively from one step to another. For example, as you go from step 1 to step 2 the percentage of increase is exactly 100 per cent, but after that it gets steadily less until you go from step 7 to step 8, where it is quite low. This makes it hard to get a quantitative idea of the effects of exposure in terms of the tones created when it is either doubled or halved, which is the easiest thing to visually grasp.

The 5-5-10-20-type test strip solves all these problems very neatly and easily, but you will probably need it only the very first time you use a particular printing paper or other photosensitive material, such as process film, blueprint paper, or sensitized cloth. You will

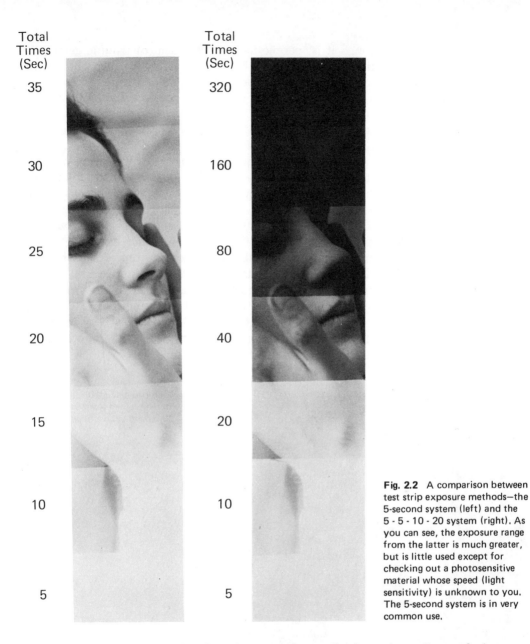

Total Times (Sec)		Total Times (Sec)	
35		320	
30		160	
25		80	
20		40	
15		20	
10		10	
5		5	

Fig. 2.2 A comparison between test strip exposure methods—the 5-second system (left) and the 5 - 5 - 10 - 20 system (right). As you can see, the exposure range from the latter is much greater, but is little used except for checking out a photosensitive material whose speed (light sensitivity) is unknown to you. The 5-second system is in very common use.

welcome this fact, because the method can be quite confusing, even when you are used to it.

The method consists of making the exposure the same the first two times and thereafter doubling it at each step. (The lens should be stopped down three stops.) Thus you get *individual* exposure times of 5, 5, 10, 20, 40, 80, 160, and 320 seconds. However, the exposure *totals* on the strip *add up to* 5, 10, 20, 40, 80, 160, 320, and 640, seconds. Note that the first two *totals* aren't the same and **15** that the last *total* is double the last *individual* exposure time.

Simple though it is, people have a great deal of trouble getting it straight in their minds, so you had better sit right down and figure it out for yourself with pencil and paper. Make a rough drawing of a strip with all the *individual* exposures received by each section marked on one side and all the *total* exposures marked on the other. If you can sort yourself out concerning what happens in the first three sections, you will probably be out of the woods.

The large exposure range from 5 to 640 seconds will show you the speed and tonal range of any enlarging paper you are likely to encounter and will do the same with many contact papers (very slow), too. However, there are some extremely slow materials, covered later in the book, that may require much longer times. All you have to remember is to make the first two *individual* exposure times the same and thereafter to double the exposure time for each step. You can start with 30 seconds, 1 minute, 2 minutes, and so on, depending on how slow you think the material might be. With any material, slow or fast, this particular test strip method is the best way for quickly zeroing in on its speed (relative sensitivity to light). Until you know that you are in no position to make good prints.

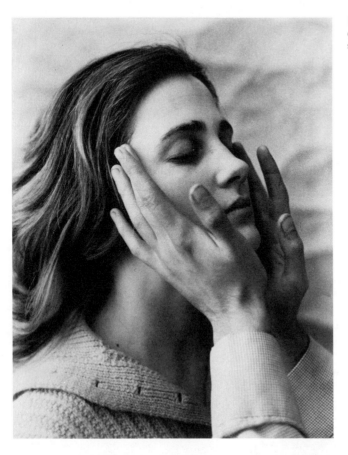

Fig. 2.3 A print made with the exposure data obtained from the test strips. A 30-second exposure was used.

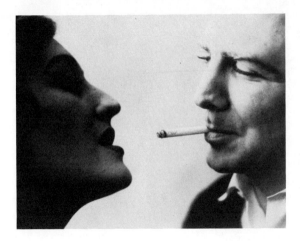

Fig. 2.4 A straight print (no dodging or burning-in) in which one face is too light and the other too dark. Thus a test strip for one would be of no value for the other. This situation calls for duplicate-image test strips.

THE DUPLICATE-IMAGE TEST STRIP

Widely useful though it is, there is still another shortcoming of the test strip made with 5-second exposures on a 1-inch strip of paper. It is that you get exposure tests for only that small part of the image actually covered by the strip. Furthermore, only one small segment of the strip will have the correct exposure or something close to it. This means that with an image of 80 square inches (8 x 10) you will have the correct exposure for only 1 square inch.

The problem is this: the correct exposure for one area may not be correct for the rest of the picture. In time you learn to spot this problem on a 5-second strip and can estimate exposure corrections,

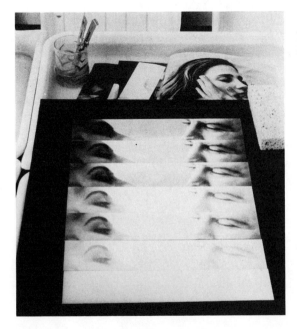

Fig. 2.5 Duplicate-image test strips laid out on a print inspection board (a sheet of glass with black Con-Tact paper on one side, white on the other). The exposures are 5, 10, 15, 20, 25, 30, and 35 seconds, 35 being about right for the man, 15 for the woman.

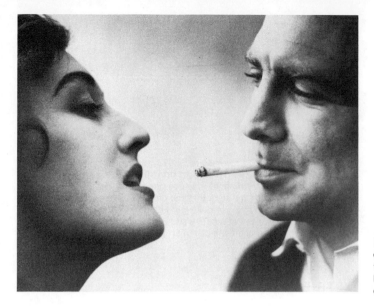

Fig. 2.6 A final print using the exposure data from the duplicate image test strips. The man was darkened by burning-in, the woman lightened by dodging.

but at first you don't know how. A related problem is that you might have the correct exposure for a very unimportant part of the picture and the wrong exposure for important parts.

The most obvious way around the difficulty would be to make a series of exposure tests for the whole image with whole sheets of paper, giving each sheet a single exposure. You might try 5, 10, 15, 20, 25, 30, 35, and 40 seconds. Since paper is expensive, this would cost you quite a bit of money, but you should try it at least once in your career just to see what happens. You will find the experience rewarding and informative.

A reasonably good compromise is to use six or eight 1-inch strips of paper instead of whole sheets. You can give each of them one exposure, positioning them all in exactly the same place across an important part of the image. Process them all at once, stirring them like spaghetti, then lay them out side by side on the back of a tray. You will then get a very good idea of what various exposures might do to the whole image.

This method is more time-consuming and expensive than the simple 5-second method, but you ought to use it now and then until you have had quite a bit of experience in printing. Later on, when you have learned to make accurate exposure estimates from a 5-second strip, you will find that you seldom need duplicate-image tests—that is, strips with the same part of the image on them.

EXPOSURE CHIPS

You may find it practical to make an exposure test with a 2 x 2-inch square of paper positioned on an important part of the image. Use

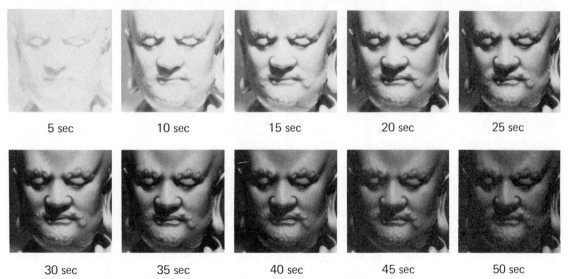

5 sec	10 sec	15 sec	20 sec	25 sec
30 sec	35 sec	40 sec	45 sec	50 sec

Fig. 2.7 Two-inch exposure test chips. Usually two or three chips are enough for getting the correct exposure, but this group of ten gives you a better idea of what exposure does to printing paper.

several, each with a different exposure, or make two exposures on just one such chip. After you have been printing for a few months the latter will usually give you all the exposure information you need.

Fig. 2.8 A full-size print made with the 20-second exposure. The bottom half of it required burning-in, but this information couldn't be gleaned from the exposure chips, which were, after all, very small.

TWO-WAY STRIPS: SOLARIZATION AND FLASHING

There will be times when you will want to get two sets of exposures on the same whole sheet of paper—for example when you are solarizing prints or reducing image contrast by flashing. Such an exposure test could be called a two-way strip, because the exposure sections extend in two different directions.

Solarization, properly called the Sabattier effect, is a way of partially reversing print tones to give a picture a strange and interesting effect. It involves exposing a print twice: once in the usual way and once with a solarizing light source after development has gone about halfway. After the second exposure it is developed the rest of the way.

Because a lot of contrast is lost in this process, a certain very-high-contrast paper called Agfa Brovira no. 6 is used to compensate for the loss. Papers with less contrast work less well. However, in making solarizations from color slides, which generally have a lot of contrast, you can use a no. 5 paper. Agfa's no. 6 is the highest-contrast paper on the market, but Kodak makes several no. 5 papers.

You expose the first part of your full-sheet, two-way test strip with the 5-second method, then develop the paper for $1\frac{1}{2}$ minutes in Dektol that has been diluted 1:10 (1 part Dektol, 10 of water). Then you put the paper in a tray of water and make a second set of exposures with the solarizing light source. Make them at right angles to the first set.

The solarizing light should be a round white $7\frac{1}{2}$-watt bulb positioned 5 feet above the water tray. The set of solarization exposures should be 3 seconds each, not 5. After these exposures, return the print to the developer tray for another 2 minutes, processing normally thereafter.

The full-sheet, two-way test strip will look somewhat like a checkerboard, with a lot of squares. As with an ordinary test strip, you simply pick the square that looks best to you. Then you figure out both the first and the solarization exposures for that square and use them for making a final solarized print. It is really very easy.

Flashing a print is equally easy and is done with the same small lightbulb in nearly the same way. The only thing is that the print isn't partly developed before the second set of exposures. Flashing is used to reduce the effective contrast of a paper. For example, a no. 5 or 6 contrast can be reduced well below a no. 1, which is the lowest contrast grade available in papers.

The flashing exposures for your two-way test strip should be of the same duration as solarization exposures—that is, 3 seconds each. Both solarized and flashed prints may need a little overall bleaching to make their tones lighter (Chapter 5).

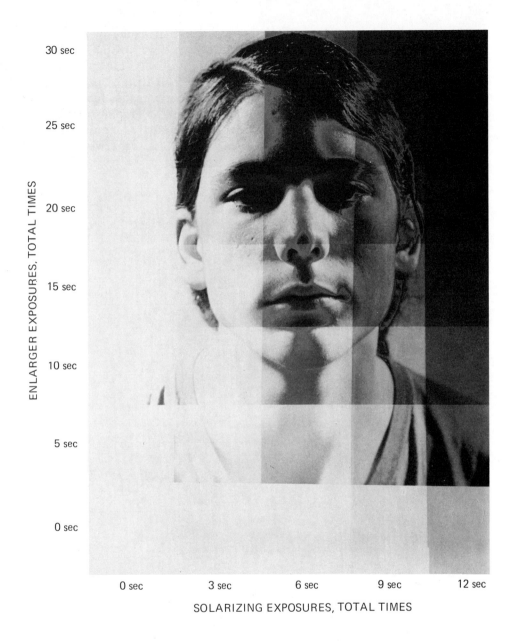

30 sec

25 sec

20 sec

ENLARGER EXPOSURES, TOTAL TIMES

15 sec

10 sec

5 sec

0 sec

0 sec 3 sec 6 sec 9 sec 12 sec

SOLARIZING EXPOSURES, TOTAL TIMES

Fig. 2.9 A full-size, two-way exposure test strip made for solarizing. First the enlarger exposures were made and the print developed for 2 minutes in Dektol diluted 1:10. Then, with the print under water, the solarization exposures were made with a 7½-watt bulb at a distance of 5 feet, followed by an additional 2 minutes of development. Prints made with the exposure data from this strip can be found in Chapters 12 and 20. A two-way strip made for contrast reduction by flashing would look about the same as this one, except that there would be no solarization.

22

As you have seen, test strips, either regular or two-way, are very easy to make and provide an accurate way of determining exposure times. The kind that you will probably use most is the simple 5-second strip made on an 8 x 1-inch strip of paper, though other kinds have their special uses. Properly made, test strips offer you a magic passport into the art of photographic printing. For this reason they should always be accurately exposed and processed as carefully as if they were final prints. Otherwise, they will be of little value.

3 Dodging and Burning-in, Regular and Contact

Frequently, when a print has been given the correct overall exposure (basic exposure) it will look all right as a whole but have certain areas within it that are either too dark or too light. The former can be corrected by dodging, the latter by burning-in, both of them simple procedures.

DODGING

You can lighten an area by dodging it. Dodging means to cast a shadow over a part of an image for a part of the basic exposure time, usually no more than half of it. That is, you hold a shadow-casting object between the enlarger lens and the printing paper. You can use a hand or a finger, but people generally use a "dodger," which is a 10-inch length of wire with a 2-inch cardboard disk taped to one end and a $\frac{1}{2}$-inch disk affixed to the other. The disks are used as shadow casters.

If it is held still during dodging, the dodger will make a round, light image of itself on the print. However, if the disk is moved constantly

23

around, the lightened area will blend in subtly with the rest of the picture, which is usually what one wants. However, you can make a dodger of any shape you wish and make its image show up on the print if you want it to. For example, you may want a light star shape to show up clearly on a print and would then use a stationary star-shaped dodger.

You may find it convenient to dodge edges or corners of a picture with a sheet of cardboard, which is moved back and forth to make the blend.

The only thing at all difficult about dodging is correctly estimating the right dodging time. However, if you miss it once, you can try again, and with a little experience you will guess it right most of the time. There is one thing you definitely shouldn't do: don't start dodging a print until you have worked out the correct basic exposure time. If you do, you will soon confuse yourself to the point where you won't really know what you are doing.

Figs. 3.1, 3.2 In a straight print the cook's face looks a little dark and dirty. A little dodging lightened it and made his skin look healthier.

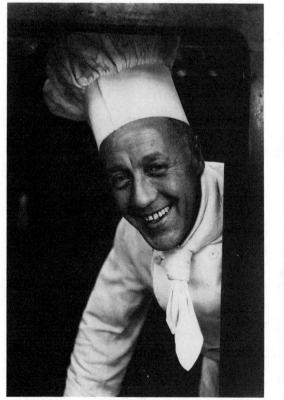 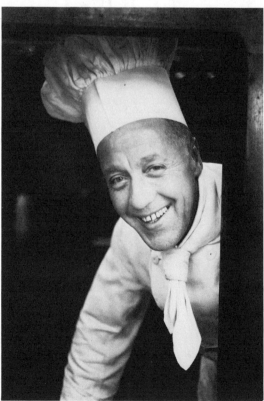

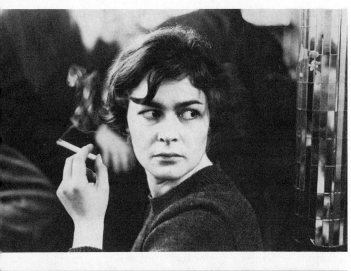

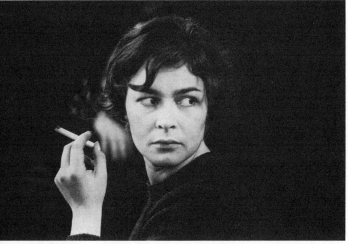

Figs. 3.3, 3.4 In a straight print
the background is quite distracting,
as you can see. However, heavy
burning calmed it down very well.
The only thing left in the background is a
hand, which could have been burned-in
also. Since it works as an abstract shape
it does no harm to the picture—unless
one knows what it is.

BURNING-IN

Burning-in is the exact opposite of dodging. Instead of shading an area to make it lighter you give it extra light to make it darker. This is usually done with a burning-in card, which is a sheet of cardboard with a small hole in the center. You should have several cards, with hole diameters of $\frac{1}{2}$, 2, and 3 inches.

Though dodging of a given area is usually limited to half or less of the basic exposure time, burning-in times are frequently much longer. For example, you may wish to burn an area down to a dead black, which might well take a minute or more. If you anticipate fairly long and tedious burning-in times, open up the aperture a stop

or two just for burning-in. That will let more light through and shorten the times.

For burning-in the edges and corners of a picture use a card with no hold in it, moving it back and forth to make the blend. You can also use the side of your hand, if you like. By holding it close to the enlarger lens you can even use the 2-inch dodger; if it is held high enough, it will block off the whole sheet of printing paper.

Be sure not to do any burning-in until you have worked out the correct basic exposure time. Otherwise, you will confuse yourself. Sometimes you will find it necessary to do both dodging and burning-in on the very same picture. No problem: it is quite easy.

PROFESSIONAL PRACTICE

Most professional printers seldom or never use dodgers or burning-in cards. They use their fingers and both hands instead, making a variety of shadow shapes for dodging and using holes between the hands or fingers for burning-in. Once you have learned to work with your hands you can move a lot faster, but it is a bit frustrating until you have learned how to use them properly. The professional's main interest in the technique is for its speed and convenience; he doesn't have to fumble around in the half-dark for a dodger or burning-in card.

CONTACT DODGING

You can lay a dodger right on the printing paper and get a good blend by moving it around. One doesn't ordinarily do this with a regular dodger, because the size of the shadow it will cast is determined by its distance above the printing paper, and putting it right on the paper limits the size of the area you can dodge. However, there may be a time when you wish to dodge a complex shape that the roundness of the dodger shadow just won't fit.

In that case, put a piece of black paper on the printing easel, open the lens all the way, project the image, and with a pencil trace the area you wish to dodge. Then cut out the shape, tape a piece of wire (or your regular dodger) to it, and use it for contact dodging, employing the wire to move it around. The technique generally works best if the dodger shape is somewhat smaller than the area to be dodged.

You can do approximately the same thing with one or more pieces of black paper and ordinary window glass. Trace the outlines of your picture on a piece of typing paper, then put the drawing under the glass and use it as a guide for positioning the black paper where you

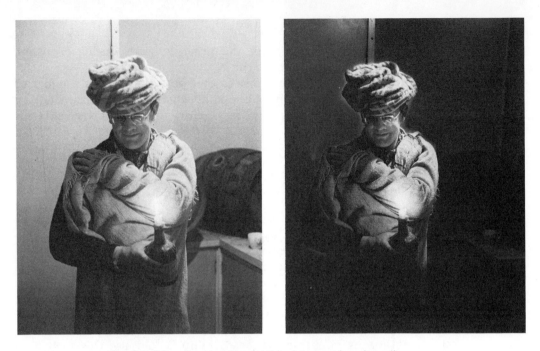

Figs. 3.5, 3.6 As a straight print this picture works quite well, but it would be interesting to dramatize it a bit anyway, which was done by contact dodging. The print was given the basic exposure without the dodger. Then the dodger was laid down and extra exposure given, with the dodger in movement all the while. The movement created the interesting halo effect around the figure. Because it was too bright in places, it was toned down here and there with spotting dye on the print.

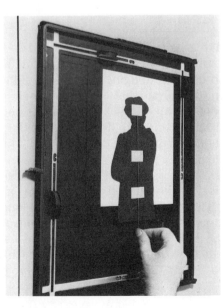

Fig. 3.7 The contact dodger used for the picture of the man in the turban. A wire was taped to it so that it could be moved around during exposure.

want it. Hold the glass over the printing paper during exposure, moving it constantly to make the blend.

The advantage of using glass is that you can dodge a number of areas, and they don't have to be connected. With ordinary dodging you can only dodge very few areas before the basic exposure time is up.

CONTACT BURNING-IN

For contact burning-in you follow the same general procedures as for contact dodging, except that you do it by letting extra light shine through holes in black paper after the basic exposure time has been given. Put the black paper right on the enlarging paper and move it constantly during exposure.

Ordinarily, there isn't much need for contact burning-in, though it permits you to burn-in a number of areas at once. However, it is easy enough to burn-in one area after the other, giving each area as much extra time as you think it needs. You would use this technique mainly for oddly shaped areas that would be hard to burn-in evenly through a round hole in a cardboard.

If you want the burned-in areas to have sharp edges, which might be desirable for an artistic effect, simply let the black paper lie stationary during the burning-in time. To get neat edges on your cutouts (which some people aren't very good at), use very sharp barber scissors or a razor-edge Xacto knife.

CHIP DODGING

If you have to make a large number of identical dodged prints from the same negative, one way of getting the dodging exactly the same in all of them is to do chip dodging. Tape a 2 x 2-inch piece of glass to the enlarger lens barrel so that it hangs about ½-inch below the rim. On the glass put a chip of black paper about one-fourth the size of a dime. You can make this chip dodge any area of the picture that you wish by changing its position on the glass; you should leave it there for the whole exposure time.

The enlarger light "bends around" the chip during the exposure, so that the image is not fully shaded off in the area in which the chip casts its shadow. The darkness of the shadow and the degree of consequent lightening of the dodged area are controlled by the lens aperture. When the lens is wide open it will be hard to tell from looking at the image that the dodging chip is even there. However, as the lens is stopped down the shadow becomes progressively darker

29

*Dodging and
Burning-in,
Regular and
Contact*

and the edges of the dodged area more clearly defined. You can see all these things quite readily in the darkroom, so don't worry about them.

The distance of the glass from the lens also makes a difference, the shadow getting darker and sharper-edged as the glass-to-lens distance is increased. This is also easy to see. If you wish, you can have the glass in contact with the rim of the lens. This will permit you to stop down more without getting a shadow that is too dark or sharp-edged.

You can of course use more than one chip, and the sizes can range from minute to fairly large. You can also make them any shape you wish. You can tell pretty well what a given chip is doing by watching the image as you push it into position with a fingertip or pencil eraser.

You might use this technique for printing a bunch of Christmas cards when you want a lot of identical dodged images. In the world of commercial photography it is used mainly on the automatic machines that expose pictures on roll paper in runs of a thousand or more. These pictures are often used for salesmen's sample kits and general public relations.

By now you should have surmised that dodging and burning-in are very easy to do. However, to do them skillfully will take a bit of experience. Fortunately, your errors, even in the beginning, will stand out so clearly to you that you will usually be able to make corrections by simple trial and error.

4 Contrast Dodging with Variable-Contrast Paper

Sometimes an image is more contrasty on one side than on the other. Thus a certain contrast grade of paper or printing filter that is right for one side may be wrong for the other side. You could choose a paper grade or filter right in the middle, but then no part of the picture would be exactly right. The thing to do is to use a single sheet of paper to get two quite different grades of contrast, high on one side and low on the other. This can be done with a variable-contrast paper, using two different printing filters.

LENS FLARE

The usual source of this contrast problem is lens flare, caused by unusually bright light striking the camera lens. The light is reflected back and forth repeatedly inside the lens elements, until it is scattered all over the place, at last emerging from the lens to spray, as it were, all over the image inside the camera. This causes a strong flattening effect in the image, a loss of contrast.

30

The negative image may be flattened overall, in which case the remedy in printing is simply a high-contrast paper or filter. Or a part may be flattened, usually the top, bottom, or one side. In this event the remedy is contrast dodging.

OTHER CAUSES

Another cause that you may encounter is a difference in lighting contrast from one side of a pictorial subject to another. That is, the tonal difference between highlight and shadow may be greater on one side. However, contrast is also caused by the degree to which objects are tonally different than their backgrounds, which can also vary from one side of a scene to another.

On negatives there will be a contrast loss in portions that are heavily under- or overexposed. In printing we generally don't do anything for the underexposed areas, except for a modest amount of dodging, perhaps. The flattened-out overexposed areas often have to be burned-in, which can be done with a high-contrast filter, possibly a no. 4, in order to increase their contrast somewhat. This is a type of contrast dodging, even though the context is burning-in. The contrast increase usually won't be great, but enough to make a difference.

Fortunately, we don't too often encounter negatives with this contrast difference from side to side, because making a correction in printing is a bit of a hassle. However, it is nice to know how to do it should the need arise.

VARIABLE-CONTRAST PAPER

A variable-contrast paper has two entirely different emulsions mixed together on its coated surface, one contrasty and the other flat. It is exposed through different printing filters, which range in contrast from no. 1 (flat) through no. 4 (contrasty). The flat emulsion is most sensitive to the light passing through the flatter filters, the contrasty emulsion sensitive to light from the higher-contrast filters. The filter numbers are equivalent to paper contrast grades, though there are some between-grade filters such as $2\frac{1}{2}$ and $3\frac{1}{2}$. Thus by using filters you can get any image contrast you want through a range of four paper contrast grades, with half-grades in between (in the case of Kodak Polycontrast filters).

If you print a negative of normal contrast with a no. 1 filter, you will get a rather flat print. With a no. 4 it would be rather
contrasty—as contrasty a print as you can get with a variable-contrast

paper. Graded paper has higher degrees of contrast—namely, no. 5 and no. 6—but it doesn't go lower than no. 1.

Still printing a negative of normal contrast, if you give two separate exposures, one with the no. 1 filter and the other with the no. 4, you would come out with a medium-contrast print that would look as if it had been printed with a no. 2, 2½, or 3. However, it is easier to choose the filter you want in the first place than to get the same effect with two exposures. The important thing to realize is that you *can* give two exposures if there is a reason for it, which there is in contrast dodging.

CONTRAST DODGING

Contrast dodging usually consists of printing one side of a picture with one filter, the other with another, and getting the two sides of the image to blend together well. For example, we might use a no. 2 and a no. 4. This is the most usual combination when we have lens

Figs. 4.1, 4.2 The bright sky and nearby sun caused lens flare in the upper portion of the negative, which in turn led to loss of contrast in part of an otherwise contrasty negative. To correct this contrast difference, the bottom of the picture was reprinted with a no. 1 Polycontrast filter, the top with a no. 4.

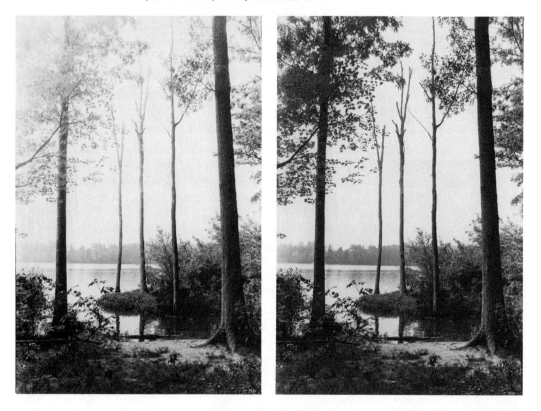

flare in part of a negative. The normal side of it would require a no. 2 filter for a normal-contrast print image. The flared side, with reduced contrast, would require a no. 4 filter to produce a normal-contrast print image. That is, low contrast in part of the negative is compensated for by high contrast in the printing filter, thus making the printed image in that are have normal contrast.

In printing, you give separate exposures, one for each filter. When you are exposing with the no. 2 filter, you dodge half of the printing paper with a sheet of cardboard, moving it back and forth so there will be a good blend. Cover a distance of about 6 inches in the movements, ranging on both sides of the center of the picture. Then expose for the other side of the picture with the no. 4 filter, moving the dodging card in the same manner to make the blend and protecting the already-exposed side from additional exposure, except in the area of the blend. The blend area, you understand, must be exposed to light through both filters. Otherwise, the tonal merger of the two sides won't be smooth.

TWO TEST STRIPS

As you may have guessed, doing contrast dodging isn't really very hard, but there is one small fly in the ointment: you need to use different exposure times with the two filters, because one of them is quite a bit darker than the other. The density of the higher-contrast filter cuts down the light intensity, making a longer time necessary.

Typically, you will discover that the no. 2 filter requires an exposure of, say 10 seconds, while the no. 4 may need anything from 40 seconds to a minute or more. With Kodak Polycontrast filters the actual speed ratio between these two filters is 1:4, the no. 2 being four times as fast as the no. 4. However, flared parts of a negative tend to be unusually dark, so they require more exposure than you would decide upon by simple calculation with the filter speed ratio. For this reason you should make test strips.

You should make test strips for both sides of your picture, using a different filter for each one. Process them both at the same time and use them for determining the correct exposures for the two sides of your picture.

ENLARGING DIAL

For using Kodak Polycontrast paper when you are not doing contrast dodging there is a useful little enlarging computer made of cardboard. You use it when you have already found the correct exposure for one filter and decide to switch to another. By simply setting the dial you can find the correct exposure for the new filter.

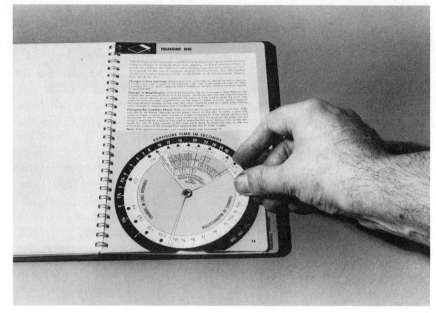

Fig. 4.3 When using Kodak Polycontrast papers it is convenient
to have an enlarging dial, such as this one in the *Kodak Darkroom
Dataguide* (it is also available separately). Once you know the
correct exposure for one filter, you can dial the correct exposures
for all the others.

If both sides of a partly flared negative were of the same density
(degree of darkness), we could use the computer for contrast
dodging, too, but we've seen that they usually aren't the same.
However, the dial will give one a rough idea of the exposure
difference for two sides of a picture exposed with different filters.

TRY AGAIN

In printing a negative by contrast dodging it is almost certain that
you won't get the print right on the first attempt, even with carefully
made test strips. You may have to adjust exposures, the movement
pattern of the dodging card, or both. Because a badly made
contrast-dodged print can look rather awful, you may be discouraged
and want to give up. Don't. In two or three more tries you will come
up with the print you want—perhaps even in one more try.

5 Local and Overall Print Bleaching

Watching an image come up in the print-developing tray is magic of the first order, and making it go away again is very magical, too. You can do the latter with a silver bleach made of potassium ferricyanide, a moderately poisonous and very inexpensive compound in common use in photography.

Remember that the image on a print is composed of black metallic silver. A solution of potassium ferricyanide will change the silver into a colorless silver compound that becomes a part of the bleach solution and no longer associated with the image. The silver image gets progressively lighter, finally disappearing altogether—which is just what you would expect a bleach to do.

Bleaching is done after a print has been put into the hypo bath or even after it has been washed and dried. A dried print should be soaked in hypo before bleaching.

FARMER'S REDUCER

The ferricyanide can be mixed with a solution of sodium thiosulfate, 35 which is the main chemical in a hypo, or fixing, bath. Then it is

correctly called Farmer's reducer (after the man who invented it). However, it works just as well when mixed with plain water—and is still called Farmer's reducer, though incorrectly.

With the water mixture, which we will talk about in this chapter, the thiosulfate (hypo) is nonetheless required, for it removes the yellow stain caused by the ferricyanide and helps complete the bleaching process. You first bleach your print with the water solution, then put it in a hypo bath. Use either the first or second hypo that you normally use in print processing. Unless you accidentally dump in a sizable quantity, the ferricyanide will do the hypo bath no harm, so you can continue to use it for print processing.

RATE OF BLEACHING

In order to make print bleaching a controlled process you need to know the factors that make it fast or slow. One is the strength of the bleach solution, of course, concentrated solutions working faster than weak ones. Light tones on prints bleach much faster than medium or dark tones. Underdeveloped prints bleach fast, normally developed ones at a moderate rate, and overdeveloped ones quite slowly.

The light tones in underdeveloped prints bleach very rapidly, and the medium and dark tones bleach fairly fast, too. Medium and dark tones in normally developed prints bleach rather slowly. In prints developed 2 minutes or more the medium and dark tones bleach very slowly, though the very lightest tones will still bleach fairly well.

The age of a bleach solution makes a considerable difference in the rate of bleaching. A freshly mixed dilute solution will bleach fairly fast, but it soon slows down and after about 15 minutes hardly works at all, its weakness being indicated by the fact that it has turned from yellow to green. Concentrated solutions will also slow down somewhat and turn green, but they will still work fast after several days, so for them greenness per se shouldn't be used as an indicator of exhaustion. The green color doesn't stain prints.

The best idea is to mix a fresh solution each time you intend to do bleaching. Then you will become accustomed to the bleaching rate of fresh bleaches and soon learn to estimate how rapidly a print will be lightened. You use more ferricyanide this way, but it is very inexpensive stuff.

STRENGTH OF SOLUTIONS

For overall bleaching, in which you immerse an entire print in a bleach bath, use a rather dilute solution: about $\frac{1}{8}$ teaspoonful of

ferricyanide per quart of water. This will work fairly fast when freshly mixed.

For lightening local image areas somewhat use a stronger solution: about $\frac{1}{16}$ teaspoonful in 4 ounces of water. If you like to work fast, make it $\frac{1}{8}$ teaspoonful, but there is a risk of the solution getting out of control and bleaching too much.

For cutting medium or fairly dark areas back to white you can use a very strong bleach: up to $\frac{1}{2}$ teaspoonful in 4 ounces of water. With such a strong bleach you have to be *very* careful not to let it get out of control.

PHOTO-FLO OR DETERGENT

When you are working on local image areas the bleach will normally stand up on the print surface in small droplets wherever you apply it. This is due to the surface tension of the water. And each droplet will bleach too fast. You can flatten out the droplets by adding about 5 drops per ounce of Kodak Photo-Flo or dishwashing detergent to the bleach. This will make for much smoother bleaching jobs.

SEALING YOUR BRUSH

For applying bleach locally it is most convenient to use a pointed sable brush, size 8, 9, or 10. The problem with a brush, however, is that the inside of the ferrule is not chrome-plated like the outside.

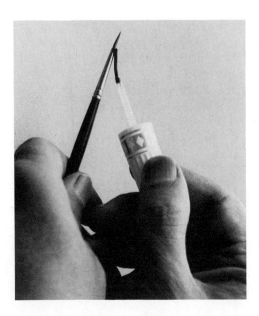

Fig. 5.1 Very often, the inside of a brush ferrule is uncoated iron, which will react with potassium ferricyanide to form a blue stain. To prevent this, seal the brush with nail polish, putting a small drop of the lacquer into the brush hairs just at the point where they disappear into the ferrule, thus sealing off the inside. Then lacquer the outside of the ferrule as well.

Since it is made of iron it will react with the ferricyanide to make bright blue stains on your prints. However, the ferrule can be effectively sealed with clear nail polish.

Wet and point your brush with your lips, then let it dry thoroughly. Now put a drop or two of the polish in the hairs just at the point where they disappear into the ferrule, taking care not to get any on the rest of the brush. Finally, paint the outside of the ferrule and the handle right next to it with two coats of polish. Your brush will be safely sealed for years, if not forever.

OVERALL BLEACHING

There are generally three reasons for bleaching a whole print: (1) to correct for overexposure and consequent unwanted darkness; (2) to make flat highlight areas a little more contrasty and possibly give them sharp edges; and (3) to alter the contrast of the print as a whole. For all three purposes the bleaching is done in the same way.

First, mix the bleach in a tray, making sure that all the ferricyanide crystals are dissolved. Then put in the print and start rocking the tray vigorously to agitate the bleach. After only 5 seconds, jerk out the print and immediately put it in the first or second hypo bath for about 30 seconds. Now examine it under a bright light for evidence of lightening. If it needs more lightening, repeat the process as many times as necessary. If the bleaching action is very slow, you can extend the time somewhat, but don't do so otherwise.

You see that you creep up on bleaching in easy steps. When people try to do bleaching with just one trip to the bleach bath they nearly always let it go too far, and then it is too late to do anything about it. The print is wrecked.

You can get slightly more even bleaching by using the cotton swab method of agitation. Just trail a wet cotton swab over the print while it is in the bleach tray, making the pattern of movement as random (erratic) as possible.

After bleaching, leave the print in the hypo for about twice the time it takes the yellow to go away—at least 2 or 3 minutes—then put it in a water tray.

LIGHT EDGES

With most (possibly all) enlargers the light is a little dimmer near the edge of an image than in the middle, which means that prints are usually a little lighter than they should be at the edges. You may not ordinarily be able to see the difference, but bleaching may bring it out. For this reason if you know beforehand that you are going to bleach a print, you should burn in all the edges a little bit.

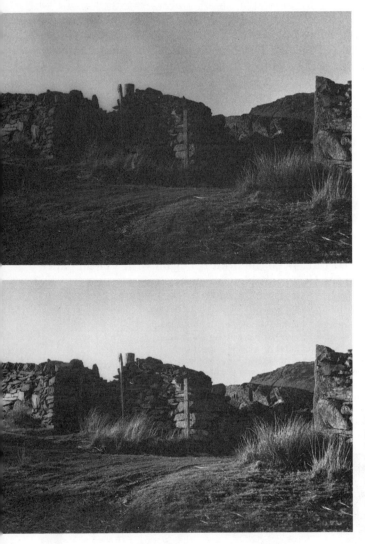

Figs. 5.2, 5.3 For overall bleaching a print should start out quite a bit too dark, both overexposed and over-developed. Indeed, it should look like a leading candidate for the wastebasket. As you see, bleaching improves matters quite a bit for this early evening scene in Wales. Notice that the light areas were bleached, but the dark ones mainly were not.

Prints get lighter near the edge in the bleach for another reason, too. With agitation by tray tipping the bleach moves fastest near the edges, which makes it work fastest there. To counteract this you can abandon tray tipping and use the cotton swab type of agitation mentioned in the preceding section.

INCREASING PRINT CONTRAST

You usually wish to increase print contrast when you find that your highest paper grade or printing filter isn't quite contrasty enough for a negative. Do it as follows: (1) overexpose the print about 25 per

39

cent; (2) develop it $2\frac{1}{4}$-$2\frac{1}{2}$ minutes (which is a substantial amount of overdevelopment); and (3) bleach it in the manner described above.

Since light areas will bleach fairly well and darker ones hardly at all, the print contrast will be automatically increased.

THE BLEACH-AND-BLOT METHOD

The "bleach-and-blot" method is used to control the bleaching rate and to keep bleach from spreading when you are bleaching local areas. In other words, you use it to keep the bleach from getting away from you, which it can do very easily.

Soak your print in hypo until it is thoroughly wet. Then put it on the bottom of a tray or on a print inspection board and wipe it off thoroughly with a viscose sponge that has been wet in hypo and thoroughly squeezed out. Wipe the print off again with a clean paper towel, so that even the tiniest droplets are gone.

Fig. 5.4 The "bleach-and-blot" method is one way of controlling bleaching so that it neither goes too far nor works too fast. The print is removed from the hypo, laid out on a print inspection board, and relieved of all surface moisture (even tiny droplets) with a sponge, followed by a paper towel. Apply the bleach (not too strong!) with a brush, then *immediately* blot it with a fresh paper towel, not waiting to see the bleaching action. If you wait, the bleach may go too far and too fast. You can bleach-and-blot a given area numerous times, but should return the print to the bleach bath after every few treatments.

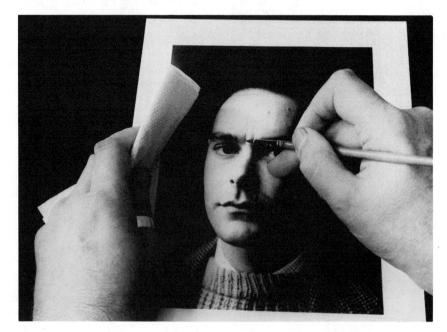

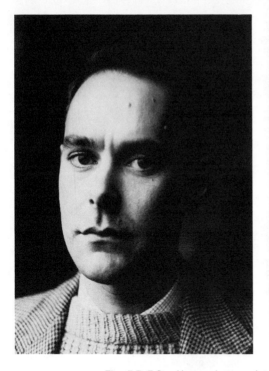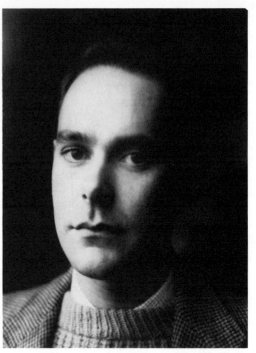

Figs. 5.5, 5.6 Here we have a print that could stand a little bleaching—the moles and frown lines, mainly. The retouched print was diffused a little bit (Chapter 6), then worked on with bleach, spotting dye, and white watercolor. If the bleach hadn't gotten away from me, the dye and watercolor wouldn't have been necessary. So be warned: bleaching a portrait can really turn out to be a hassle, but you won't be happy until you have tried it.

Apply bleach with a brush and immediately blot it very thoroughly with a fresh paper towel. Then examine the print carefully under a bright light for evidence of lightening. Repeat this bleach-and-blot procedure as often as necessary. After every second sequence apply hypo liberally to the bleached area with the sponge; then wipe it off thoroughly as before and go on to the next sequence.

You see that once again we are creeping up on bleaching in easy steps, because if you let it go too fast and too far your print is a goner. This is a time when the old saying that haste makes waste is nothing but the truth.

DETOUR: HYPO BLEACHING

Freshly mixed hypo makes an excellent bleach bath, which is why you shouldn't ordinarily leave prints in it too long. But a print may
41 need bleaching, so leave it in the hypo for as long as necessary, say

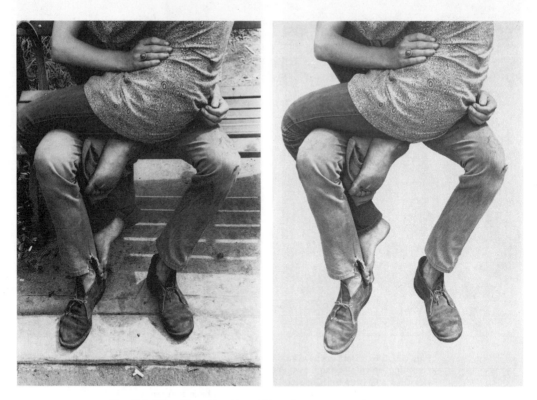

Figs. 5.7, 5.8 Since bleaching this much area can turn into a very tedious job, you should eliminate as much of the tone as you can in printing by doing contact dodging, or masking, during the entire exposure time. This will leave just a fringe of tone around the figures in need of bleaching. Use strong bleach on a carefully wiped print, but don't bother with the bleach-and-blot method.

5-15 minutes, agitating intermittently, keeping it under the surface, and making sure not to lay other prints on top of it. Regular papers bleach fairly fast in fresh hypo, resin-coated papers quite rapidly.

STAINS

You may have a problem with stains in bleached areas, either bright blue or brown. The blue ones are caused by the combination of ferricyanide with the iron in the water supply, in the form of rust or dissolved iron compounds. You can easily remove such stains by putting your print in a tray of print developer, which will not mar or change the image in any way. The blue will disappear almost instantly. Then put your print in the hypo and wash it as usual.

Brown stains are partly converted silver. If you are bleaching an area all the way to white you can generally get rid of the brown with

a very strong bleach and a fresh hypo bath. However, with partially bleached areas, you have to neutralize the color after the print has been dried. Do this by applying dilute washes of blue spotting dye which turns brown to gray.

As you have seen, there are no arcane secrets for working with Farmer's reducer. Overall bleaching is very easy to do, and you will probably be entirely successful on your very first attempt. Local bleaching is quite a bit more complicated, because you have to select exactly the right areas for lightening and must do it exactly to the right degree. Furthermore, on your first print or two you will probably get impatient and hasty and let the bleaching action get away from you. But you should have little trouble making up your mind concerning what you are or are not accomplishing, which will make it easy for you in the long run.

Figs. 5.9, 5.10 Without masking and very strong bleach it would have taken forever to cut out the background on this picture. The blacks were masked out entirely, for even the strongest bleach works slowly on them.

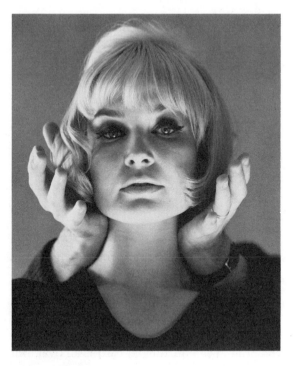 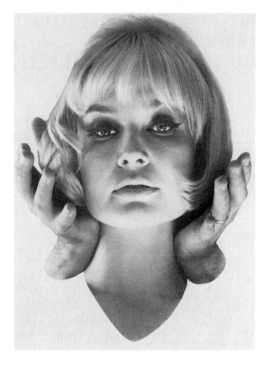

6 Vignetting and Flashing

Vignetting and flashing are ways of masking out, or eliminating, the backgrounds from photographic subjects. In vignetting the backgrounds come out white, in flashing either gray or black. Both techniques are very easy.

VIGNETTING

To vignette you merely print part of a picture through a hole in a burning-in card, giving no exposure at all to the masked-out area. During the exposure the card is moved constantly to blend the edge of the image into the surrounding white background.

Vignetting is usually done with faces—for example, to isolate one person from a group—though it can be used for other purposes. The most popular shape for the hole in the burning-in card is an oval, but you can use any other shape you like.

If you wish, you can make a 2 x 2-inch burning-in card with a tiny hole in it and put it on a glass plate right under the enlarger lens, as

you do in chip dodging. This is a way of making a number of identical vignettes from the same negative. Otherwise, there is no particular advantage to it, except to see that it can be done.

FLASHING

There are two main kinds of flashing. The kind used to reduce paper contrast mentioned in Chapter 2 involves exposing a whole sheet of printing paper to a non-image-forming light source, such as a $7\frac{1}{2}$-watt bulb. The kind we are interested in here is done by giving an image the basic exposure, then removing the negative from the enlarger. Then the edges of the picture are flashed, or burned-in, with "raw" enlarger light (with no negative in the enlarger), the subject of the picture being protected from additional exposure by a dodger, usually in the shape of an oval. To control the flashing exposure time

Figs. 6.1, 6.2 Vignetting is often used for getting rid of unwanted junk in the backgrounds of pictures. You do it by giving the entire printing exposure through a hole in a burning-in card, in this case an elliptical one. During the exposure the card is constantly moved around, so that the edges of the vignetted area will be soft rather than sharp.

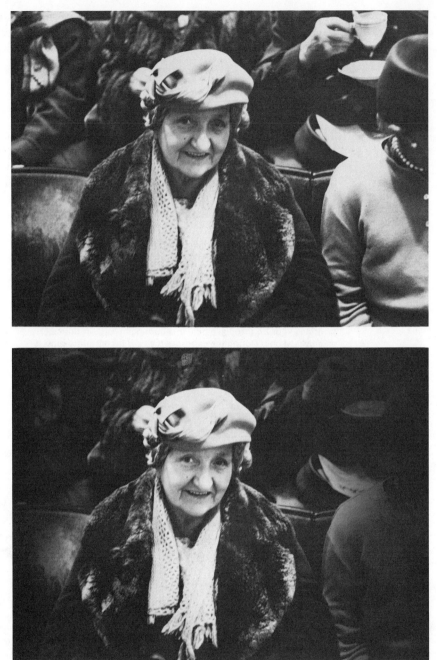

Figs. 6.3, 6.4 In the straight print the woman is surrounded by
visual distractions, none of which help portray her very well. In the
modified print the distractions were flashed, which is like burning-
in with no negative in the enlarger. It is fast and easy to do. It
always reduces contrast in treated areas, whereas regular burning-
in sometimes increases it.

the lens is usually stopped down most of the way. The dodger is moved around constantly to blend the middle of the picture with the edges.

Often the background is merely burned down to a gray, instead of black, so that image material is visible all the way to the edges of the print. However, flashing reduces print contrast and changes the entire feeling of the picture.

You can determine the flashing exposure either by guesswork or by making a test strip near the edge of the picture. Once you know the exposure for one picture you can use the same one on others.

FLASHED VIGNETTES

Sometimes it is interesting to vignette a picture, then flash it. Though you may have to make an extra print or two before getting the background tones to merge properly, you may find it well worth the trouble.

7 Local and Overall Diffusion

Some pictures, especially portraits and nostalgic landscapes, are improved by making them a little diffuse, or fuzzy. This makes their subjects look softer, smoother, and less texturally complex. This is because very fine details blend together and disappear. With portraits, small skin blemishes tend to drop out, faces look softer and younger, and they take on a more feminine quality. There is also a time-travel effect, diffused pictures seeming to go back in time to a point many years ago, when print diffusion and soft-focus camera lenses were all the rage.

OVERALL CELLOPHANE DIFFUSION

The easiest way to give a print overall diffusion is to wad up the cellophane from a cigarette package (or its equivalent) into a tight ball, then straighten it out again. It will be all wrinkled, of course. The wrinkled cellophane is then waved around right under the

48

Fig. 7.1 You can handsomely diffuse a print by waving
wrinkled cellophane under the enlarger lens during all or part
of the exposure time. The cellophane from cigarette packages is
popular for this. Wad it into a tight ball, straighten it out again,
and it is all ready to go.

enlarger lens during all or part of the printing exposure. Be sure to
keep it moving. For very heavy diffusion, do it for the whole
exposure. For more subtle diffusion, try one-half or one-quarter of
the time. Though the diffuser costs nothing, the results are excellent.

LOCAL CELLOPHANE DIFFUSION

You can make a dodger with a disk of wrinkled cellophane instead of
cardboard. Stick the wire right through the cellophane as if it were a
sewing needle. Use it as you would an ordinary dodger, waving it
around over the things you wish to diffuse or soften. It will also
lighten them somewhat, because the cellophane scatters the light so
that much of it never reaches the printing paper or is diverted to
another part of the image.

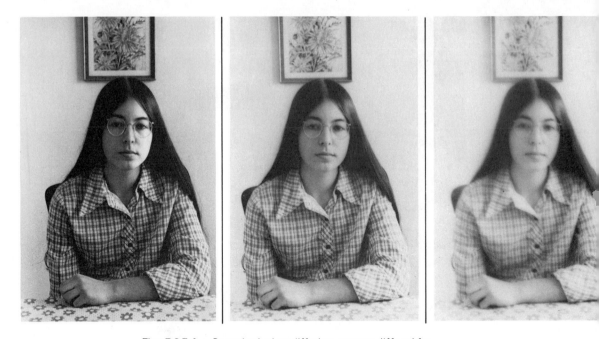

Figs. 7.2-7.4 One print had no diffusion, one was diffused for half the exposure time, and the last one for the whole time. Note the steady decrease in contrast with the increase in diffusion. Many people would accept the first two prints but find the third a little too woozy.

You can also do cellophane dodging in the way that one does chip dodging, putting the wrinkled cellophane on a piece of glass suspended under the enlarging lens with masking tape. A piece 4 x 6 inches is about right; position it 2 or 3 inches below the lens. Use as many bits of cellophane as you like, pushing them into position with tweezers, a pencil eraser, or a fingertip, the tweezers being best. You don't need to move the glass during exposure, but the images of the cellophane bits will show up in the print if the lens is stopped down too far.

Since part of the image will be fuzzy anyway, there is no special reason for not using the lens wide open or close to it, when it is just a little bit fuzzy at the edges. However, the exposures may be very short, perhaps only 2 or 3 seconds with thin (light, underexposed and/or underdeveloped, unduly transparent) negatives. Except for the problem of getting the times accurate, there is nothing whatever wrong with very short exposures. Some professional printers consistently use basic exposure times of less than 1 second, but they have brighter enlarger bulbs and special electronic timers that are accurate

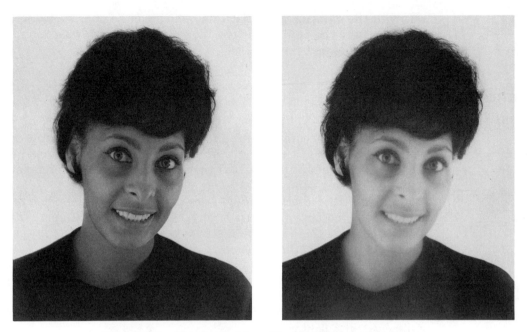

Figs. 7.5, 7.6 There is certainly nothing wrong with the girl's face in the straight print, but it is nice to see what local diffusion does to it, anyway. The diffusion was done with a circular disk of wrinkled cellophane on a dodging wire—for about 50 percent of the total exposure time.

to small fractions of a second. They do it to save time and because they get bored with longer exposures.

DIFFUSION BOX

Instead of using a glass suspended from the enlarger head by tape you can make a glass-top wooden box that sits on the enlarger baseboard. It should have an open front so that you can reach your printing paper. If you want to get fancy, make wooden channels at the sides for the glass to slide into, so that you can position it at any level you wish.

The box and glass will give you a stable platform to work on, much easier to use than tape-suspended glass, which swings back and forth every time you touch it. There are also other things that you can do with the box—for example, print masking.

Of course, there wouldn't be much point in constructing a box just for one or two prints. In that case it would be wiser to sweat it

out with the swinging glass platform, which can be constructed in 2 or 3 minutes. The fact that it is a bit irritating to work with doesn't mean that it doesn't function well.

CRISCO DIFFUSION

You can do very accurate diffusion with a hydrogenated vegetable oil such as Crisco by just rubbing it on the glass in place of cellophane. That is, you can diffuse selected parts of an image with precision without diffusing other parts.

Ordinarily, the coating should be very thin, hardly thick enough even to see, because Crisco is a very effective light diffuser. With thicker coatings there may be a pronounced dodging effect, so that the diffused areas of the image come out blank white.

It is easiest to apply Crisco and move it around from area to area with a Q-Tip, though the little fingertip also works well. With the enlarger light on, you can easily see what the Crisco is doing to the image. You can rub it off the glass with cotton, either dry or dampened with lighter fluid.

Fig. 7.7 A crudely made glass-top stand made for doing Crisco diffusion. The Crisco (in the 35mm film can) is put on the smaller plate of glass in the middle, which is easy to clean off. Below is a makeshift easel—merely a strip of cardboard for a guide, the paper being held in place with tabs made by looping masking tape back on itself.

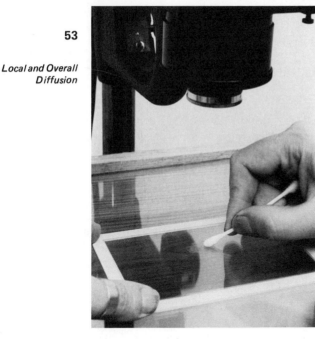

Fig. 7-8 Showing how Crisco is thinly applied to the smaller glass plate. Actually, you do it in the dark with the enlarger light turned on and the image focused on a piece of paper. This way you can see rather well how the Crisco is affecting the image and where.

With Crisco on your glass plate you don't have to move the glass around during exposure, provided that it is close to the lens and the aperture isn't stopped down too much. That is, it works very much the same as cellophane dodging but doesn't blow around, as bits of cellophane tend to do.

Fig. 7.9 You could call this a metaphor for blindness, if you like—physical or mental. It was done by local Crisco diffusion.

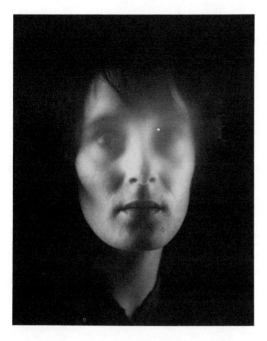

For diffusing just one thing with a fairly simple shape, cellophane on a dodging wire is best. For a more complex shape, or for several shapes at a time, cellophane or Crisco on glass is best.

Remember that diffused areas are also lightened, which you may not want. However, if you are using a glass platform for your diffusion material, it is easy enough to burn-in a lightened area.

Whereas overall diffusion with moving cellophane usually gives you soft and rather pretty results, local diffusion often tends toward the strange and weird. This is especially true when you are using the glass plate, for there is a certain amount of optical distortion involved. Light coming through the enlarger lens is bent or deflected by the cellophane or grease, thus warping the image somewhat, often with interesting effect. This also happens with moving cellophane, but the movement cancels out the warping.

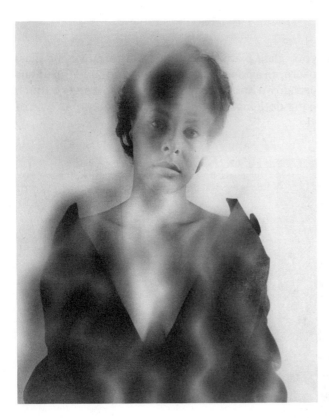

Fig. 7.10 Local diffusion caused by putting Crisco on the glass in wavy lines. Notice that the Crisco dodges and diffuses at the same time.

8 Texture Screens

Some people like to get textures in their prints to make them look like etchings, paintings, mezzotints, lithographs, and so on. Others like texture for itself and don't care whether their photographs look like other art media. The traditional and easy way to get the texture is with texture screens.

There are two kinds of screens: contact and projection. A contact screen is laid on printing paper, covered with a heavy glass plate, and an exposure for the negative is made. In this way the image and the texture are combined. The glass insures good contact between paper and screen, which makes the texture sharp in the print.

A projection screen, which is much smaller, is sandwiched with the negative and put into the enlarger with it. The negative carrier and the weight of the enlarger head hold them in close contact.

Both kinds of screens look like printed pictures of pure texture, and that is indeed what they are. They may look like textured wallpaper, coarse fabric, gravel, sand, scratch marks used for etching, artist's canvas, and so on. The main thing required for a texture screen is that the texture be handsome, fine, and even, though coarse and uneven textures have certain graphic possibilities.

Projection screens are available in photography stores, though contact screens may not be. However, for contact screens you can use benday or Zip-a-Tone screens, which are sold in a very wide variety of textures in artists' supply stores. The best of them work as well as photographic contact screens and cost a good deal less. Which are the best? Well, buy the fine textures you most like to look at, and they will usually work just fine.

USING CONTACT SCREENS

You can leave a texture screen in contact with the printing paper for all or just part of the exposure, depending on the particular screen pattern and image that you are combining. A delicate image may be completely broken up by a strong texture left on the full time, so that you can hardly see what the picture is all about. However, if you leave the screen on for only one-quarter or one-half the time, the image may look very good indeed.

Figs. 8.1, 8.2 Two prints made with a Zip-a-Tone texture sheet used as a contact texture screen. In one the figures are quite obscure, because the screen was left on the printing paper for the entire exposure time. For the other the exposure was 12 seconds with the screen, 6 without it. As you see, the 6 seconds was sufficient to clarify the image.

Splitting the time is very simple. Instead of using an easel, tape the paper directly to the enlarger baseboard. The cover it with the screen (texture side down) and the glass plate and give part of the exposure. Them remove the screen, put the glass back on the paper, and give the rest of the exposure.

You can find the best exposures by making a two-way test strip (Chapter 2) on a whole sheet of paper. Make one set of test exposures with the screen in place, the crosswise set without it.

There is another way of making the print for which you would also use a two-way test strip. Make your first exposure without the screen. Then remove the negative from the enlarger and stop the lens down some more. Then put the texture screen on the printing paper, cover it with glass, and make the second exposure with raw enlarger light.

The various ways of making textured prints lead to quite different results, so you should experiment with them all to see for yourself.

USING PROJECTION SCREENS

With a projection screen you can also give all or part of the exposure with the screen in place. In the latter case the negative should be taped to the negative carrier so that it won't slide out of position. Then the screen is placed emulsion down on top of it. With both the negative and screen positioned emulsion down you should stop down three stops so that both will be in sharp focus.

If you wish to use a wider aperture, sandwich the negative and texture screen (which is also a film negative) emulsion to emulsion (dull side to dull side). This will put the images that are on them in the same plane and at the same distance from the lens, so that they will both be in focus at the same time without your having to stop down. But remember that a lens isn't its sharpest at its maximum aperture.

However, you may want either the image or the texture slightly soft. You can do this by sandwiching them both emulsion down and using the lens wide open, focusing either the image or the texture. For an even greater sharpness difference, sandwich them back to back. You will probably like the both-sides-emulsion-down method best, because the negative and screen curl comfortably together like nestling spoons. When they are emulsion to emulsion or back to back they are as hard to handle as an angry octopus.

You can give part of the exposure with the negative and screen and part with just the negative. Or part with the negative alone and part with the screen alone. Or you can give the entire exposure with them sandwiched together. For the methods employing split exposures, make two-way test strips.

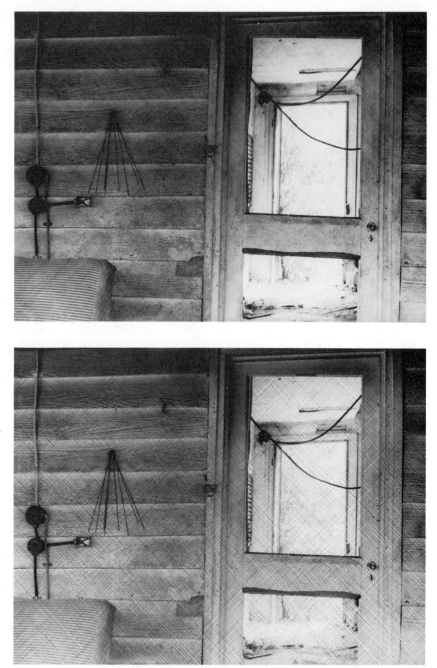

Figs. 8.3, 8.4 A screened print and an unscreened one. The former was exposed twice—once for the picture alone and once for the screen alone. Had not the screen been exposed separately there would have been no pattern in the bright doorway. Notice the considerable drop in contrast in the screened print. A projection screen was used.

Fig. 8.5 A considerably enlarged picture made with a projection screen, which was used for the entire exposure. At a lower degree of enlargement the picture would seem to have a fine reticulation pattern, but here it is quite large.

MAKING YOUR OWN PROJECTION SCREENS

You may like experimenting with homemade screens, which are very easy to make. You just go around photographing textures with your camera, and they can be found almost anywhere. Because texture screen negatives should usually be a little thinner than ordinary negatives, it is best to make a series of four exposures for each texture: one normally exposed and the others becoming progressively underexposed in one-stop jumps.

It is easiest to do this by stopping your camera all the way down and giving the correct exposure. Then start doubling the shutter speed for each of the remaining shots. Outdoors, use Panatomic-X, because it isn't too fast. Indoors, use Tri-X, because you may need its speed.

Develop your texture screens normally, treating them very carefully like any other negatives.

CONTRAST LOSS

When you texturize a picture it loses quite a bit of contrast, so you should compensate in advance. For example, for a picture that you would normally print with a no. 2 paper or filter you should use either a no. 3 or 4 for texturizing. It will then look just fine.

PATTERN SIZE

With a given contact screen the texture pattern on the print is always the same size, usually quite small. With a projection screen the pattern size can vary, depending on how high you have raised the

Fig. 8.6 Picture made with a homemade projection screen (lentils) used for part of the exposure. It is the kind of image one would expect to find in a photographically illustrated book for children.

enlarger head. With a big blowup it may get fairly large, which you may not want. You can get around this by exposing for the image and the screen separately, lowering the enlarger head considerably for the screen exposure.

When you are making your own screens you can make the patterns any size you like, from very small to very large. Small patterns are easiest to work with, but large ones can be very interesting, too. The problem with large patterns is that they seem to shatter the images with which they are printed, but you may want this effect now and then.

9 Printing-in

You can print more than one negative on the same sheet of paper, either to get a picture that obviously looks like a montage, or combination, or to get one that does not. You generally get the montage effect almost automatically unless you take special pains not to.

The printing-in technique is just one of the ways for making a combination print, perhaps the simplest one. You print one negative and dodge one area of the image so that it gets no light at all. Then you print something from another negative into that area, shading off the rest of the paper so that it doesn't get additional exposure. The problem is to keep track of the exact location of the area, because when the first negative is removed from the enlarger the image of the area disappears.

THE PROCEDURE

Partly developing the dodged image from the first negative will get you around the problem of knowing where the dodged area is, for you can then see it very clearly. Stop the development with the stop

bath, but don't use the fixer. The printing paper will thus remain sensitive to light. You can then print part of the image from the second negative into the area while seeing very clearly what you are doing.

The details follow: expose for the first negative, dodging out the area, then develop the print for 45 seconds. Then put it in the stop bath—30 seconds for regular paper, 5 for resin-coated. Next wash it off in clean water, preferably running, for 1 minute. Wipe it off with a very clean viscose sponge or hang it on a line with a clothespin for 1 minute. Then put it on the enlarger baseboard, still damp.

Put a red filter under the enlarger lens, open the aperture all the way, and turn on the light. Adjust the height of the enlarger head and the position of the paper to get the image from the second negative to the desired size and in the right place. Stop down the lens, turn off the light, and remove the red filter.

Now burn-in some of the image from the second negative into the blank space, constantly moving the burning-in card to make a good blend. Develop the print for $1\frac{1}{2}$ minutes, processing the rest of the way as usual. Wash and thoroughly wipe the enlarger baseboard, and it will in no way be damaged.

SAFELIGHT FOG

Since the print is exposed to the safelight for a longer time than usual, there is some danger of safelight fog. This can be prevented by covering the safelight with paper to cut down its intensity considerably.

WIPING MARKS

When some types of paper are partly developed, wiped with a sponge, and reexposed and redeveloped you will get disagreeable dark wiping marks. Such a paper should be drained on a clothesline instead of being wiped. Furthermore, you should not touch its emulsion side during the initial development or the reexposure. And be sure all the surface water has drained off before you make the reexposure. If there is still water on the print you may get flow marks, which are also dark and disagreeable.

RED FILTER

It is very convenient to have a red filter for printing. Because black-and-white paper isn't sensitive to red light, you can shine a red image on it without exposing it at all. Thus you can check an image, re-

Fig. 9.1 In doing the printed-in picture I dodged out the background print in this manner. I then developed it partway, stopped, rinsed, and drained it, then put it on the enlarger baseboard for an exposure from a negative with a wild-eyed man in it.

Fig. 9.2 A straight print of Pan in his cups.

Fig. 9.3 Mr. Pan returned to his sylvan environment by means of the technique called printing-in.

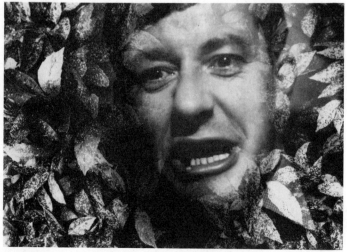

position it, and so on without removing the printing paper from the easel. In order to see better it is good to turn off the safelight when you are using the filter.

SHAPES OF HOLES

Depending on the shape of the area you are printing into, you may want special shapes for your dodger and burning-in card. Just trace the image on black paper or light cardboard and cut out the shapes you want.

The less complex an area shape you work with, the better your chances of success. The easiest thing is simply to blend half of one image into half of another. It is especially easy if the blend area is supposed to be either black or white.

Fig. 9.4 The mountain is actually the rear end of a statue at the Museum of Modern Art in New York. The printed-in clouds are from a color transparency, which explains why they came out negative instead of positive.

EXPOSURE DIFFERENCE

In the printing-in procedure the image from the first negative gets a total development time of $2\frac{1}{4}$ minutes, the second image only $1\frac{1}{2}$ minutes. For this reason the first image should get about 10 per cent less than the exposure normal for it. However, if you expose both images normally, you may not be able to tell the difference. The thing is that not much happens to a print in the developer after the first $1\frac{1}{2}$ minutes, anyway. Very gradually, it gets slightly darker, until it eventually starts to get developer or safelight fog. In many cases the darkening is hardly noticeable.

CLOUDS

This particular printing-in technique—there are others—is most frequently used for printing clouds into cloudless landscapes, using cloud negatives shot specially for the purpose. This is relatively easy, because the blend area is nearly always the horizon, where the sky is usually white or very close to it. It is also easy if the blend area falls among dark trees, because a little extra exposure from the cloud negative won't change them perceptibly. Thus you can make many mistakes and no one will know the difference. With clouds it is easiest to make a montage that doesn't look like one. Instead it will appear that you used only one negative.

10 Negative Sandwiches

Many people find multiple-image prints fascinating but just don't know how to make them. A very easy way is simply to sandwich two negatives, put them in the enlarger together, and print them as if they were a single negative. Frankly, it's as easy as it sounds—technically. Artistically, it is much more of a problem, because you have to combine the right negatives to get a pleasing effect.

TRIAL AND ERROR

One way to pick the negatives is by trial and error, making more or less random selections until you get an idea of what you are looking for. Sometimes you will succeed in getting a print you like, but more often you'll fail. Perhaps that is the price of using a technique so easy that even a goony bird could handle it.

Fig. 10.1

Figs. 10.1-10.6 No captions necessary.
The technique is so idiot-simple that
there is no point in saying anything
about it.

Fig. 10.2

SELECTION BY INSPECTION

A better approach is to hold various pairs of sandwiched negatives in front of a bright window or light box until you find a pair that makes a handsome abstract design (most of them won't). Though the tones will be negative (reversed) the image can still be handsome. From this starting point there is a good chance that the picture itself will also be handsome, though it may not work out. All you can do is print it and see.

EXPOSURES

With both negatives positioned emulsion down in the enlarger you will have to stop down three times to get both images sharp, which could lead to exposures from 30 seconds to more than 1 minute. However, there is nothing intrinsically wrong with a long exposure time if you don't mind waiting, though you should cool off the enlarger after each minute. Of course, if you don't mind having one image a little out of focus, you can use a larger aperture opening. Or you can get both images sharp at a larger opening by sandwiching the negatives emulsion to emulsion.

Fig. 10.3

DODGING AND BURNING-IN

When negatives are sandwiched, the image tones you want dark often come out light and vice versa. The corrective may be to do rather radical dodging and burning-in. When printing a single negative you should only dodge a given area for up to 50 per cent of the basic exposure time, or it will look washed out and muddy. With a sandwich you can often dodge an area for 75 per cent of the time before it starts to look washed out.

A sandwich is usually a lot darker than a single negative, so less light will pass through it. This can lead to very long burning-in times. Try opening up the lens just for burning-in. If a burned-in area comes out quite dark, you won't be able to see that it is slightly less sharp than the rest of the picture.

Fig. 10.4

CONTRAST LOSS

In printing sandwiches there is often a contrast loss, though sometimes the reverse is true. It all depends on how the negative densities (tones) are overlapped. Most of the time, however, you can count on needing a contrasty paper or printing filter.

Fig. 10.5

Fig. 10.6

11 Double-Focus Printing

There is a printing technique in which you focus and expose more than once to get a multiple image effect from just one negative. With the right negative the print can look quite good. With the wrong one, however, it will look pretty messy, but this is the way it usually is in photography: you have to bring together the right things at the right times in the right places. You can sort this all out by experimentation, which is reasonably easy to do in this case.

HALF-FUZZY

One way to do multiple-focus printing is to start the exposure with the image sharp, then about halfway through the exposure time begin throwing the lens out of focus until it is all the way out. This will give you a print that is part sharp, part fuzzy. Whether this will look good or not will depend on the negative you use. The fuzzy areas may look like shadows behind the sharp ones.

72

Fig. 11.1 Two exposures and two enlarger settings explain this
quietly strange picture. First there was an exposure with the image
sharp, then there was a second exposure with the image racked
far out of focus.

You can also do this by giving half the exposure and turning off
the enlarger light. Then throw the lens out of focus as far as you
like and give the rest of the exposure. Doing it this way instead of
moving the focus during exposure will make the shadow effect more
obvious. It is a kind of ghostlike effect, a bit on the strange side.
Naturally, you should choose a subject for which this strangeness is
appropriate.

Fig. 11.2 The shadow on the sky is
actually from a second, out-of-focus
exposure from the negative with
the workmen in it.

Fig. 11.3 I made a straight print of Anne without any dodging, then raised the enlarger head, refocused (with a red filter), and printed one of her own eyes into her forehead. Since there was a little tone in her forehead from the first exposure, I had to brighten up the whites of her extra eye with dilute Farmer's reducer.

ALL SHARP

You can also get two images that are sharp but of different sizes. Focus for one, put the enlarging paper in the easel, and give an exposure. Then replace the enlarging paper with the focusing paper, change the height of the enlarger head, and focus again. Now put the enlarging paper back in the easel and make the second exposure.

When one image is fuzzy, its position with respect to the sharp one usually isn't all that critical. However, when both are sharp, their placement may make a good deal of difference. The way to get accurate placement is to trace both the first and second images on the focusing paper before you begin to make any exposures. Then use the tracing as a template to get the images the right size and in the desired positions. That is, for a given image you move the enlarger head, focusing assembly, and easel until the projected image fits right into the tracing; then you put the enlarging paper in the easel and make an exposure.

74

NOT TOO MANY IMAGES

There is no technical reason why you should limit yourself to just two images from one negative. However, the more images you have, the more complex your picture becomes. With the average negative, two images will give you all the complexity the picture can take. Sometimes you can get away with three, and every now and then several more than that. The simpler the negative, the more images the picture can take.

RADICAL DODGING

It is sometimes interesting to do rather radical dodging with the multiple-focus technique. For example, you can entirely dodge out the middle of image 1 and the edges of image 2. This can make the things in the middle of a picture seem to be at a different distance from the viewer than the things at the edges. There may also be a transparency effect.

Fig. 11.4 Mr. E. Mole, terror of the seven seas, riding on the Staten Island Ferry. In the larger, out-of-focus image, I dodged out a space for Mole. The smaller image was printed through a hole in a dodging card into the space that had been dodged out for it.

STAND WARNED

It is very difficult to predict what a multiple-focus print from a given negative will look like. The best you can do is try it and see. If the print doesn't look like much, try another negative. You are warned in advance, however, that the technique produces very disreputable results with most negatives. Even so, it has become quite popular in recent years.

It is probably easiest to use the method successfully with abstract subjects, mainly because one doesn't react emotionally to seeing an abstraction being changed by it. In contrast, it would be hard to be indifferent to seeing dear Aunt Gertrude come out double and half-fuzzy.

12 Intentional Print Fogging

Though photographers think of paper or film fog as an enemy, it is actually very useful when properly exploited. Indeed, certain photographic processes depend on it—for example, so-called reversal processes for color and black-and-white films and papers. As you will see, it is useful elsewhere, too.

Two of the commonest kinds of fog are due to light or to chemical fumes or solutions. We will deal mainly with the former. Since this book is about printing, we will define this kind of fog as any darkening of a print by a non-image-forming light. Image-forming light is that which has passed through either a negative or positive transparency or its equivalent. In enlarging it also passes through a lens, but in contact printing it does not. In contrast, non-image-forming light neither projects nor transmits images. It is sometimes referred to as "raw light," meaning that it is the pure stuff.

LIGHT SOURCES

In order to do the things covered in this chapter you will need certain controllable light sources:

Fig. 12.1 For print fogging for contrast reduction or solarization, a 7½-watt round white frosted bulb is a good light source (at a distance of 5 feet). Here is one shielded by a 2-inch black paper snoot (to cut down light scatter in the darkroom).

1. An enlarger
2. A penlight
3. A round 7½-watt frosted lightbulb
4. A safelight with an OC filter
5. A photoflood lamp

When employed for fogging purposes, the enlarger is used with no negative in it. Convert the penlight to a minispotlight by taping a 4-

Fig. 12.2 Flashlights with cardboard or black paper snoots are handy for various print-fogging tricks, though the penlight is by far the most useful. The larger light is handy when you drop something on the floor and don't want to turn on the overhead white light in order to find it.

inch cylinder of black paper around the bulb end. Make the 7½-watt bulb into a larger spot by taping a 3-inch cylinder of paper around it. The safelight and photoflood can each be used as is, though it is convenient to have the flood in a reflector.

DECORATIVE BLACK LINES

Many people like to make prints with wide white borders and narrow black lines around the images. You can get the white borders with the masking leaves on your easel and the black lines with a penlight and a piece of cardboard.

Cut the cardboard to the image size that you wish to use, making sure to do a neat cutting job. Then put it on your easel so that it fits just within the masking leaves. Move each of the leaves back about $\frac{1}{32}$ inch, so that there is a narrow space between them and the edges of the cardboard. The width of the space will determine the width of your black lines.

After you have exposed a print, put the cardboard right on top of it, positioned so that the spaces are of equal width. Then turn on the

Fig. 12.3 A print with a decorative black border line fogged in with a penlight. It is a simple problem of masking, as the text makes clear.

penlight and run it along the spaces, holding it vertical to the print surface. The light works fast, so you can move rather briskly. When your print is developed you will see the desired black step-off line, neat as you please.

BLACK BORDERS

Sometimes you have pictures that would look better with black borders than with white ones. One answer is to trim off the white borders and dry-mount your prints on black mounting board. But for a much richer-looking black you can get your borders by fogging, again using cardboard as a mask.

After exposing, position the cardboard between the masking leaves. Then carefully remove both the paper and cardboard from the easel and put them on a work surface underneath an overhead room light fixture. Put a weight on the cardboard to hold it flat and turn on the room light for 3 or 4 seconds.

Fig. 12.4 A wide decorative black border made by fogging with the 7½-watt bulb while the image was covered with a piece of cardboard.

STRAIGHT FOGGING

Though overall print fog is something we ordinarily try to avoid, some pictures look better with it. They are usually prints that are underexposed and too contrasty. Instead of discarding them, try fogging them. One way is to leave a print in the developer for a long time—5 minutes or more. Another is to take it out of the developer and put it in a tray of hot water (about 125F).

Still another way is to put a partly developed print in a tray of clean water and position it under a $7\frac{1}{2}$-watt bulb (at a distance of 5 feet) for a 2- or 3-second fogging exposure, then put it back in the developer.

A problem with fogging is that it tends to go too fast and too far. One way to control it is to return the print to a developer that has been diluted about 1:30, which slows down the development considerably. If necessary, you can give it additional fogging exposure.

When done carefully, fogging can be very pretty. Fog can come in a variety of smooth, grainless, handsome tones. Because it flattens pictures a lot, it should mainly be used on pictures that are initially much too contrasty. The things that can make fog look splotchy and ugly are too long a fogging exposure followed by too short a developing time.

DODGED FOGGING

Dodged fogging is the same as flashing (Chapter 6) and is most easily done with raw enlarger light with the lens stopped all the way down, or close to it. People usually fog in corners of pictures, but you can also darken skies, tone down objects that are too light, make dark tones even darker, and so on. For dodged fogging you usually use a burning-in card and/or a dodging tool or dodger.

WHITE SPOTS

Sometimes there are black areas in prints that have light spots or objects in them we would like to get rid of. They can be burned-in, of course, but sometimes this takes a long time. It is easier to get rid of them with the penlight minispot, during exposure, after it, or even while the print is in the developer tray. Just a touch of the light will make the white things turn dead black in the developer. Don't use too much light, or you may get image reversal.

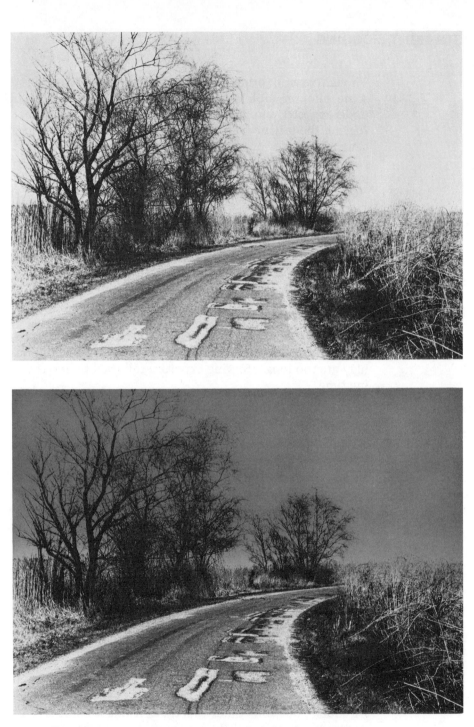

Figs. 12.5, 12.6 The darker print was locally fogged (by dodging) with a 7½-watt bulb while it was in a developer (Dektol) diluted 1:30. Dilution slows down development, so that fogging doesn't get away from you so easily.

FOGGING MASKS

For interesting design effects it is sometimes helpful to cut black paper shapes and lay them on the printing paper after exposure. Then the uncovered areas can be fogged to any desired tone with raw enlarger light. In preparation, stop the lens down all the way and make a test strip to learn the exposure times for various tones.

PHOTOGRAM FOGGING

A photogram is a picture made by putting objects, opaque or transparent, right on the surface of printing paper, then fogging it with raw light, usually from the enlarger. Opaque things block off the light, of course, while transparent things bend or divert it, making a variety of interesting patterns. Heavy glass objects are very popular for this purpose.

Sometimes you can get interesting effects by using a penlight as the light source, aiming it at a glass object at a low angle. You can also use it as if it were a paintbrush to draw around the edges of things sitting on the printing paper.

Fig. 12.7 Here we have a photogram (a way of fogging) with the author's kindly face stuck into it. I used the printing-in technique (Chapter 9), exposing and developing the hand photogram first, then printing the face into the still-damp print.

It is sometimes interesting to expose paper with a negative, then put objects on it and make a photogram exposure. For example, you might make a portrait in such a manner that the face falls in the center of a pattern made by a heavy glass ashtray. Though this sounds a bit prosaic, it wouldn't necessarily look that way. Indeed, by varying the angle and distance of your light source you can make many different and intriguing patterns with one ordinary ashtray.

CONTRAST REDUCTION

If a print is given a light-fogging exposure after the regular exposure, the image contrast will be reduced in proportion to the amount of fogging exposure. Many European photofinishers take advantage of this fact and use only one grade of printing paper, Agfa Brovira no. 6, which is very contrasty. With it they get all the other contrast grades, 1 through 5, by using very accurately controlled fogging lights built into their printing machines. In the prints they make there is no evidence of fogging, and most people aren't even aware that a fogging technique is used.

Also using Brovira no. 6, you can do the same thing by using a $7\frac{1}{2}$-watt bulb as the fogging light source. You can fog and flatten lower-contrast grades of paper, too, but you would use shorter fogging exposures, because lower grades are more sensitive to light than a no. 6. Your light source should be positioned 5 feet above the printing paper.

The way to initially assess the potentials of contrast reduction by fogging is with a two-way test strip (Chapter 2), with one set of tones exposed to an image and the other to the fogging light. Make a preliminary 1-inch test strip for the image tones, using 5-second exposures. Use it to figure out how to adjust the aperture setting so that the darkest image tone on the two-way strip will be the one with the correct exposure. Using this new setting, make a set of image exposures on a full sheet of paper.

Now, position the paper under the fogging light and make a set of 3-second fogging exposures at right angles to the image exposures. Process the two-way test strip normally.

Upon examining your checkerboard strip you will see some interesting things. For example, in some of the image exposure areas there will be no image at all, until flashing brings it out. The range in contrast from square to square will be very considerable, certainly more than the range of available paper contrast grades from nos. 1 through 6. Some of the squares will look fogged, but others will not.

The idea now is to pick the square that shows the desirable decrease in contrast and use the exposures to make a full-size print. If you make one with a considerable decrease in contrast and find that it looks fogged, a little bit of overall bleaching will usually be the cure.

Figs. 12.8-12.11 A two-way test strip on Brovira no. 6 paper for contrast reduction by fogging (flashing), with 5-second enlarger exposures and 3-second flashing exposures. Also an entirely unfogged, very-high-contrast straight print. The print with medium contrast has a 7½-second enlarger exposure and a 6-second fogging exposure. The very flat print (which had to be bleached) had 5- and 9-second exposures.

85

However, if you merely wish to drop the contrast by a paper grade or two, you will seldom have to bother with bleach.

Though this technique can be used to give you a contrast range of more than six paper grades, you will probably use it for this purpose very seldom. Perhaps the main use for it is to help you understand the contrast potentials of a given paper, especially one that is very contrasty to begin with. However, there may be times when you have run out of low-contrast paper grades and come to a negative that requires one. Then you can solve the problem by lowering the contrast of the paper you do happen to have.

On rare occasions you may have pictures that would look good in an arty sort of way if they were printed extremely flat. This technique is the answer, because you can reduce contrast until it is gone entirely. Sometimes people will try to make pictures that look as if they came from old family albums and find that extreme flatness is something they need.

INTENTIONAL SAFELIGHT FOG

There is an ancient trick for dropping image contrast by one or two grades, or even half a grade. It consists of holding an exposed print very close to a safelight for a while before putting it in the developer. Use such a print to make a safelight-fogging exposure test strip for whatever kind of safelight you are using. Once you know the exposures you can use them again and again. Do not use unexposed paper for your test strip, because it won't give you the information you want.

If nothing else, a test strip will prove to you that a safelight is only relatively safe. If it is too close to a print and the exposure time is long enough, it can fog it very dark indeed.

The advantages of the safelight trick are that the safelight is always there and the fogging times are long enough to be very controllable.

THE SABATTIER EFFECT

The Sabattier effect, often erroneously called "solarization," is very interesting and has many pictorial possibilities. It is the result of fogging a print when it is about halfway through development. Oddly, some of the tones are reversed, changing from positive to negative. Sometimes the contours between contrasting areas in an image will turn into lines that look as if they had been drawn there. All in all the results are very peculiar and unexpected.

There is a considerable contrast loss when you use the Sabattier effect, so people generally do it only with a Brovira no. 6 paper. You start with too much contrast and end up with about the right amount.

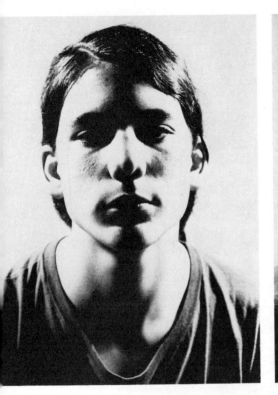

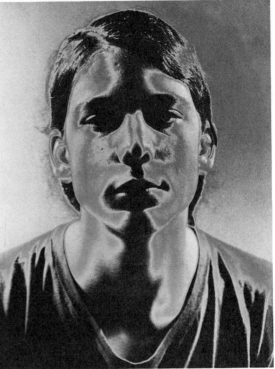

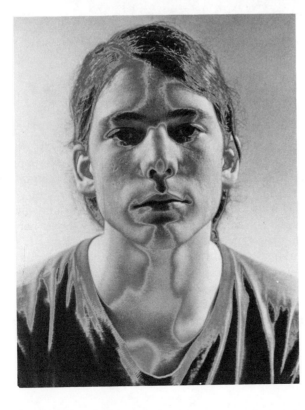

Figs. 12.12-12.14 An unsolarized
print and two solarized ones made on
Brovira no. 6 paper from the negative
used for the two-way test strip in
Chapter 2. As you see, the straight print
is very contrasty, but much contrast is
lost through the solarization process.
In Chapter 20 there is still another
solarization from this negative; you
will find it quite different.

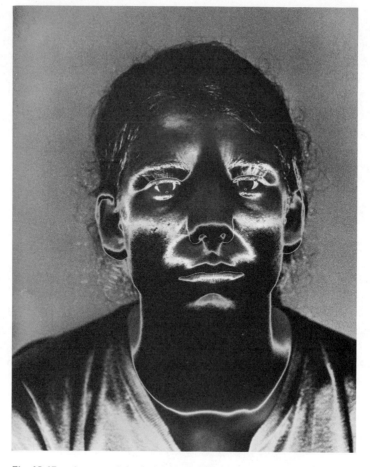

Fig. 12.15 A very weird solarization from another negative. The highlights have been lightened somewhat with Farmer's reducer.

One problem with the Sabattier effect is to slow it down, which you can do with a print developer diluted 1:10 or 1:20. After a print is exposed you put it in diluted developer for 2 minutes, then into a tray of clean water for 1 minute. Position the water tray under the fogging light (the $7\frac{1}{2}$-watt bulb at a distance of 5 feet) and give a solarizarion exposure. Then put the print back in the developer for another 2 minutes. You can lengthen both developing times if you like, but they shouldn't be shortened. If a print is coming out too dark, let it—you can bleach it later.

You need a two-way test strip to give you your image exposure and solarization exposure times. Do it in the same way as you would for contrast reduction by flashing. The only difference is that the fogging is done on a partly developed print that is under water. Use 3-second flashing exposures again.

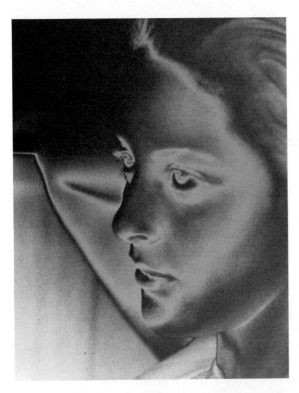

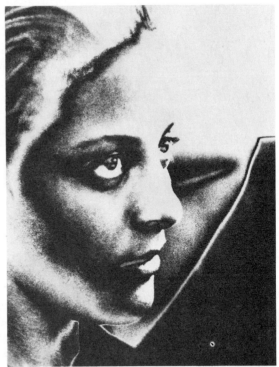

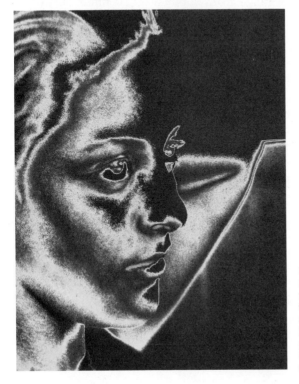

Figs. 12.16-12.18 A solarization
made directly from a positive color
transparency, a contact print made from
the solarization, and another contact
made from it, then solarized. Thus the
image in the third print has been
solarized twice along the route. You use
exactly the same techniques in solarizing
contact prints and enlargements.

You can develop a print and expose it to a photoflood light after it has been in the stop bath for 30 seconds, and some lovely colors will emerge. With Kodak resin-coated (RC) papers you will initially get a beautiful rose pink, which gradually deepens to a handsome reddish purple. Unfortunately, these colors are transient in the presence of light; they keep on changing until they turn a purplish gray, which is not very interesting. They are also chemically sensitive, so that if you touch the print surface with your fingers you will leave marks.

If you put a thoroughly flashed print in the fixer, something unusual happens: the dark color disappears almost in a flash, leaving a very pretty light one, which may range in hue from yellow-orange to peach. This light color will also bleach out in time, so don't leave the print in the hypo too long. The effect of this pretty color overlaying a black-and-white print can be very handsome.

If your stop bath is very clean, you can leave your print in it while exposing it to the photoflood. Otherwise, you should drain the print (don't sponge it off!) and hang it on a line until dry before exposure. If you use an RC paper this won't take very long. If you remove a print from the stop bath and expose it while still wet, you will get disagreeable flow marks.

With the photoflood positioned about 2 feet from a print the fogging exposures can range from about 3 to 10 minutes. You will see the color effects very clearly.

There is a way of getting a color more on the handsome brownish side that will not bleach out in the fixer. Develop a print normally in Dektol 1:2, then transfer it to a tray of Dektol 1:50. Then give a series of 1-second exposures with your $7\frac{1}{2}$-watt bulb positioned about 2 feet above the tray. First give an exposure and wait to see what happens. Keep on adding brief exposures until the print slowly begins to turn brown. When brown enough, put it in the stop bath, then in the fixer. Since a print is flattened and darkened by this process, it should be a little contrasty and underexposed to begin with. The resulting color is very handsome indeed.

THREE-COLOR POSTERIZATION

It is quite easy to use color fogging to get a lovely three-color posterized print, the colors being black, white, and peach (or orange). Make a high-contrast print with a Kodalith negative (Chapter 17), which will give you a picture consisting entirely of black and white, with no grays. After it has been developed, put it in the stop

bath, color-fog it, and put it in the hypo. It will then be black and orange, with no whites.

Put it on the back of a tray, wipe it off thoroughly with a paper towel, and start drawing in a few whites with a brush and fairly strong Farmer's reducer. You will find that the color bleaches very readily (so does a brown color). If you bleach with taste and discrimination you will end up with a handsome three-color poster.

By this time you should see why fog shouldn't be such a dirty word in photography—unless, of course, one gets it by accident. It is more profitable to see it as an excellent creative tool when controlled and used with purpose.

13 Dodging on Paper

It is possible to do very accurate and subtle dodging right on the printing paper itself. You use chalk dust, pencil dust, pencil, or a combination of the three. You can make very finely divided chalk or pencil dust by rubbing either artist's black chalk or a no. 2 pencil on crocus cloth, which you can get from a hardware store. As you will see in a moment, dodging on paper is rather easy to do.

The technique should be used on a very finely textured semimatte surface, such as the Kodak N type. Paper dodging on rougher textures brings out obvious texture patterns in the areas worked on that are quite unlike the rest of the print surface.

MATERIALS

In addition to chalk, a pencil, crocus cloth, and fine semimatte printing paper, you need a few other things. Buy some artist's stumps, which are pencil-shaped sticks of cardboard or tightly wrapped paper.

You also need surgical cotton and Q-Tips or some other brand of swab stick. To sharpen your pencil it is handy to have a used razor blade and some fine sandpaper.

USES

Sometimes you have a negative that needs dodging in a half-dozen or more places, which is more than you have time for with regular dodging. Paper dodging will handle it easily. Because it is quite a bit slower than regular dodging, it is not the technique to use when you are producing numerous prints from a single negative. In that case, red-dye dodging (Chapter 27) would be better.

THE GIST OF IT

You smudge crayon sauce or graphite dust on unexposed printing paper in areas of the image that need to be lightened. This forms a built-in mask to hold back light from these areas when the paper is exposed. During development the dodging is removed, leaving you with a fully dodged print.

For crayon you can use chalk, pastel, or conte crayon. For graphite dust you can use pencil or powdered graphite from a hardware store.

For smooth smudging you use a ball of cotton, a Q-Tip, or a paper stump. For fine detail work you can use a pencil with a long point, a no. 2 for medium tones and a 2B for darker ones.

THE PROCEDURE

1. Assemble the dodging materials next to your printing easel.
2. Put the negative in the enlarger and make a test strip to determine the correct exposure.
3. Cover the enlarger lens with a red filter, open the aperture all the way, put unexposed printing paper in the easel, and turn on the enlarger light.
4. Turn off the safelight to make the red image on the printing paper more visible.
5. Using the red image as a guide, lightly smudge crayon or graphite powder on the areas you wish to lighten. To smudge large areas, a wad of cotton is ideal. Dip it in the powder, test it on a scrap piece of printing paper to see how much will be deposited, then work directly on your unexposed printing paper. Use a circular motion. If

93

necessary, build up the density of your smudges with successive applications of powder. For small areas, smudge with either a Q-Tip or paper stump.

For fine details you can use a pencil with a long, sharp point, but you should use a very light touch. Since pencil marks are likely to show in your print, you can blend them together with the stump. If necessary, a stump can be sharpened somewhat on fine sandpaper, though new ones don't usually need it.

While you are working, put a piece of typing paper over the adjacent area of the printing paper so you won't get fingerprints on it.

6. When you are through smudging, remove the paper from the easel and blow off all the excess powder. Then put it back on the easel, using the projected red image to make sure that you've got it positioned right.

Figs. 13.1, 13.2 A straight print and one that has been dodged with pencil strokes drawn right on the paper surface, which is semimatte, before exposure. In the pencil-dodged print the horse has been lightened somewhat by regular dodging, and the top right and top left corners have been burned-in. The same basic exposure was used for both prints.

7. Stop down the lens, turn off the enlarger light, remove the red filter, and make your printing exposure.

8. Develop your print for the normal time. As soon as it is wet with the developer wipe off the smudging with a wad of wet cotton. It comes off readily, so this will require just a few seconds. If you should miss some, it won't really matter. You can wipe it off later.

As you can see, the technique is simple enough and not very hard to use. The visibility of the red image is not very good, but your eyes can adapt themselves to it fairly well. You should probably make a trial print to help you decide how dark your smudges should be.

With an N-type surface you can do very smooth and even smudging, so there is no reason why there should be any evidence of it in your finished print. Dodging on paper can be a precision technique, but making it come out that way depends on the care with which you work.

14 Matte Acetate Dodging

It is sometimes necessary to enlarge a small negative that requires a lot of very precise dodging. A regular dodging tool, or dodger, is not very precise, and to dodge a lot of places on one print during the basic exposure time you would need either ten hands or five people holding dodgers. Dye dodging right on a negative with red food dye (Chapter 27) is a good thing, but it is very hard to do with precision on a miniature negative. You could make an enlarged duplicate negative, say 8 x 10, then dye-retouch it and contact-print it—but that adds up to a bit of money for the film. The best answer may be to do your extensive precision dodging with matte acetate, which costs little and is easy to use precisely.

THE GIST OF IT

You turn a sheet of matte acetate into a print dodger by making lines and smudges on it with pencil. The sheet is put over the printing paper, matte side down, and the exposure is made through it. The

pencil lines and smudges block off some of the enlarger light that falls upon them, thus lightening, or dodging, the areas underneath.

MATTE ACETATE

Kodak manufactures acetate sheets under the trade names of Kodapak Diffusion Sheets and Matte Kodapak Sheets, obtainable through photographic dealers. Other companies also make diffusion sheeting in sheets and rolls, and it is usually available in stores that sell art and drafting supplies.

Because matte acetate is an excellent light diffuser it must be held in close contact with the surface of the printing paper. Otherwise, a diffuse or blurry image will result. Close contact is maintained by covering the acetate and paper with a sheet of glass before the enlargement exposure is made. The acetate must be positioned matte side down, also to minimize diffusion. For best contact the paper should be glossy, semiglossy, or fine semimatte.

Even with the above precautions there will be a slight amount of diffusion, which will soften and flatten the image somewhat. The

Fig. 14.1 A straight print (not dodged, burned-in, or otherwise manipulated) which was made through matte acetate, which diffused it quite a bit. The acetate was laid on the paper surface and held in close contact with it with a plate of glass. The acetate was used because it would give a better idea of what the final print would look like.

loss in contrast is about the equivalent of one-half of a paper contrast grade. If this disturbs you, go to the next-highest paper grade. The slight diffusion effect itself is quite pleasant and goes well with certain subjects, especially portraits, which can often stand a little softening to minimize skin texture and blemishes.

DODGING

You do your dodging, or smudging, with pencil—a no. 2 for light and medium tones, a 2B for dark ones. Pencil tones can be blended or smoothed with a cotton ball or a paper stump. For doing large areas hold the pencil almost parallel to the paper so that the graphite comes off the side of the point. You will find that matte acetate takes pencil very easily. Pencil irregularities can be smoothed by rubbing them hard with a stump, though it is better to put the pencil down smoothly in the first place. Too much rubbing may remove some of the "tooth" from the matte surface, thus changing its printing characteristics. Small irregularities will be diffused, or blended together, in the final print by the matte acetate itself, but

Fig. 14.2 The final print, also made through matte acetate, has been matte acetate-dodged in the areas that printed very light. That is, pencil was applied to the acetate in these areas so that it would mask them and make them print lighter. For dramatic purposes the top and bottom of the picture were burned-in considerably.

Fig. 14.3 The penciling on the matte acetate sheet used in making the finished print.

don't let this encourage you to work in a sloppy or casual manner. In photography, slovenly work habits never pay off.

GUIDE PRINT

In order to do accurate pencil dodging you need a very accurate guide to tell you where to put the penciling. You can get one by making a reversed print. First, put the negative in your enlarger and get the focus, image size, and cropping that you want for your final print. Then turn the negative over so that it is emulsion side up and make a print, which will come out with a reversed image, then wash and dry it.

Tape the print to a well-lit work surface. On top of it tape a sheet of acetate, matte side up. Then start your penciling, working slowly with a light touch. Avoid oily fingerprints on the matte, because they will print darker than surrounding areas. To do this cover the acetate with a sheet of typing paper, leaving bare only the section that you are working on.

THE PROCEDURE

1. With a reversed negative, make a guide print, then turn the negative emulsion side down for the final print.

Matte Acetate
Dodging

2. Tape the acetate over the guide print and do your pencil dodging.

3. Untape the acetate and turn it emulsion side down on a piece of typing paper, which will make the penciling show up clearly.

4. Position the acetate and paper on the enlarger baseboard and get the negative image in register with the penciling.

5. Make a tape hinge along one side of the acetate sheet so that it will lift up like the page of a book.

6. Replace the typing paper with printing paper, cover the acetate with glass, and expose for your final print. Since air may get caught between the printing paper and the acetate, you can assure better contact by pressing down on the glass, especially in the center, before making your exposure.

With the hinged acetate mask you can make as many duplicate prints as you like without any difficulty. Before you make each one you should dust the top of the mask and both sides of the glass with a wide, soft brush to get rid of any dust that may have drifted onto them.

You may have a little difficulty in registering the acetate drawing and the projected image, finding that the two aren't exactly the same size. This is because the guide print may have changed dimensions slightly when it was processed. However, you can get registration by changing the height of the enlarger head.

15 Making Multiple Images with Dodging Chips

More and more people are finding themselves fascinated with multiple-image photographs, which can be made in a variety of ways. One of the most interesting is to use dodging chips—tiny pieces of light cardboard or heavy black paper.

THE GIST OF IT

For this technique you need a filter holder with a piece of plain glass in it. The holder is attached to the enlarger lens in such a way that the glass forms a stable platform for holding the dodging chips, which can block off light from parts of a projected image, just as a regular dodger does.

You put a negative in your enlarger and arrange the chips to block out one or more areas. Then you expose a piece of printing paper, which will get no exposure in these blocked-out areas. Then put another negative in the enlarger and rearrange the chips so that the

light will fall only in the areas that were formerly blocked out. Expose the paper again and process the print.

You can use as many as five or six negatives for this technique, but it is very tedious. But there are so many things you can do with just two negatives that you will seldom wish to use more.

JERRY N. UELSMANN

The great exponent of this technique is Jerry N. Uelsmann, one of the world's finest photographers. He calls it "blending," because he blends parts of two or more negatives together in a very subtle way, using as many as six enlargers, each with a different negative in it. Actually, he has nine enlargers in his darkroom, but he hasn't yet had to use the last three.

Uelsmann is a superb craftsman who does fantastic things with his dodging chips. Though you shouldn't expect to equal such an experienced artist, you can at least experiment at a reasonable level with the technique he uses and get some very exciting results. Uelsmann himself started out with just one enlarger, and so can you.

DIFFRACTION AND BLENDS

Putting a chip of cardboard under the enlarger lens does a rather peculiar thing to the part of the image that is blocked off. The light striking the edge of the cardboard is diverted from its straight path, or diffracted. In effect, the image in that area is "bent around" the dodging chip. The result is a dodged area with soft rather than sharp edges. You can see this effect by holding a finger under the enlarger light at different heights. When it is near the easel it casts a sharp-edged shadow which gets progressively softer as you bring it closer to the lens. You are thus observing diffraction.

Now, within the soft edge made by a finger or dodging chip there is image. That is, there is a zone around the perimeter of the dodged area into which image is diffracted. You can see it very easily in the darkroom, so don't worry about it. At the edge of the area the image is fairly strong, but it fades out rapidly.

Uelsmann calls this soft-edged band of image surrounding a dodged area the "blend." The reason is that if you overlap the soft edge from one negative with the soft edge from another, the two edges, or zones, will blend together in a print, often imperceptibly. That is, the images themselves will blend together due to overlapping blends, or blend zones.

The blend zone around a dodged area can vary quite a bit in width, from a fraction of an inch to 2 inches or more. For an 8 x 10

print a 1-inch blend usually works very well, but 2 inches may also be good. The width of a blend zone is determined by three factors: (1) the distance of the dodging chip from the lens, (2) the lens aperture setting, and (3) the height of the enlarger head. The closer the chip to the lens, the wider the blend; the larger the aperture setting, the wider the blend; and the higher the enlarger head position, the wider the blend. And vice versa in all three cases.

If the chip is almost touching the lens, the blend zone will be much too wide. Indeed, from the image on the easel you may not even be able to see that the chip is there at all. A good chip-to-lens distance is $1\frac{1}{2}$-2 inches.

When the lens is wide open, the shape of the dodging chip may almost disappear on the printing easel. Thus the blend zone is much too wide, but stopping down narrows its width. You will probably find that a setting of $f/8$ is about right, though this is partly dependent on the chip-to-lens distance. You don't have to worry about this, however, because you can easily see the width of a blend zone in the darkroom and adjust it by opening up or stopping down.

The width of a blend zone affects the sharpness of the edges of a dodged area. With very narrow blend zones you get sharp edges, with wider zones softer edges. Now, it happens that soft edges from one negative are easiest to meld together with soft edges from another, whereas narrow, sharp-edged zones may be quite difficult to meld together imperceptibly.

You may have found the text so far a little sticky, a little hard to follow. However, a few minutes' experimentation in your darkroom with your enlarger, a negative, a piece of glass, and some chips of cardboard should make things quite clear to you without your having to stretch yourself very much.

FILTER HOLDER

To hold your glass plate and dodging chips you need a simple filter holder, which you can make out of cardboard and tape to the lens barrel or mount. When taped in place it should be firm and stable, or you will go crazy trying to accurately position the chips. A 2 x 2-inch piece of slide glass is about the right size, though a larger piece would do just as well. With a smaller piece you would run into trouble, however.

If you are mechanically inclined, you could make yourself a holder with slots in it for positioning the glass at different distances from the lens. On the other hand, with sufficient experimentation you will learn to get all the effects you want with just one distance.

The holders that come with variable-contrast filter kits aren't so good, because they hold the glass too close to the lens, making it very difficult to arrange the dodging chips.

Fig. 15.1 A cardboard filter holder taped to the enlarger lens mount. It has a small plate of clear glass in it and serves as a stable platform for dodging chips, one of which can be seen here.

MEASURING THE BLEND

Because the blend zone is the secret to this multiple-image technique, you should take pains to learn just what it is and how it works, for what you see on the printing easel is somewhat deceptive. For example, you may see a blend zone about 2 inches wide that changes very gradually from light to dark as you move your eyes toward the center of the blocked-out area. You would think that in a print it would show up as a gradual change in tone of the same width, but it doesn't work out that way. In a print the tone of a blend zone drops off much more rapidly.

You should check this out for yourself with test strips and will certainly be surprised at how rapidly the tone drops off. Notice also *where* it drops off, for you need to know this when blending your second image.

Frequently, blend zones must be burned-in, sometimes quite a bit. So with your test strips try burning-in for various lengths of time to see what happens. Notice how much it widens the blend zone.

Note that the image detail in a printed blend zone is sharp, though this is a bit unexpected. When looking at the easel one sees a kind of

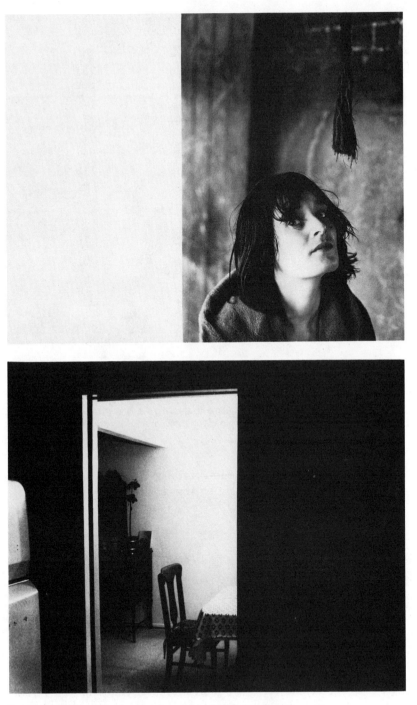

Figs. 15.2, 15.3 Two pictures chosen for blending together by the chip-dodging method. The fact that they both have a lot of black in them made blending fairly easy, for black blends readily with black.

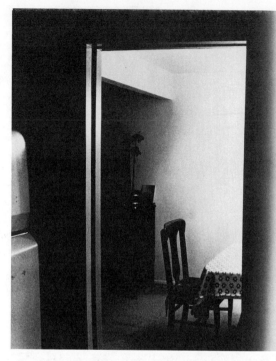

Fig. 15.4 A chip-dodged print of the background negative
showing the visible part of the blend zone (the fuzzy vertical line
to the right of the doorway). The zone actually starts inside the
doorway and extends well into the white area at the right. Making
an exposure test strip along the zone would show this.

fuzzy blob, but the fuzziness is due not to unsharpness of image detail but to gradual lighting falloff.

MAKING A DRAWING

In making a blend print with two negatives you will find yourself putting each negative in the enlarger several times, so you will need a little drawing to help you get the enlarger head and easel positioned right each time. Usually there is a background negative, then another negative with an object or figure that you want to blend into the background. Put the former in the enlarger first and get the image size and cropping you want on a piece of focusing paper.

Then cut out one or more dodging chips to mask out the area that the figure or object will fit into. Now trace some of the important parts of the image on the focusing paper so that you can get it positioned in exactly the same way later. Also trace around both the inside and outside of the blend zone.

Now put the second negative in the enlarger and adjust its height and the easel position so that the object or figure fits precisely into the area surrounded by the blend zone. Then cut out one or more dodging chips to mask out the area in which the background image will be printed. This will establish a second blend zone. Arrange the chip(s) so that this second zone is exactly superimposed on the first one. Use the tracing of the first zone as a guide for this. Now trace the important parts of the second image on your drawing for later use in positioning.

With your drawing as a guide you will be able to put your negatives in the enlarger as many times as necessary and get the images and chips correctly positioned each time. Draw it with care, because very accurate positioning may turn out to be important.

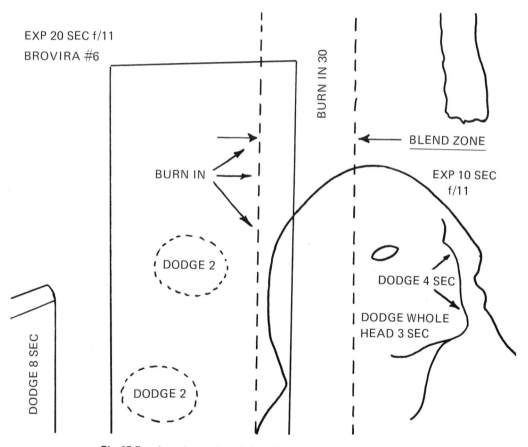

Fig. 15.5 A tracing made to help in image placement. It shows the actual width of the blend zone, exposures used for both negatives, dodging, and burning-in. Though used mainly for working out just one blend print, it could be used a year from now for duplicating it.

TEST STRIPS

For each of your negatives make a test strip. Make them about 4 inches wide so that they can include portions of the blend zones. This will help you see how various exposure times affect the width of printed blend zones and help you decide whether you wish to burn them in.

MATCHED NEGATIVES

To make things easier for yourself it is best to have negatives of similar contrast and density (relative darkness). Then they will fit together nicely on one contrast of paper, and the printing exposures will be about the same. It is possible to print negatives of different contrast by using variable-contrast paper and different printing filters, but this gets to be quite a hassle. Having to use exposure times that differ considerably isn't nearly as much of a problem. However, both negatives should be printed at the same aperture setting so that they will produce blend zones of similar widths.

If you plan carefully or are just plain lucky, you may have two negatives that don't require you to change the height of the enlarger head. This would make image repositioning easier, for you would only have to move the easel a bit. It is unlikely that you will be this lucky, however, so don't count on it.

If the height of the enlarger head differs radically for your two negatives, you may get two kinds of print quality that don't match up very well. That is, the greatly enlarged image may be noticeably grainier, less sharp, and less contrasty. A way around the problem is to use negatives that are fairly close in the degree to which they must be enlarged. An alternative is to use a very sharp, very-fine-grain film, such as Panatomic-X; then the degree of enlargement won't matter so much. This is the film that Jerry Uelsmann uses.

GOOD BLENDS

When blend zones are overlapped in a multiple-image print it is desirable that the merger be so subtle that there is no evidence of blending. That is, the two images should blend together so well that they look like a single image in the print. This is easiest to do if the blend zone in the finished print is supposed to be either black or white. If it is supposed to be gray, the process is more difficult.

It helps if you can blend texture into texture—for example, grass into grass, gravel into gravel, or leaf patterns into leaf patterns. Dis-

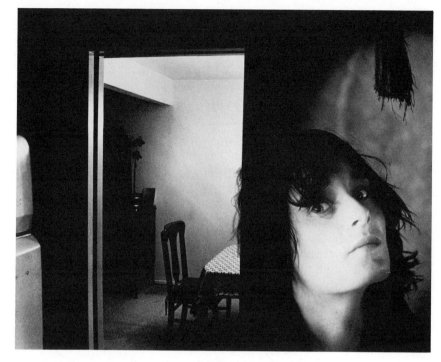

Fig. 15.6 The finished blend print. Though it came out almost exactly right, the blend zone and the girl's hair had to be touched up somewhat with spotting dye.

similar textures will often blend together, too, provided that the pattern size is about the same. Thus gravel may blend into grass or leaf patterns into gravel. It doesn't so much matter what the textures are so long as there is a visual similarity or relatedness. The easiest thing, of course, is to blend two nearly identical textures.

These textures should be irregular, as grass and gravel are, because blending mechanically perfect textures (such as printed patterns on paper or fabric) is difficult. Little irregularities help ever so much.

Plain untextured gray tones can also be blended, but it takes a lot more fiddling around to get them to come out right. Fortunately, blends don't always have to be perfect. Sometimes their very imperfections make them interesting, even if they look like blends that didn't quite come off.

If you should get turned on by blending, as many do, you should follow the path laid out by Uelsmann, who for years has been making negatives of blendable subjects. He now has so much material that he can apparently print endlessly without running out of it. However, many a person has done well with the method without having a large collection of specially made negatives. With blending in mind it is possible to get several suitable subjects on one roll of film.

Because blending is fairly complicated, it may help to have a step-by-step guide. The following one is for only two negatives, because you should limit yourself until you have had quite a bit of experience. However, you will find that you can make lots of fascinating pictures that way.

1. Make a drawing for both images and their overlapping blend zones.

2. Return the first negative to the enlarger and reposition the first image and the dodging chip(s).

3. Make a test strip for the image proper and a portion of the blend zone.

4. Expose a full sheet of printing paper for the chip-dodged first image, then return the paper to the package.

5. Using the drawing as a guide, reposition the second image and the dodging chip(s).

6. Make a test strip for the second image and a portion of its blend zone.

7. Put the partly exposed paper back in the easel and make an exposure for the second image.

8. Process the print.

Using your test strips as guides you may wish to burn-in the blends on your first full-size print. Or you may wish to make one without burning-in to use in deciding how much burning-in is necessary, if any.

Before exposing your final print you should clean each negative just before you put it in the enlarger, because negatives collect dust like magnets.

It is very unlikely that your first print will come out just right, but you can use it as a guide for adjusting your exposures, aperture settings, burning-in times, and dodging chips. You will surely find that making blend prints is a challenge to your patience and craftsmanship, but if you stick with it, you will get remarkably interesting pictures.

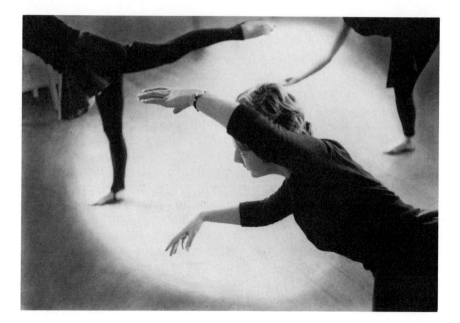

16 The Fine Print

If you find yourself really interested in photography, there is a phenomenon within the art that you really ought to know about. We might call it the mystique of the fine print. It involves seeing the printer's art as almost divine and his print as something that should invariably be exquisite beyond compare. Otherwise, it is hardly worth looking at. Prints that are merely good or excellent don't go far enough: they must be superb.

People who feel this way about prints often call themselves "serious photographers," which is another term you ought to know about. They are not necessarily more serious than other photographers, but they think that they are. Perhaps the thing they are most serious about is the mystique of the fine print and in making prints themselves that will measure up to it. Photographers outside the "serious" group, which includes most professionals and most amateurs, don't feel quite this way, for they will accept and like prints that are merely excellent and not necessarily "exquisite beyond compare." However, photographers in general do like good print quality, so the "fine print" is something to look into.

111

WHERE YOU STAND

You may wonder what your chances are for learning to make fine prints without investigating the subject very carefully. It's hard to tell. A certain percentage of people learn to make superb prints by working by themselves and using textbooks such as this one, but they are specially gifted. I suspect that nowadays most people would come to the point of making excellent prints, which is certainly nothing to sniff at.

The reason that modern people can usually learn to make excellent prints on their own is most certainly television, which has sensitized everyone to images and image quality.

Now, a person who has learned to make an excellent print can also learn to make a fine, or superb, print if he will take the trouble to learn about the qualities that such a print should have. One can do this best by studying the pictures by people who habitually make fine prints—for example, Ansel Adams, Paul Caponigro, and W. Eugene Smith. You can usually see fine prints in museum and gallery exhibits and in salon shows conducted by the Photographic Society of America. A bit of gallery hopping is almost a necessity for anyone who wants to know what the fine print is all about.

THE NEGATIVE

To make a fine print you have to start with a fine negative, which usually means properly exposed and developed, sharp, and fine-grained. Most fine-print makers prefer fine-grain films, such as Panatomic-X. If they use a coarser-grain film like Tri-X, they may develop it in a fine-grain developer, such as Microdol. The general idea is that perceptible grain in an image doesn't fit the fine print mystique very well. Though a few fine printers like grain and use it as an important, integral part of their pictures, the majority do not.

DEGREE OF ENLARGEMENT

Because enlargement decreases image sharpness and brings out granularity, the typical fine printer enlarges his negatives as little as possible. His ideal is the contact print, with no enlargement at all, and its infinite detail and relative grainlessness. He would like to make 8 x 10 and 11 x 14 contact prints, but the cameras for making such large negatives are usually considered much too bulky and in-

flexible today. I know one fellow who started making 35mm con-

tacts and mounting them on 11 x 14 board, but this is a strange way of meeting the fine print ideal.

The typical fine printer might enlarge a 35mm negative as high as 8 x 10, printing the whole frame, but he would feel in danger of losing too much quality. Though other photographers tend to think that only large prints should be exhibited, our man thinks that 8 x 10 is quite large enough.

For prints larger than 8 x 10 the fine printer will use 120 or 4 x 5 cut film if he can, though he doesn't always have the choice.

SUBJECT MATTER

The main ingredient in print quality is handsomeness, or beauty, which nearly always originates as one of the potentials of something you photograph. Photography is merely a way to record it and bring it out. Though it is possible to make a print of wonderful quality of an ugly subject, the fine printer doesn't usually go for this. He wants his picture to be beautiful from start to finish.

Everything must be right, including the subject itself, the lighting, the camera angle, the depth of field, composition, and so on. And absolutely everything in the image should be contributing to the efficacy of the picture.

The fine printer wants his pictures to "look like pictures should look," too. That is, they have to fit within the photographic traditions, and his subjects have to be "proper photographic subjects." However, if they happen to fit within the traditions of painting instead, that is all right. The best way to learn what these traditions are, incidentally, is to become a devout gallery hopper. Traditions are very fine for use as guides, as long as you don't let them strangle you.

PRINTING PAPER

The fine printer selects his paper carefully and nearly always standardizes on a single brand for all of his work. Agfa Brovira 111 and Kodak Medalist are two popular choices. Spiratone, Luminos, and all resin-coated (RC) papers are avoided, for they are said to contain insufficient silver in their emulsions. This means that the black tones aren't black and deep enough. This is especially a problem with Kodak RC papers. Though excellent prints can be made with all the avoided papers, they still aren't good enough for the fine printer.

He almost always prefers double-weight papers over single-weight. Though excellent prints can be made on the latter, it is much more

prone to getting creased or cracked while it is being handled and processed.

PRINT DEVELOPMENT

The fine printer usually likes to give his prints a very full development, which for him means a developing time of 2 or $2\frac{1}{4}$ minutes in developer diluted 1:2. He picks a particular time and sticks with it—say, 2 minutes. If a print comes up either before or after that time, he discards it and makes another. Though the discarded prints may be very good, they are not good enough for him.

The fine printer holds the developer temperature at 68F, plus or minus a degree or two. He does this by floating his developer tray in a water bath that is at the correct temperature. He would never develop at 75F or above, or below 65, for he would see this as extremely bad procedure.

He is also dead-set against using a given tray of developer for too many prints. He usually has some formula that tells him when to discard a trayful and mix a fresh batch. One such notion is that you can get only one really good 8 x 10 print from each ounce of developer stock solution that you use in making your diluted, working solution.

Perhaps you are beginning to see that the fine printer is a little bit ritualistic and quirky, but the fact is that he does indeed know how to make fine prints. This is certainly sufficient reason for knowing how he goes about doing things.

Sometimes the fine printer will put additives in his developer. One of them is benzotriazole, an antifoggant sold as Kodak Anti-Fog. No. 1. It permits one to develop a print for 3 or 4 minutes without getting fog and supposedly guarantees better blacks and a rich print color. People who use it usually use it all the time.

Some fine printers like the De Beers two-solution developer, for it enables them to maintain better control over shadow detail and contrast. They may choose other developers for a variety of reasons, but the objective of this chapter is merely to give you a brief idea of how they go about doing things. A compendium of all the things that fine printers do would probably fill a whole book.

FIXING, WASHING, AND DRYING

Since they go to a great deal of trouble to make superb prints, fine printers often attempt to guarantee that their prints will last almost forever by fixing, washing, and drying them with great care. They use fresh stop bath, followed by a fresh fixer, usually in a carefully main-

tained two-bath system. Prints are agitated carefully in the fixer and the fixing time carefully watched.

In washing, prints are usually treated in a washing aid, such as Perma Wash, which helps get the fixer out of the emulsion and the paper fibers. Many fine printers wash their prints in archival washers, which are special water boxes designed for washing with utmost efficiency.

Prints are often dried between clean sheets of photographic blotter or on special print-drying racks. The most particular of the fine printers often store their prints in special cardboard boxes made with cardboard that is free of chemical impurities, especially sulfur compounds.

WORK PRINT

Many fine printers make two prints for each negative: a work print and a finished print. The work print, often made without dodging or burning-in, is merely an image to study while trying to decide how the final print should be made. The printer may tape it to the wall and live with it a few days or weeks before deciding how the final print should look.

One of the main ideas behind work prints is that you don't really see a picture very well the first time you print, that really seeing it well takes quite a bit of time. Until you really see it you cannot make the best decisions with respect to printing it. Another idea is that the work print helps the photographer to make better emotional contact with his subject matter, to really get a feel for it.

Though many photographers consider the work print a waste of time and money, the serious photographers certainly don't think of them that way. Indeed, more and more people are now making work prints, so they must be getting something out of it. Perhaps they are in fact being helped to see their own pictures better. At any rate, many of the people who subscribe to the work print concept do make superb final prints.

APPEARANCE

Though fine prints vary a lot in appearance, they do tend to have certain things in common, the trait most often shared being overall darkness. Serious photographers like to preserve every single bit of highlight detail in their negatives, which they can only do by printing them a little dark—too dark, in fact, for the taste of the uninitiated. However, the photographers argue that the darkness can be compensated for by viewing prints under strong light, maintaining

that anyone who really cares about photographs will take pains to have such a viewing light available.

The color of a fine print is very handsome, particularly to the initiate. Though it is usually black-and-white, it often has a delicate color cast to it—purplish, bluish, or brownish, for example. And serious photographers pride themselves greatly on the color of their prints, working very hard to get them the way they are.

The tonal range in many fine prints is very wide, varying from the blackest black possible in a photographic paper up to a clean white. Some fine printers even insist that without such an extended range a print can't possibly measure up to fine print standards, though this is an unreasonably restricted point of view.

The photographer's seriousness is another common factor in fine prints. When you look at one, you just know that the photographer was dead serious about his subject, his technique, his print, his audience, and himself. One thing about serious photographers is that they are indeed serious about nearly everything, though a little bit of levity wouldn't hurt them a bit.

The fine print nearly always shows signs of having been handled with exquisite care after drying—no nicks, chips, fingerprints, or scratches; carefully mounted on very expensive mount board; packed in print boxes or portfolios with interleaving sheets to protect print surfaces from scratching; and so on. The serious photographer is often very touchy about his pictures and nearly dies when he has to let anyone else handle them. He may even give handling instructions before he parts with a print for even a minute or two. This is going a bit far, of course, but it is a way of protecting your prints against getting all beaten up.

NO ILLUSTRATIONS

After all the talk about fine prints it would be very nice if you could see a few of them in this book. However, the reproduction processes used in the vast majority of books are not nearly fine enough to give you even the slightest idea of what fine prints actually look like, and there is no point in pretending that they are. The only way you can learn what fine prints actually look like is to become a gallery hopper or to seek out photographers who make such prints and ask to see their work.

WHY BOTHER?

Why bother to find out about fine prints? Well, the fine print is the most universally accepted standard of excellence in photography, a very diverse field. To some extent, almost every photographer aims

for this level of excellence. Though many photographers find serious photographers a little weird, they nonetheless admire and emulate their printing.

Let us just say that finding out about fine prints will give you both a standard to shoot for and a gauge for measuring your own performance. And learning to make such prints is a passport into the company of those you admire most in photography.

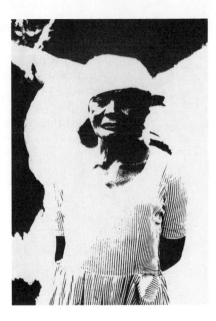

17 High- and Low-Contrast Images on Kodalith Film

There are certain films made especially for the graphic arts (the printing industry) that have extremely high contrast. Though not intended for pictorial photography, they are very often used for that purpose. One of these films that happens to be extremely good and readily available (in printers' supply stores) is Kodak Kodalith Ortho Type III. Since it is employed in some of the techniques that will be described later in this book, I will discuss it in some detail.

SAFELIGHT

Kodalith is an orthochromatic (or "ortho") film, which means that it is quite insensitive to red light, though it is very sensitive to other energy wavelengths, especially blue and ultraviolet. Unlike films that are panchromatic (sensitive to all colors of light), such as Plus-X and Tri-X, an ortho film can be handled under a dim red light without **118** fogging it if it isn't left out too long. a 7½-watt round red G.E. (BMS)

bulb at a distance of 4 feet works well as a safelight, but you shouldn't position it any closer. When your eyes are adjusted to the light the visibility is rather good.

LINE IMAGES AND CONTINUOUS-TONE IMAGES

Used as intended, Kodalith is very contrasty indeed, producing a so-called "line" image. Such a film image consists of only black tones and clear areas. It may be made up of lines, shapes (from large areas down to mere dots), or a mixture of the two. Even if it is made entirely of shapes, with no lines whatever, the image is still called a "line" image. When you print a picture on Kodalith, the "midtones"

Fig. 17.1 Two enlarged Kodalith negatives on a 10 x 10-inch light box—on the left a line (or high-contrast) image, the other continuous-tone. They were made from the same color transparency but enlarged to different degrees.

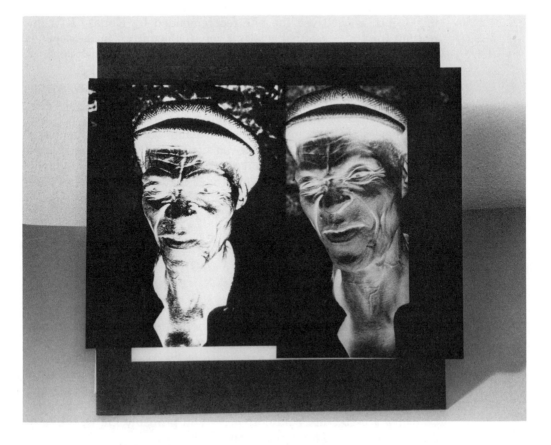

(all the grays) tend to "drop out," or disappear, due to the very high contrast of this material. You end up with blacks and clear areas, or a line image, which was the intention of the manufacturer.

However, Kodalith can also be used as a "continuous-tone" film, which means that it can produce images in which there are blacks, clear areas, and a wide range of gray tones, going from very light to very dark. The fact that a single film can be used for both line and continuous-tone images is very, very convenient.

THE DEVELOPER MAKES THE DIFFERENCE

Whether Kodalith will function as a line film or as a continuous-tone film depends on the particular developer you choose to use and how you employ it.

To use the film for high-contrast (line) images you should use the developer designed for it—special Kodalith Developer, a very-high-contrast developing solution. Use the regular type, not the special-purpose kinds. Other satisfactory developers are available, but you might just as well use the one recommended by Kodak. It is important for you to see that getting a very-high-contrast image depends on combining a very-high-contrast film with a very-high-contrast developer. Not just any old developer will do.

In order to use Kodalith as a continuous-tone film you merely shift to the kind of developer you would normally use for films such as Tri-X and Plus-X and use an abnormally short developing time. The chances are that any well-known brand would do well enough, but in this chapter you will be given figures for Kodak D-76 diluted 1:1. It is dependable, cheap, and obtainable in nearly all photography stores. These are the reasons why Kodak materials are the ones most often recommended in this book, not because the author has a special love affair with Eastman Kodak.

KODALITH DEVELOPER

A very-high-activity developer, Kodalith Developer tends to break down and become ineffectual fairly soon after it has been mixed, which is a general characteristic of very energetic developing solutions. Therefore, it is mixed and stored in two parts, solutions A and B, both of which are quite stable, or resistant to disintegration. If you mix the two parts together just before you start processing, the mixture will last for about 4 hours. On the following day, however, you might better use cold coffee. As you probably know, ordinary film developers will hold up a good deal longer.

KODALITH AVAILABILITY

Kodalith Ortho Type III film comes in 35mm rolls and in sheet sizes of 4 x 5, 8 x 10, and 11 x 14 inches and larger. The 8 x 10 size is convenient for most people, and it can easily be cut down to 4 x 5 or 5 x 7. Few photography stores carry the film (or *any* high-contrast film, for that matter), so you will probably have to go to a printer's supply store, which is almost certain to carry it.

As films go, Kodalith is fairly inexpensive. An 8 x 10 sheet costs a little more than twice as much as a sheet of double-weight enlarger paper of the same size.

EXPOSURE

Kodalith has approximately the same speed as enlarging paper and is exposed in the same way. As usual, correct exposures are determined with test strips. The film is placed in the printing easel emulsion side (dull side) up.

Whether you are using the film as a line (high-contrast) or continuous-tone material, the exposures are approximately the same. However, you should make test strips for each type of usage.

HANDLING

Kodalith is an extremely tough film, its emulsion very firmly bonded to its clear plastic support. Even so, you should be careful not to scratch it with fingernails and should eschew the use of print tongs. Before processing, handle it only by the edges, for it is chemically sensitive to fingerprints.

Aside from requiring a little extra care, Kodalith is just as easy to handle as enlarging paper. In fact, it is very much like a resin-coated (RC) paper, except that its base is transparent.

HIGH-CONTRAST PROCESSING

For high-contrast (line) images, Kodalith is developed in a bath of Kodalith Developer mixed with equal parts of solutions A and B, temperature 68F, plus or minus 1 degree. Recommended developing time is $2\frac{3}{4}$ minutes. The acceptable developing time range is $2\frac{1}{4}$-$3\frac{1}{4}$ minutes.

To start development, drag the film emulsion down across the developer surface, then immediately turn it emulsion up and push it to the bottom of the tray.

Agitate by rotational tray tipping. That is, continuously use a repeated cycle in which you lift up the far side of the tray, the right side, near side, and left side—each cycle taking about 8 seconds. Keep this up for the entire developing time.

For slightly more even development, use the cotton-swab method. During the entire developing time, drag a sizable developer-wet cotton swab around on the film surface, making as random (erratic) a pattern as you can.

After development, drain the film for 3 or 4 seconds and put it in the stop bath for 10 seconds, agitating continuously. Then put it in the fixer (hypo), agitating continuously for the first 10 seconds and intermittently thereafter. Leave it there for twice the clearing time (the time that it takes the milky appearance to disappear). This should be from 2 to 4 minutes with a regular fixer and from 1 to 2 minutes with a rapid fixer.

Wash the film for about 10 minutes in running water at 65 to 70F. To minimize drying marks, treat it in Photo-Flo, or wipe both surfaces carefully with a chamois, a viscose sponge, or a soft rubber squeegee. Then hang it from a line with a film clip or a clothespin.

TIME, TEMPERATURE, AND AGITATION

With a printing paper the developer temperature can vary as much as 10 degrees Fahrenheit without substantially affecting the image quality, though it is best to stick close to 68F. Almost all of the exposed silver halide crystals are destined to turn dark, after which development slows nearly to a halt. Though the temperature affects the speed with which this happens, the same amount of darkening is going to take place, whatever the temperature. The time and agitation aren't all that critical, either, though it is good practice to agitate systematically and stay within a reasonable developing time range.

With films it is entirely another story: you should follow the predetermined time, temperature, and agitation schedule very exactly. Otherwise, there is no way whatever for learning to predict what your results will look like. Though you may find it troublesome to have to follow the rules, you will surely rue the day if you don't.

A PRINT ON KODALITH: EXPOSURE

If you use a regular negative to make a print on Kodalith film, you will get a positive image, of course. Held in front of a bright window or a light box it should look very much like a regular print. However, if you have given it high-contrast development, it will be very con-

trasty, with many of the midtones dropped out. If the exposure is correct, you will see mainly solid blacks and clear areas.

If this hypothetical film positive is considerably underexposed, the darks will be fairly transparent, so that you can easily see light through them. If they are dark but have a lot of little clear pinholes in them, the film is about one stop underexposed.

With an overexposed image the darks bleed into (spread into) areas that are supposed to be clear, the amount of bleeding being dependent on the degree of overexposure. With a very heavy overexposure the entire image will turn black.

FROM A COLOR SLIDE

You can also make a Kodalith print from a color slide, in which case the image comes out negative. Because color transparencies are usually quite contrasty to begin with, more midtones are likely to drop out. The rule is: the greater the contrast of the original, the greater the degree of drop-out.

CLEARING

Overexposed Kodalith positives and negatives can be "cleared" with Farmer's reducer, which pushes back the bleeding in areas of line negatives that are supposed to be clear and eliminates many of the remaining midtones. Use twice as strong a ferricyanide bath as you would use for overall print bleaching (Chapter 5). Take precautions not to let the bleaching go too far, because it can easily get away from you with Kodalith.

CONTACT PRINTING

Kodalith positive and negative transparencies can be contact-printed on either enlarging paper or Kodalith film. With paper you get a print, with film a transparency.

Contact printing is quite easy. To do it you need a sponge rubber pad (the type used for a typewriter or an area rug) cut down to about 10 x 12, a heavy piece of plate glass, and your enlarger light. Since plate glass is very expensive and easily scratched, you might prefer to use a glass sandwich made with four sheets of ordinary single-strength 12 x 16-inch window glass taped together at the edges. Don't squeeze the sheets together when you are taping, or you may get Newton rings.

Fig. 17.2 A setup for making contact prints. The essential parts are the enlarger (light source), the timer, the glass plate, and the sponge rubber pad on the enlarger baseboard. The glass plate is actually four sheets of single-strength glass taped together at the edges. This was done to give the glass sufficient weight to hold photographic materials together in tight contact.

To make a contact print, center the rubber pad on the enlarger baseboard and check to see that the rectangular light pattern from the enlarger will be large enough to cover it. Turn off the light. Put the printing material (Kodalith or enlarging paper) on the pad, emulsion up. On that put the Kodalith transparency, emulsion down, and cover it with the glass, the weight of which will assure good contact. Stop down the lens two or three stops and expose with the enlarger light. Process in the manner appropriate for the type of material you are printing on.

Of course, you should preface all this by making a test strip in the usual manner—by progressively covering up a strip of photosensitive material and giving 5-second exposures with the lens stopped down two or three times.

Another approach to contact printing is to use a contact-printing frame instead of a rubber pad and plate of glass. Though nondecorative, it looks somewhat like a picture frame with glass in it. However, it has a hinged spring back. You load it by turning it face down and laying a transparency, negative or positive, on the glass, emulsion up.

Next you put in the printing material emulsion down, then put on the back. The spring forces everything against the glass, assuring excellent contact.

Contact-printing frames come in various sizes, but I think you would find the 11 x 14 size most generally useful.

Once you get the idea of contact printing you can contact-print every Kodalith transparency you make, even if it originated as a transparency itself. (Be sure you understand here that a transparency is any image, positive or negative, on a transparent base such as acetate.) For example, you can make a contact transparency and use it to print another. Then you can use the second one to contact-print a third, and so on. Naturally, you keep going back and forth from negative to positive to negative to positive images.

DROPPING-OUT

You can carry the negative-to-positive-to-negative process as far as you like, but people seldom carry it very far. The reason for doing a certain amount of it is to progressively drop out more and more of the tones of a line (high-contrast) image, until there are no more mid-

Fig. 17.3 A line cut (high-contrast image) made from a Kodalith line negative, which had been processed for high contrast in Kodalith Developer.

tones left at all. This is so you can end up with an image that is all black or clear, which is how we defined a line image. With a high-contrast film and developer the tones drop out fast, so a couple of contact printings will usually do the job. When you work from color slides the midtones will often drop all the way out in the very first negative.

Except for the purpose of creating very-high-contrast prints, the positive-to-negative-to-positive bit isn't usually carried very far, because image qualities other than sheer blackness and whiteness always suffer progressively along the route. For example, image clarity and fine detail are eroded. The progressive erosion is particularly apparent when you work with continuous-tone images.

A SHORT DETOUR TO RC PAPER

Though this chapter is about Kodalith film, we should detour to resin-coated (RC) papers for a moment, because they can sometimes be used for similar effects. For example, you can get splendid high-contrast prints by using Kodak Kodabrome Ultra Hard (no. 5) RC paper and normal print processing. From a negative with good contrast first make a print on RC paper, which will come out positive, then use this positive to contact-print an RC negative. Next use this negative print to contact-print your final high-contrast positive.

To get to the final result even faster, start out with a color slide, preferably one-half stop underexposed. Printing it will give you a negative RC print, which you then contact-print for your final positive print.

Whether you start with a negative or a color slide, the midtones tend to drop out rapidly with the Ultra Hard paper. If a few of them are stubbornly resistant, they can easily be removed by local bleaching.

You can make handsome high-contrast contact prints from RC paper prints because the resin-coated paper backing of an RC paper is virtually grainless. Regular papers have a fairly heavy grain, or paper texture, which shows up in images that have been contact-printed with them. It is usually, but not always, a bit on the ugly side.

CONTINUOUS-TONE KODALITH IMAGES

Remember that a continuous-tone image is one with a complete range (or continuation) of gray tones, from light to dark. Your ordinary prints have such images, and so do your negatives. Though Kodalith isn't designed for continuous-tone work, it can be used that

way with beautiful results. The secret is in using an ordinary film developer, such as D-76.

One reason for using Kodalith this way is to get a very-high-quality fine-grain black-and-white print from a color slide. You merely make an enlargement print (which will come out negative) on Kodalith and develop it for 3 minutes in D-76 diluted 1:1 at 68F. Then you contact-print this negative on normal-contrast enlarging paper and process it in the usual way. Very often the resulting print will be of better quality than you could get by enlarging an ordinary negative.

(Another reason for using Kodalith as a continuous-tone material is to get large negatives that can be retouched with pencil, red dye, bleach, opaque, or etching knives. With 110, 35mm, and 120 negatives this is nearly impossible; they are just too small.)

Fig. 17.4 A continuous-tone positive print on no. 1 paper made from an enlarged Kodalith negative processed for continuous tone in D-76 diluted 1:1.

Though there is usually no need for it, the developing time can be cut as low as $1\frac{1}{2}$ minutes, which will considerably reduce image contrast (which should be normal at 3 minutes). You can also increase contrast by extending the time to 15 minutes or more. However, you will start to get safelight fog after 3 or 4 minutes and thus should mask your safelight with heavy paper.

The normal 3-minute time for Kodalith is far below the times used in developing ordinary films like Plus-X and Tri-X. Such a short time is used because it is necessary to reduce the built-in high contrast of Kodalith. Shortening development times will reduce the contrast of any normal type of film.

This drop in contrast applies to any developer you are likely to use, even Kodalith Developer, which is noted for its extreme contrast. If you cut the time for this developer down below 1 minute you will get a continuous-tone Kodalith image rather than a high-contrast one. However, with times that short the image is likely to come out mottled, or splotchy, which is one reason why you should use D-76 instead.

You have already read how to get a continuous-tone positive black-and-white print from a color slide. To get one from a negative requires another step. First you make an enlarged film positive, which you contact-print to get a film negative. Then you contact-print this negative on enlarging paper to get your final positive print. Unless you wish to do retouching on either the enlarged film positive or the negative (or both), this would be a very roundabout way of getting a print from a negative.

Incidentally, for enlargement printing from a color slide you should always remove it from the slide mount, in which it is slightly curled at the edges. Slide projector lenses compensate for this curl, but enlarger lenses do not. As a consequence, mounted slides will produce pictures that are out of focus either at the edges or in the middle.

DETOUR: CONTINUOUS-TONE RC IMAGES

You can get an excellent black-and-white continuous-tone print from an unmounted color slide by using RC paper and normal processing procedures. Simply print the slide with a no. 2 paper or printing filter, which will give you a normal-contrast paper negative. Then contact-print this negative on the same-contrast paper (or with the same-contrast filter), and you will get a normal-contrast continuous-tone positive print. Prints made in this manner are usually of very high quality, though very slightly diffuse.

You can also start with a regular negative, getting first an RC positive, then a negative, then a final positive. However, the final print

quality isn't nearly as good as you would get by starting with a color slide. This is because there is a certain amount of texture in RC paper, and it begins to show up after a few steps in contact printing.

RETOUCHING HIGH-CONTRAST (LINE) IMAGES

The retouching that you do on high-contrast film negatives or positives can usually be of a rather crude sort; it just doesn't matter. The usual problem is to get rid of unwanted clear spots and marks in black areas, or unwanted dark spots and marks in clear areas. To patch up black areas you use a special tempera paint called photographic opaque (use the black kind), which blocks off light from printing materials. Just daub it on with a brush wherever there is an unwanted clear spot or mark.

Get rid of the dark spots and lines in clear areas with very strong Farmer's reducer, taking care that it doesn't slop over onto dark areas of the image. Before bleaching, wipe off the film emulsion very thoroughly with a paper towel so that the bleach won't spread into areas where it doesn't belong. Instead of using ferricyanide you can use ordinary Chlorox, which will take the emulsion right off, the unwanted spots and lines with it; apply it with a Q-Tip. The film will look a little messy, but it doesn't matter if you are going for a high-contrast final print.

If you like, you can also scratch lines on a film image with a single-edge razor blade or Xacto knife. If you scratch on a Kodalith positive, they'll come out white in the final positive print. Scratch on a Kodalith negative to get black lines.

You can block out large clear areas by taping thin black paper over them, instead of taking time to apply large amounts of opaque. You can make lines or borders with black tape cut in various widths. In truth, the high-contrast image will take a good deal of handling without its affecting the quality of the final print.

Retouching a continuous-tone image is a much more delicate matter. The techniques for doing it are described in the chapter on negative retouching (Chapter 27).

HALFTONES AND LINE CUTS

It is now time for you to understand how the printing industry uses films like Kodalith, for you will find the information useful. The first thing to consider is the halftone reproduction, which is the kind of photograph you see in all magazines, newspapers, and most books (including this one). It looks like a continuous-tone photograph, but 129 it's not. Indeed, it is a high-contrast image made up of only solid

blacks and clean whites. There are no gray tones at all, though there seem to be.

If you will examine such a reproduction through a strong magnifying glass, you will see what is actually going on. The image is made up almost entirely of tiny dots—black ones in light areas, white ones in dark areas—though there are some areas, usually small, that are solid black and some that are solid white. There are also areas in which you can't be sure whether you are looking at white dots or black ones, for they don't really look much like dots. For convenience, however, we simply say that the picture is made up of dots, which make it look like continuous tone. We call it a halftone reproduction and say that the printing plate was made from a halftone negative with an image also made up of dots. A halftone negative is made on a film of the Kodalith type.

You also frequently see reproductions in magazines and newspapers that have not dots at all in them but are composed of whites and solid black masses and lines. They are made from pictures, usually line drawings, that have only black and white in them and no midtones. They can also be made from linoleum block and woodblock prints, engravings, high-contrast photographic prints with no midtones in them, and so on. The important thing is that the original picture consists entirely of only black and white.

A reproduction made up of black lines and/or masses is called a "line cut," even if it is all masses and no lines. The original picture, chart, graph, lettering, or printed text from which a line cut is made is called "line copy," meaning that it can be reproduced directly without the use of dots. The terms *line copy* and *line cut* are common throughout both the graphic arts and phtotography, so you should try to remember what they mean.

A halftone reproduction is made from "continuous-tone copy"—that is, from an image that has a range of gray tones. Here we would find regular photographic prints, shaded drawings, paintings, and so on—in fact, any visible image that has more tones than just black and white. A halftone image itself is not continuous-tone, but it seems to be on account of the dots. The thing to remember is that it starts out as a continuous-tone image, which is then translated into dots.

MAKING A LINE CUT

Line copy is photographed on a high-contrast film of the Kodalith type to make a "line negative." The line negative is then contact-printed on a photosensitive printing plate. It is a different type of photosensitivity than you are familiar with, and the processing is also very different. These matters needn't concern us here, for the only objective is to show you the route that line copy takes to get on the

printing plate. When it is printed, it comes out as a line reproduction, or line cut.

MAKING A HALFTONE

Continuous-tone copy is photographed through a halftone screen to make a halftone negative. This negative is then contact-printed on a printing plate. Again, the type of photosensitivity and processing involved don't concern us here, for most of us will never use them.

A halftone screen may be a plate of glass with lines scribed on it. Or it may be a piece of plastic sheeting upon which is printed a cross-hatch grid of straight lines which make it look like a window screen with a very fine mesh. The latter type of screen is most useful for our purposes. When such a screen is positioned (face down) on film during an exposure, the lines block out light, while the spaces between them let it through. The light coming through thus forms little dots on the film when it is developed. They can vary moderately or radically in size according to the amount of light that gets through. This in turn depends on the relative brightness of various areas of the continuous-tone copy. However, dot size can also be changed by giving longer or shorter exposures. The greater the exposure, the larger the dot with a given screen.

The variable size of the dots in a halftone image is what makes it look like it has continuous tone, though it does not. A halftone reproduction merely starts out as continuous-tone copy and thereafter creates the illusion of it. All praise the illusion, for the printer's art is mainly dependent on it!

Now, there are both fine screens and coarse ones, depending on how many lines they have on them per square inch. Newspapers use coarse ones—say, from 65 to 85 lines—while coated-paper magazines use fine ones—150 lines and up. Coarse screens make large dots, fine screens make small ones. You can see the dots from a 65-line screen with the unaided eye but would need a strong magnifier to see the dots from a 200-line screen.

Halftone screens are also used in silk screen printing, but they are usually rather coarse. The reasons for this are made clear in the chapter on silk screening (Chapter 22).

As you will soon see, there are many things one can do with Kodalith film. It is nearly as easy to work with as ordinary enlarging paper, so don't be hesitant to work with it. As film goes it is very inexpensive—about twice the cost of enlarging paper. Kodalith Developer costs quite a bit more than Dektol, but you won't need all that much of it. The main thing to keep in mind is that Kodalith Ortho Type III is a very exciting material for the creative photographer.

18 Posterization

It is possible to turn an ordinary photograph into a photoposter made up of three or more flat tones, with no tonal gradation whatever. It will look much like a flat-tone art poster made with air brush, tempera, or silk screen, yet have a photographic quality that is all its own.

Once you know how to make high-contrast negatives with Kodalith (Chapter 17) it is relatively easy to posterize, though it does take a little time.

THE GIST OF IT

For a three-tone poster the process in brief is as follows: from a single original negative make two high-contrast Kodalith positives. Expose one so that when it is held up to a light after processing it will look just a little darker than a normal picture; there should then be detail in all the highlight areas. Give the second positive about half the exposure of the first one, so that only the darkest areas of the image are printed.

Now, contact-print each of the film positives to get two high-contrast Kodalith negatives. Retouch them with opaque to get rid of pinholes in the black areas, and clean up the clear areas with bleach. Finally, on a single piece of enlarging paper, contact-print both of the negatives, one after the other. When developed, the print will turn out to be a poster with three flat tones. This description is an oversimplification, for there are several questions that must be answered.

HOW MANY TONES?

We have seen that a poster has three or more flat tones, but how many would actually be best? You can make as many as you like by making more positives and negatives. The number of resulting tones is the number of negatives plus one (the white of the final print). Some people go for four-tone posters, some even for five. However, the best bet is to go for three tones. Not only is it easier, but it usually looks better.

Oddly, with four or more tones a posterized print may not even look posterized. Instead it may look like an ordinary print with something just a wee bit odd about the tones. With a six- or seven-tone poster you could be sure that this would be the effect. Thus you can see there is no special virtue in having a lot of different tones. You will usually get the best and most predictable results with just three.

PIN REGISTRATION

In a poster you have to be very careful to get the two images registered precisely (overlapped exactly). Therefore, the two negative and two positive images have to have exactly the same position on the film. This is usually done with a "pin register board," a simple device for holding paper or film precisely in a preselected position.

Usually homemade, it is a piece of board, plywood, or chip board with two short pins (studs or buttons) taped to it. The edge of the film is punched with a two-hole punch, so that the holes will fit down over the pins. This holds the film in position and guarantees that other pieces of punched film can be given exactly the same alignment.

Your board should be about 11 x 14 inches. To the back of it glue a dozen rubber hose washers, so that it will have a tread like an automobile tire and not skid around on the enlarger baseboard and knock good registration right out the window.

You can obtain register pins at a graphic arts (printers') supply store. Ask for Bregman (R-3) register pins, which are $\frac{1}{4}$ inch in dia-

Fig. 18.1 A pin register board with ½-inch plywood, a piece of
sponge rubber cut from an area rug pad, and two short pieces of
¼-inch dowel. Punched paper (or film) fits exactly over the pins
(dowels). Rubber hose washers (about twelve) are glued on the back
of the board to prevent it from sliding around too much on the
enlarger baseboard.

Fig. 18.2 A three-hole office punch. Since it has an adjustable
border it can readily be adapted for punching two holes in 8 x
10-inch photographic materials, though two-hole punches are
recommended in the text.

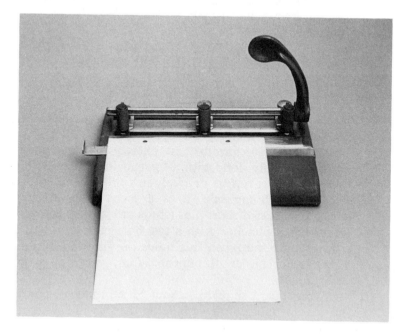

meter and about $\frac{1}{20}$ inch high, each mounted on a flexible stainless steel base $1\frac{1}{2}$ inches long and $\frac{1}{2}$ inch wide. The bases are taped to the register board, but the spacing between the pins must be exact.

Now, you need a nonadjustable, two-hole, $\frac{1}{4}$-inch-diameter office punch. Some brands punch slightly larger holes, but don't get one of those. Use it to punch holes in the 8-inch side of a piece of 8 x 10 paper, making sure to get the holes equally spaced from the corners. Used the punched paper as a template for positioning the pins on the board. Push the pins through the holes, align the paper on the board, and tape down the metal mounting strips. Getting precise alignment is dead easy, so don't let yourself get spooked.

You will use your punch for making precisely spaced holes in both Kodalith and enlarging paper. If you like, you can make your own pins out of short pieces of $\frac{1}{4}$-inch dowel set in holes drilled in your register board. Sand down the edges a little bit so that the holes will easily slide over them. You might like your pins a bit longer—say, $\frac{3}{16}$ inch.

GLASS AND DUST

For work of this kind it is customary to hold the photosensitive material flat with a heavy plate of glass. Thus you would use glass for making the film positives, for contact-printing them to get the negatives, and for making the final posterized print. But the trouble with glass is dust, which collects on it and shows up in photographic images at every step along the way. You can block out the resulting dust spots with opaque, but that's a lot of work. Another answer is to have the glass very clean, getting rid of the dust with a static cloth or brush just before making each positive, negative, or the final posterized print. The films should be wiped off, too, of course.

Another answer, much easier, will work sometimes but not always. If your unexposed Kodalith film, the positives, the negatives, and the enlarging paper will all lie quite flat, perhaps curling just the slightest bit, you can get along without the glass, though you will still need the pin register board. Fortunately, Kodalith tends to lie flat anyway, and so does resin-coated (RC) paper.

If there is a slight amount of curl in your materials, there will be a small degree of image distortion if you work without the glass. However, posterization itself is a kind of image distortion, so a little bit more won't hurt at all. Well, if you are lucky, you can get along without the glass and save yourself a lot of retouching. Work without it at first and see what happens. The determining factor is mainly humidity, with dry air promoting film and paper curl and humid air favoring flatness.

Make test strips to determine your exposures, of course. Remember to use Kodalith Developer (Chapter 17) for highest possible contrast. The correct exposure for the first film positive will give you a picture that looks a little bit darker than normal when held up to the light. The second positive should have about half that exposure; you can tell that it is right if most of the highlight tones drop out. If necessary, both film positives can be bleached to compensate for overexposure.

Make a test strip for contact-printing the first film positive. The same exposure should work with both positives. The negative from the first positive, the one with the almost-normal-looking image, should have clear areas that are quite a bit smaller than those in the other negative. The size difference is what causes the posterization.

For the final posterized print, expose the paper through the negative with the largest clear areas for the time that will give you a pretty, medium gray. With the other negative you should probably expose for a black tone, though a dark gray might be nice. You can get the exposure data for both tones with a single test strip made with the negative with the largest clear areas.

Fig. 18.3 A straight print of the picture posterized in this chapter.

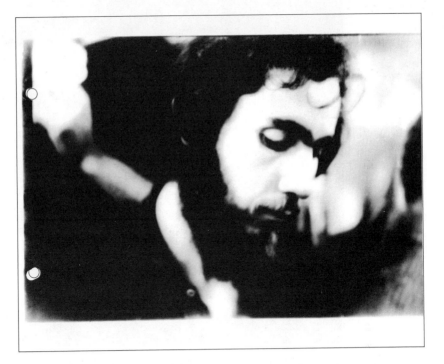

Figs. 18.4, 18.5 Two enlarged Kodalith positives made from the original negative, each with a different exposure time (about one stop apart). To lessen graininess they were diffused with cellophane for the entire exposure time and were then developed for high contrast in Kodalith Developer. They were exposed on a pin register board.

Figs. 18.6, 18.7 Kodalith negatives made by contact-printing the two Kodalith positives on a pin register board, then developing in Kodalith Developer for maximum contrast. Notice that a considerable number of tones have dropped out by this stage. The negative with the smallest amount of clear area was made for producing the blacks in the final posterized print. The other one is for producing the grays.

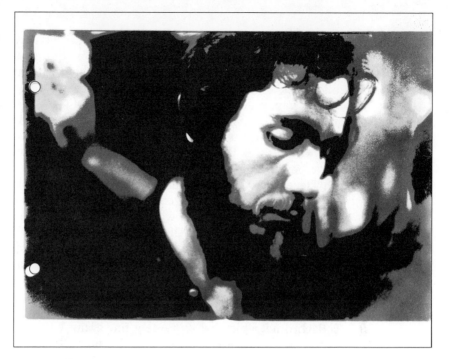

Fig. 18.8 This three-tone poster was made by consecutively printing both Kodalith negatives on the same piece of printing paper on the pin register board. The negative for the blacks was printed first and given a rather long exposure. The other negative— for the grays—was printed with considerably less exposure. After both exposures the paper, Kodabrome Ultra Hard, was processed normally.

DROPPING OUT TONES

Ideally, the Kodalith negatives should have only black tones and clear areas, with no midtones at all, but it seldom works out exactly this way. There are usually midtones left, but if the negative images are also very contrasty, it doesn't usually matter—the final posterized print will still have flat tones.

You can drop out more tones by using the negatives to contact-print a second set of positives, then printing the positives for a second set of negatives. Before going to the trouble it would be better to print a trial poster with the first negatives.

ACCIDENTAL HALFTONES

Remember that a halftone is an image composed of dots and that it is usually made with a halftone screen. But sometimes you get the dots without the screen. This is usually on account of the grain in the

original negative, which the very-high-contrast Kodalith converts into solid black dots. These dots, which may be quite substantial, resist dropping out. It is not too easy to bleach them without bleaching the solid black areas too much at the same time.

One way to get rid of the grain is to blend it all together when you are making the two positives. You can do this during exposure by diffusing for the entire time with wrinkled cellophane (Chapter 7). One would think that the images would then come out soft, but they don't because of the very high contrast of Kodalith film and Kodalith Developer. High contrast itself (and the dropping-out process) will give you sharp edges, even with this much diffusion.

Another way that often works is to start out with a color slide instead of a negative. If the slide is just slightly too dark, it will usually have so much contrast that most of the tones will drop out when you make two Kodalith negatives from it. Thus these negatives can be used to contact-print a poster.

As for the dots, color transparencies have much finer grain than the average black-and-white negative, especially if they are made with Kodachrome, which has extremely fine grain. With much less grain to start with there is less chance of getting an accidental halftone.

RETOUCHING

From reading Chapter 17 you know that on Kodalith you can retouch blacks with opaque and clear areas with Farmer's reducer, on either negatives or positives. But what about the midtones that haven't dropped out? How should they be retouched? Certainly not with opaque, because the outlines of opaque daubs are likely to be visible in the next contact print. Similarly, the marks of bleaching may show up, though they are less likely to. Thus the answer is that it is best to leave the midtones alone. They will either drop out or they won't, and it's hard telling which they'll decide to do.

On the final print the whites can be cleaned out with strong bleach, the blacks touched up with spotting dye, and the grays worked on with either bleach or dye or both.

AN ALTERNATIVE METHOD

It is possible to make good posters with Kodabrome Ultra Hard RC (resin-coated) paper in place of Kodalith for both the positives and the negatives. Though the paper isn't as contrasty as the film, it nonetheless works very well. Furthermore, when you are contact-printing the paper positives, or printing the poster itself, there is a slight amount of diffusion when the light passes through the white

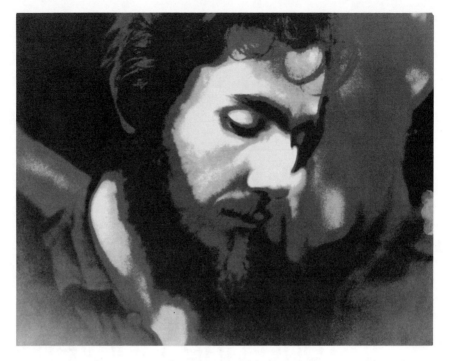

Fig. 18.9 This *four-tone* poster from the same original negative
was made by an alternative method in which the intermediate
negatives and positives were all made with Kodabrome Ultra Hard
RC (resin-coated) paper instead of Kodalith film. It was processed
normally in Dektol at 1:2. To produce the additional tone it was
necessary to make *three* negatives and *three* positives and expose
the final posterized print *three* times, not twice. Otherwise, the
procedure was the same. Though this four-tone poster differs from
the three-tone one, the difference is not really all that great, do
you think?

resin-coated paper. This helps to minimize the problem of grain and
accidental halftones.

Though Ultra Hard is very contrasty, you may still need to make
an extra set of positives and negatives in order to drop out enough of
the midtones. But when you are working with paper instead of film
it is somehow easier to keep track of what you are doing, so going
through the extra steps should be no problem. If your original nega-
tive is contrasty enough, you may not need them.

You now know how to posterize with two quite different
materials—Kodalith and resin-coated enlarging paper. Some people
make posters because they find them handsome and interesting in a
rather strange way. Some do it to more or less duplicate effects ob-
tainable with certain other art media. However, the majority seem to
make posters because it is an exciting technical challenge. Take your
pick.

19 Tone-Line Conversion; Bas-Relief

There is a rather unusual technique for converting an ordinary continuous-tone picture into either a line drawing or a halftone. This is often done for purely pictorial purposes, but many people do it to see if they can. Since some of the problems involved are a little difficult, it is indeed a fine challenge.

THE GIST OF IT

From an ordinary negative you make an enlarged continuous-tone Kodalith positive, say 8 x 10 inches (see Chapter 17). From this positive you contact-print a continuous-tone Kodalith negative. Then you tape together in register (exactly superimposed) the positive and negative, with two sheets of cleared Kodalith film between them so there is space between the two images.

The tones of the registered positive and negative should cancel each other out, so that when held up to the light the sandwich looks

like a nearly unrelieved sheet of gray with very little or no image detail showing.

Then you make a contact print of the sandwich in a special way, using the enlarger as the light source (it should be at the top of its standard). The negative-positive sandwich and the printing paper are held in tight contact in a contact-printing frame.

Divide the total exposure (which you can determine with a test strip) into four parts: First hold the contact-printing frame under the enlarger at an angle of about 45 degrees, with one side resting against the baseboard, and give the first exposure. Then turn the easel a quarter-turn, maintaining the 45-degree angle, and expose again. Repeat this procedure for the other two sides; then process the print.

If your exposures are correct, you will end up with either a "line drawing" or a halftone. Or you may get a picture that has both lines and dots. Whatever be the case, it should have only two tones: black and white.

Figs. 19.1, 19.2 A straight print and a tone-line conversion made from the same original negative. Notice that the lines show up wherever there is tonal contrast between areas—for example, where the child's hood contrasts with the man's coat. Where there is no marked contrast (e.g., between the man's chin and his coat), the line disappears.

WHAT HAPPENS

It seems unlikely that a negative-positive sandwich that looks like a dark, extremely flat print, or just a field of gray with a tiny bit of detail in it, would produce a picture that looks like a line drawing made in ink. Nevertheless, that is what happens. *How* it happens is interesting, so we will look into it.

A continuous-tone image, either negative or positive, is made up of tones that contrast with one another to varying degrees. Very often there is a sharp line or edge of demarcation between lighter tones and darker ones—places, along contours usually, where contrast is very noticeable. These edges or contours where contrast is fairly strong account for the lines.

When a positive and negative are sandwiched, the contrast along these contours is neutralized, so that everything looks gray. However, if the images are separated somewhat by cleared film or plastic sheeting, much of the light striking a contour *at an angle* will "slide through," as it were, creating a line in the same position as the contour.

Much the same thing happens with strong texture or heavy grain: light sliding through at an angle creates the rough equivalent of a halftone.

THE POSITIVE

The enlarged film positive, the first step, should show normal contrast when held up to a light box or bright window. That is, it should look like an excellent TV image well tuned for contrast. However, it should be a little bit on the dark side overall, so that there is tone and detail in all the light areas. Thus the highlights shouldn't be washed out or clear.

If your original negative would make a normal-looking print with a no. 2 paper or printing filter, you can develop your enlarged Kodalith positive for 3 minutes in D-76 diluted 1:1 at 68F and get about the right contrast.

If your original negative is very flat and would require a no. 5 paper for a normal-looking print, then your film positive would also come out very flat. However, you can build up its contrast to normal by increasing the developing time, 12 minutes being about right. For less contrast you can use less time.

With a very contrasty original negative you can compensate by cutting the developing time down as low as 2 minutes; you shouldn't go any lower. You should make a test for this time and will find that you need quite a bit more exposure than for a 3-minute develop-

144

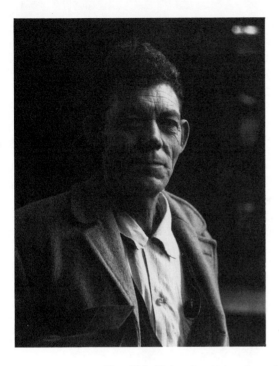 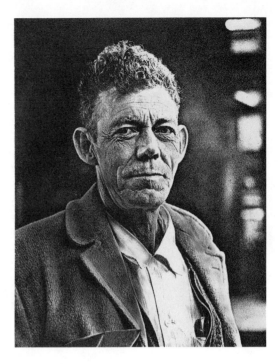

Figs. 19.3, 19.4 A straight print and a tone-line conversion made from the same original negative. The conversion is what the text describes as an "accidental halftone,"—that is, an image consisting mostly of small black dots (originating as grain in the original negative) that were not produced by means of a halftone screen.

ment. However, for times longer than 3 minutes the 3-minute strip should suffice, though you may wish to cut your exposures a little bit.

CONTRAST AND DENSITY CONTROL

As we have just seen, the contrast of an image on film can be controlled by the developing time. This is also true, but to a lesser degree, of images on printing paper. The useful time range for Kodalith film in D-76 diluted 1:1 at 68F is about 2-20 minutes, with 2 minutes giving little contrast and 20 a good deal of it. Remember, 3 minutes is the optimum time if your original negative has normal contrast, otherwise not. It is also the time to use when making a contact film negative from a normal-contrast film positive.

Now, *density* is controlled more by exposure than by development, though development does affect it. Thus if you want a heavier, more dense film positive or negative you simply increase the ex-

posure. If you want a thinner one, decrease the exposure. The general rule is: Exposure controls density.

However, for developing times below 3 minutes the time has a fairly large effect on density. If you were to give two images the same exposure and develop one for 3 minutes and the other for 2 minutes, the first one would come out about twice as dense as the second. So we see that at the lower end of the developing-time scale the time has a considerable affect on density. With longer times there is a progressive lessening of effect.

Now, the reason you need to know all this stuff is that you need to get a film positive and film negative that have the same degree of contrast and the same density. And you may have to juggle exposure and development to get what you want.

Here it should be mentioned that one of the main reasons for doing this "tone-line" project is that it will help you understand the things in this chapter very well. They happen to be important for a proper understanding of photography itself.

SAFELIGHT FOG

You must understand that safelights are only *relatively* safe. Given sufficient time they will cause fog, no matter what kind of photosensitive material you are using. Kodalith is safe with a 1-A safelight or a G.E. $7\frac{1}{2}$-watt red bulb at a distance of 4 feet as long as you work with reasonable speed and develop no more than 3 minutes. Then fog starts catching up with you; around 5 or 6 minutes you have a lot of it.

The way to counteract the fog to permit long developing times is to cut down the brightness of your safelight by shielding it with heavy paper so that you can barely see in your darkroom. You will find that you actually need very little light in order to see well enough.

From what you have just read you can understand that you shouldn't leave unexposed Kodalith lying around on a work table. Keep it in its protective box. This also applies to printing papers.

MUDDY GRAYS AND FOOD DYE

As we've seen, an important part of the tone-line conversion process consists in coming up with a positive-negative sandwich in which the light and dark tones neutralize each other. Not so easy to do. Often you will get a sandwich in which just one or two tones don't disappear into the overall grayness. If they are a little darker than their surroundings, it doesn't matter, but lighter tones may let light

through the body of the sandwich itself (instead of just through the contours) and cause messy-looking gray tones in your print.

When you have such a sandwich take it apart and locate the areas on either the negative or the positive that account for the unwanted lightness. Then coat the areas (on the back of the film) with diluted red food dye. Since printing paper isn't sensitive to red light, exposure light coming through the dyed areas won't affect it very much, depending on the density of the dye.

Dilute the dye about 1:10 with water and apply it with a small ball of cotton or a Q-Tip. Put it on as smoothly as you can, but don't worry too much about it. The dyed areas should be a bright pink—very definitely colored. It will usually do no harm if you get too much on. Dye in the wrong places can be removed with household ammonia.

CLEARED KODALITH OR PLASTIC SHEETING

Remember that in a sandwich the negative and positive have two sheets of cleared Kodalith between them to provide a space between the images for the exposure light to slide through. You can "clear" Kodalith by simply putting it in a fixing bath. When you know you have accidentally fogged film or messed up an exposure (who doesn't?), simply clear it and use it for sandwiches. Afterward, wash it and dry it as usual.

If you have some heavy plastic sheeting, such as in notebook sleeves or dividers, you can get along without cleared Kodalith. It should cost quite a bit less, too. Use enough thickness of it to give the equivalent of two sheets of film.

WIDTH OF LINES

The width of lines on tone-line conversion prints can be controlled by the number of sheets of Kodalith in a sandwich: the more sheets, the wider the lines. It can also be controlled by the angle of the printing frame during exposure: the higher the angle, the wider the lines. However, one soon reaches an angle at which most or all of the light is reflected by the glass in the frame, so it is probably best to stick to the 45-degree angle.

TURNTABLE

You may have read articles on tone-line conversion in which it was stated that the final print has to be exposed on a moving turntable,

with the light striking it at an angle. The light source remains stationary. The turntable works well, but so does the exposure method given here.

OVEREXPOSED CONVERSION PRINTS

Overexposed conversions usually look terrible, with the muddiest, sickest-looking tones you have ever seen. Don't be dismayed if you happen to make one. Just cut the exposures and try again. Or try salvaging it with Farmer's reducer, which sometimes works very well.

EDGE BUILD-UP

When you are making film positives from flat negatives and using long developing times, you will notice that your positives are heavier than they should be near their edges—if you are doing agitation by tray tipping. The developer flows fastest near the edges of the film, thus developing them more. Cotton swab agitation should cure this. Remember, you trail a sizable wad of wet cotton over the film surface in as an erratic a pattern as possible for the whole developing time.

The chances are that a build-up of edge tone will not affect your conversion print, but there is no point in taking chances.

NOT SO EASY

This project is not as easy as some, but you can learn so much that it is well worth trying.

BAS-RELIEF

In trying to get a properly matched film negative and positive for tone-line conversion you will probably have some extras that weren't just right, but they can be used for another purpose: bas-relief.

A bas-relief print looks vaguely like a bas-relief in wood, stone, or metal—hence the name. Objects in such prints seem to have shadows along one side, creating the illusion that they are raised figures capable of casting shadows.

Again you use a positive-negative sandwich, but this time intentionally out of register—how much so depends on your taste, but you

can start with an $\frac{1}{8}$-inch gap. You simply contact-print this sandwich and, presto!—you get a bas-relief picture.

Now, for the relief we don't want a negative and positive with matched density and contrast, which is why your extras will come in handy. Usually, people like to sandwich a negative with a positive that is quite a bit thinner, which will give you a print with normal (positive) tone relationships. However, you can also do it the other way around—with a heavy positive and thin negative.

FAST BAS-RELIEF

If you would like to make a bas-relief print in a hurry, there is an easy way. Make an enlarged continuous-tone Kodalith positive and leave the negative in the enlarger. Process, wash, and dry the positive, then put it in the printing easel on top of a piece of unexposed printing paper. Now move the easel a little bit, so that the projected image and the image on the positive are slightly out of register, and make an exposure.

If you are in this much of a hurry, you might try developing the Kodalith in Dektol instead of hauling out the D-76. If so, dilute the Dektol 1:20, and it will work pretty well. Develop by inspection and figure out the optimum developing time by experimentation.

For getting the film positive and projected image out of register to the appropriate degree, put a red filter over the enlarger lens, turn on the light, and do it by inspection.

Making a good tone-line conversion may be enough to drive you silly, but a bas-relief is strictly raspberry jam. So you might just as well try it.

20 Tone-Line from the Sabattier Effect

There is a fast and easy way to make a tone-line conversion, though it doesn't always work just right. But it works often enough to make it worth a try. It utilizes the fact that "solarized" prints often have lines in them caused by solarization, or the Sabattier effect. Images can be handled in such a way that the midtones disappear, leaving only the lines.

THE GIST OF IT

You make a solarization (Chapters 2 and 12) from a color transparency that has good contrast, using Kodabrome Ultra Hard resin-coated paper. This will give you a solarized paper negative. With it you make a contact print, also on Ultra Hard, using a fairly short exposure. With such an exposure the midtones will usually drop out, leaving only black lines and possibly a few black shapes. The paper **150** negative can also be contact-printed on Kodalith film.

THE TRANSPARENCY

Kodabrome Ultra Hard (no. 5 contrast grade) doesn't have quite enough contrast for solarizations from negatives, which usually aren't very contrasty. Remember, there is a considerable contrast loss. However, transparencies usually (but not always) have considerably more contrast than negatives, so a no. 5 paper is sufficiently contrasty for them.

The best bet is a color slide that is underexposed from one-half to a full stop, though normal slides will often work all right, too. Overexposed slides are not good, because they are too flat and lack highlight detail.

A slide should be removed from its mount before it is put in the enlarger and cleaned carefully on both sides. It should be positioned emulsion (relief side) up.

Figs. 20.1, 20.2 A solarization and a tone-line print made from it by contact printing. The two-way solarization test strip for this negative is in Chapter 2; other solarizations made from it are in Chapter 12. In this solarization the linear effect is quite apparent, so that one can simply look at it and tell that it will make a good line print.

TWO-WAY TEST STRIP

Make a two-way test strip (Chapters 2 and 12), working from a transparency exactly as you would from a negative. Use the same flashing light source and flashing exposures of the same duration.

You may find it rewarding to wash and dry the checkerboard strip and contact-print it on Ultra Hard. This could give you a good preview of what you will get in your final tone-line print. However, to do the job really well you should make several prints with different exposures.

What you should look for on the test strip itself is the combination of exposures that will give you the most clearly defined lines. Usually they are found in areas with the greatest degree of solarization, or reversal.

THE SOLARIZED NEGATIVE PRINT

When you make a black-and-white print from a color transparency you get a negative image, of course. And when you solarize it it is still negative—more or less, because tones do get changed around. If you are fond of solarizations and their glorious peculiarity, you will probably like it for its own sake.

Remember that resin-coated paper has virtually no paper grain, which is why we can use it to make contact prints of high quality.

For best results it is good to make several solarized paper negatives, using different exposure combinations. Then you can be fairly sure that at least one of them will make a good tone-line conversion. Since the process is fascinating, you will probably enjoy doing it anyway.

THE TONE-LINE PRINT

With your solarized paper negative make a full-sheet contact test strip on Ultra Hard (a smaller one probably wouldn't tell you all you need to know) and process it normally. Then select the best exposure and make a final print, hoping that all the midtones will drop out, leaving only lines. But they probably won't, so we turn to bleach.

BLEACH

There is a good chance that you will get the desired lines and just enough midtones to make your picture look very scruffy. Well, drag

Figs. 20.3-20.5 A solarization, a straight contact print made from it, and a print that has been contact dodged and bleached to remove many of the nonlinear areas, thus making it a tone-line image.

out the Farmer's reducer and bleach out the offending tones post-haste, using a very strong solution. Bleaching a line print is easy, because you can tell exactly where to apply the bleach.

AN ALTERNATIVE APPROACH

Instead of starting with a color transparency and printing on resin-coated (RC) paper, you can start with a negative and use Brovira no. 6. Make a solarized image on the Brovira, then use it to make a contact print. Though this paper is much grainier than an RC paper, the grain won't show up in a line print; it simply drops out. Oddly, line prints originating from negatives are very similar to those originating from transparencies, though you can find differences if you look hard enough. In terms of print quality, the images are also about the same.

IT'S DIFFERENT

A tone-line print made with the Sabattier effect will sure enough look like an ink drawing, but it probably won't look much like one made in the standard way, with a positive-negative sandwich. I personally prefer the Sabattier print—perhaps for the extra bit of strangeness it shows.

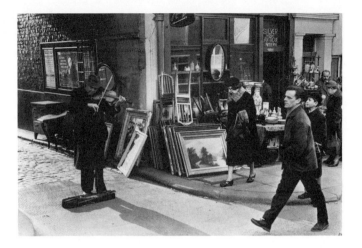

21 Duplicating Film

Usually when you print a negative you get a positive and when you print a positive you get a negative. It would seem to be one of the laws of photography, but it's not. There happen to be materials with which you can go from negative to negative or from positive to positive. A duplicating film is such a material, and one can use it with very ordinary exposure and processing procedures.

There is another way of doing it, called reversal processing, that I will describe briefly in order to emphasize the beautiful simplicity of using a duplicating film. You can print an image on an ordinary film like Panatomic-X and reverse it, which is a bit of a hassle. Using a special reversal-processing kit you carry it through the following steps: image exposure, development, bleaching, uniform reexposure, second development (redevelopment), fixation, washing, and drying. The shortcomings of the process are the very caustic bleach, a lengthy processing time, and the fact that it won't work well on many films.

With a special duplicating film the procedure is much simpler and **155** employs ordinary film-processing chemicals: developer, stop bath,

and fixer. The type that I have personally tested and found excellent is Kodak High Speed Duplicating Film 2575, which I will refer to as 2575. It makes fantastically good duplicate negatives and positives.

THE PURPOSE OF 2575

The film is manufactured especially for making duplicates from line and halftone negatives and positives. Thus the usual 2575 print has only blacks (in the form of lines, dots, or areas) and clear areas. Apparently, no special provision was made so that it would record midtones faithfully and thus be useful for making continuous-tone duplicates.

Luckily, 2575 nevertheless *does* record midtones extremely well and is an excellent material for making very-high-quality duplicates from continuous-tone negatives and positives—for example, from ordinary film negatives or color transparencies. Indeed, the quality is so good that it is difficult, if not impossible, to tell the difference between a print made with an original negative and one made with a 2575 duplicate negative.

A BACKWARDS FILM

With an ordinary film the areas receiving the most light during exposure come out darkest. For example, a white object comes out dark, a black object white (or clear). The tones are reversed, giving us a "negative." However, with 2575 the tones are *not* reversed. White objects come out white (clear), while black ones come out black. And light grays come out light gray, while dark grays come out dark gray.

Though it has a very low ASA speed, you can actually use the film in a view camera and come out with positive images. Our main use for it, however, is in the print lab. Here the important thing to grasp is that light image tones seen on the focusing paper will come out light in a print made on 2575 film, while dark ones will come out dark.

From what you already know about photosensitive materials this is exactly backwards. You would expect lots of exposure to give you dark tones and little exposure to give you light ones, but 2575 gives you the opposite of this. Indeed, an area with no exposure at all will come out dead black.

The principle of 2575 seems to be based on true solarization (not the Sabattier effect), in which we find that a photosensitive material that has received a massive exposure may reach a point where the

latent image begins to disappear. With the small exposures ordinarily used, the latent image gets progressively stronger, but with very large exposures it may reach a point where it starts getting progressively weaker until it disappears altogether. This is apparently what happens with High Speed Duplicating Film 2575.

When you purchase the film it has already been exposed to non-image-forming light, so that if you develop it without further exposure, it will come out dead black. If you make a test strip with it, the sections will get progressively lighter with exposure increases—the exact opposite of what one would expect.

SPEED AND TEST STRIPS

Kodak 2575 is quite a bit slower than most contemporary enlarging paper. You can easily compensate for this slowness by stopping

Fig. 21.1 A test strip made on Kodak High Speed Duplicating Film 2575, with the enlarger lens set at *f*/5.6 and 10-second exposure increments. Oddly, the darkest areas represent the least exposure, which seems to be entirely backward. This happens because the film was thoroughly preexposed by the manufacturer, so that what you see here is a solarization effect (in the correct meaning of the term) or a reversal.

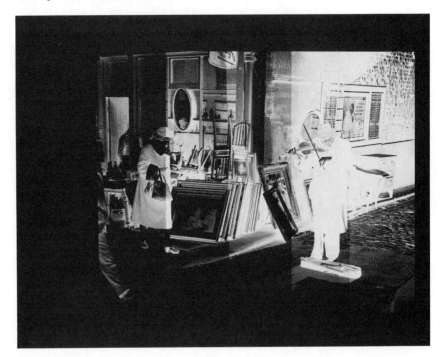

down no more than two stops and giving longer exposures, up to a minute or so if necessary.

For your test strips use 10-second exposures, which will give you a range from 10 seconds up to 70 or 80. When you interpret the test strip remember that the darkest sections represent the *least* exposure.

The duplicating film is slow, true enough, but by no means the slowest photosensitive material available—so don't worry about it. You will probably find yourself using exposures ranging between 30 seconds and 1 minute, which is certainly nothing to get unduly concerned about.

CONTRAST AND DEVELOPMENT

The contrast of 2575 is quite high, but not as high as Kodalith. However, it is a good deal more contrasty than ordinary films like Plus-X, Tri-X, and Verichrome Pan. Thus in order to make good continuous-tone duplicates from either ordinary negatives or color transparencies, you will have to reduce the film's built-in contrast somewhat. This can easily be done by using a fairly low-contrast developer like D-76 and a relatively short developing time.

Fig. 21.2 An 8 x 10-inch negative made with 2575 film, with a 30-second exposure at *f*/5.6. Though the film behaves in a very peculiar way, the negative is of splendid quality and impossible to distinguish from any other high-quality negative.

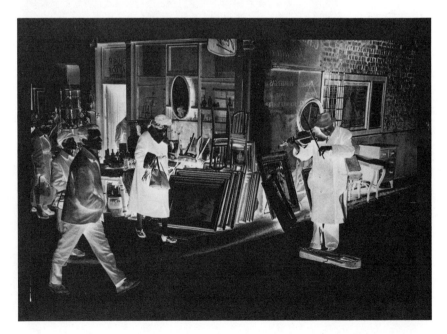

Kodalith developer is usually recommended, but that is for high contrast; it is used at 68F for the recommended time of $2\frac{3}{4}$ minutes, with constant agitation. This would give you too much contrast for a duplicate continuous-tone image. However, if your original image, negative or positive, is very flat, the extra contrast might be welcome.

To lower the contrast to about the average amount use D-76 diluted 1:1 at 68F for $4\frac{1}{2}$ minutes, with constant agitation. Starting with a normal-contrast original negative you will end up with a normal-contrast duplicate negative, though there may be a slight contrast increase. The increase is all right, because most regular negatives are just a little on the low-contrast side anyway.

To increase the contrast in D-76, increase the developing time—up to 10 or 15 minutes if need be. To decrease it, cut the time to as low as 3 minutes. Remember that for longer times the safelight should be shielded.

SAFELIGHT

You can work under a G.E. $7\frac{1}{2}$-watt (BMS) round red bulb. If you have a Kodak bullet safelight, use either an 0A (greenish yellow) filter or, for optimum safety, a 1-A (light red).

EMULSION UP OR DOWN

Ordinarily, we expose photosensitive materials under the enlarger with their emulsions up. You usually do this with 2575 too, but you can also expose emulsion down, in which case the exposures must be approximately doubled. You can get the same image reversal by putting the original negative emulsion up in the enlarger, so there is not too much point in exposing emulsion down. In the graphic arts, however, there are times when you have to do this.

ENLARGED OR CONTACT

To contact-print a negative on 2575, put it emulsion down on 2575 which is emulsion up, cover with glass, and expose with the enlarger light. If you like, you can contact-print a whole roll this way on a single sheet of 8 x 10 film, then cut out the individual strips and use them in your enlarger. They should be printed emulsion down. The copy negatives should be put in the enlarger emulsion up.

To make an *enlarged* duplicate put the original in the enlarger emulsion up. Thereafter it is like making a paper print, except that

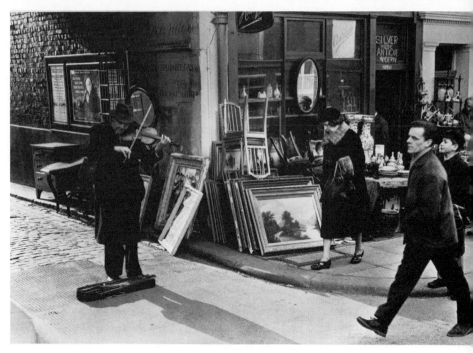

Fig. 21.3 A straight print made from the 8 x 10 High Speed Duplicating Film 2575 negative in Fig. 21.2. The negative is of such fine quality that it would be hard to distinguish between this print and one made by enlargement from the original negative.

the developer is D-76. And the tones don't come out reversed, of course.

PRINTING ENLARGED NEGATIVES

If you have an enlarger that will take 4 x 5 or larger negatives you can use small negatives (e.g., 35mm) to make enlarged duplicates to fit it. The reasons for having larger negatives will be made clear in a moment.

Enlarged duplicates up to 8 x 10 and larger can be printed by contact, usually with the aid of a glass plate to assure good contact. However, if the duplicate and the enlarging paper are lying very flat you can sometimes get by without the glass by merely putting both in the printing easel. The masking leaves of the easel may have sufficient weight to hold them in good contact. As you read earlier, glass collects dust (on both sides), which shows up in prints. Your enlarged duplicate collects dust on both sides, too, so you see that you have to work clean, with or without the glass.

SOME USES FOR DUPLICATES

It is interesting to make direct duplicates just to see that it can be done. It is also surprising to see a film working backwards when exposed, the way 2575 does. However, most people would want more reasons than these for making duplicates. Satisfying curiosity is not enough.

Say you have to send some of your best negatives somewhere and are not sure of getting them back. Make duplicates. And say you are a teacher and would like all your students to print the same negative. Have them print duplicates.

What if you wish to retouch 110 or 35mm negatives, which are much too small to work on? Make enlarged duplicates and retouch those instead. With larger negatives you can mask out backgrounds with black paper or opaque, etch, bleach, pencil, color with red dye, scratch in lines, and so on. You can make a duplicate large enough to really see what you are doing with it.

Fig. 21.4 A print made from a duplicate negative that was partly melted by holding it over a gas flame to see what creative effects might result. The negative was first printed in the ordinary way, then photostatted to reverse the tones. If you have a hankering to creatively brutalize negatives, you had better work with duplicates and leave the originals unscathed.

What if you wish to physically or chemically change a negative around but are reluctant to run the risk of destroying an original negative. Make a duplicate to experiment with instead. You can make more than one, of course, and try more than one experiment with the same picture.

You might use duplicates if you wanted to cut up negatives and splice them together again in new ways. Or you might want to cut a "window" in a negative and fit a piece from another one into it. Heat will do interesting things to negatives, too, as will abrasives, chemicals such as lye, and so on. But you don't really want to try such things at the cost of good original negatives—so try them on duplicates.

Say that somebody wants to try printing some of your negatives and you are aware of the risk that involves. Give him or her some duplicates to play with, either the same size or enlargements. Then if your negatives get ruined, which sometimes happens, your originals will be safe and sound.

ALTERNATIVE METHOD

Though it is nice to have a special film that will produce direct duplicates, you can get along very well without one and still make all the duplicates you want. For example, you can use Kodalith film and continuous-tone development (3 minutes in D-76 1:1 at 68F with constant agitation). From an original negative you make a film positive and from the positive make a final duplicate negative. This is the way duplicates are usually made, in fact, though Kodalith is not the film ordinarily employed. It makes excellent duplicates, however, and can be used for many other things as well.

The only problem with this alternative method is that every step you take (from negative-to-positive-to-negative-to-positive etc.) causes a certain amount of degradation of a continuous-tone image, and it all adds up. By using 2575 film and just one step (negative-to-negative) you lessen the potential degradation. With Kodalith and an intermediate film positive there would be very little degradation, but you could find it if you looked hard enough. It would show up in the highlights, which might look a tiny bit flat or dingy.

22 Photographic Silk Screen Printing

A silk screen print is made on paper, cloth, metal, wood, or plastic by using a squeegee to force a thick ink through a gelatin image embedded in fine silk that has been stretched on a wooden frame. There are many ways of getting images in the silk, but we will take up only the so-called indirect method, which is easy enough to do and quite practical. To keep the description sufficiently simple, the other methods will not even be mentioned as we go along. For the same reason we will stick to materials manufactured by the Ulano Company, which is very well known in the silk screen field.

THE GIST OF IT

A positive photographic image on film, either a line cut or a halftone, is contact-printed on a special silk screen film, which consists of a dried jellylike substance coated on a thin transparent sheet of vinyl or polyester. This substance may consist of gelatin, albumin (egg

white), or glue in which is dissolved either potassium or ammonium bichromate, both of which are light-sensitive. There is also a colorant, such as green, to help you see the image better.

The bichromate will make the film coating harden, or toughen, when it is exposed to light. The parts of the coating that haven't been hardened by light will soften in warm water and float away, leaving only the hardened image on the film support. The contact-printing procedure requires a very bright point light source, such as a carbon arc or a metal halide lamp, though a no. 2 photoflood will work fairly well.

After the silk screen film has been exposed (through the back) it is put in a special developer that will further toughen the exposed parts of the image. Then the image is made visible with a "washdown," done by directing a gentle spray of warm water onto the emulsion until the unhardened parts have softened and washed away. The picture can now be clearly seen.

While still wet, the completed image is transferred to the framed silk, dried, and its plastic backing peeled away. The dark parts of the image seal the silk so that no ink will pass through, while the light parts will let it through.

Printing consists of forcing heavy ink through the unblocked portions of the silk mesh with a squeegee that has a hard rubber or plastic edge. Different inks are used for different materials.

THE FRAME

You can make a silk screen frame of lengths of $\frac{3}{4}$ x $2\frac{3}{4}$ clear pine, screwed, nailed, or glued together at the corners. It should be sturdy enough so that stretched silk won't warp it out of shape, but it doesn't have to be a fancy carpentry job. To make it easier to handle the ink and the squeegee, the inside dimensions of the frame should be quite a bit larger than the images you wish to print. Leave at least 3 inches of clear space on each side of a picture.

STRETCHING

The fine-mesh silk that you use is made specially for silk screen printing. There are also synthetic fiber meshes, even metal ones, but you had better stick to silk, which is excellent.

Professionals use special stretching devices with measured tension, but you can do the job quite well by hand, affixing the silk to the frame with staples or carpet tacks. Use an abundance of staples or

tacks (on the screen side of the frame) and stretch the silk good and tight.

PREPARING THE POSITIVE

Perhaps the easiest kind of positive to prepare is a high-contrast, or line cut, image on Kodalith (see Chapter 17). If you start out with a color transparency that has good contrast, you can often get a good line negative with your first Kodalith print. Then you contact-print it to get a good line positive.

If you start with a negative, your first result will be a Kodalith positive, but it may have too many midtones. In this case you will have to make intermediate film positives and negatives until the midtones drop out, which is easy enough to do, though it takes a little time.

Though considerably more difficult to do, tone-line positives also work well for silk screen printing. Review Chapter 19 to see how they are made. The description there tells how to get positive tone-line images on printing paper, but you can use Kodalith instead. Except for using Kodalith Developer, you can follow the same instructions.

As you read earlier, tone-line conversions may come out as images made of lines, or dots and larger black areas, or a combination of both. Any of these can work for silk screening, provided the images consist entirely of blacks and clear areas and the dots are fairly large.

With some original negatives that are grainy or are enlarged considerably you can make Kodalith positives that come out as halftones. When viewed from a distance they look like continuous-tone images, but when you examine them with a magnifier you can see that all the grain has been converted into black dots and clear spaces. Provided the dots are sharp, strong, and fairly large, such a positive will be good for screen prints.

You can make regular halftones with a Kodak Magenta Contact Screen, which is a magenta-colored piece of plastic sheeting with a pattern of clear dots printed on it. You use it when you are enlarging a negative onto Kodalith. You put the screen, pattern side down, on top of the film, cover it with glass, and make an exposure. The light coming through the colored parts of the screen doesn't affect the film, which is insensitive to magenta light. And the light coming through the dots converts the image into dots, which come out black when the film is developed in Kodalith Developer.

Remember that the relative fineness of a screen is described in terms of the number of lines or dots per inch. A 150-line screen would be quite fine, a 40-line screen coarse. Experience has shown

165

that screens ranging from 65 to 100 lines are best for silk screening, though you had better stick with 65 lines until you really know what you are doing. For many pictorial purposes it is quite fine enough.

Kodak makes a very useful film called Kodalith Autoscreen Ortho that has a halftone screen built right into it, so to speak. This film has a very-high-contrast emulsion that has been preexposed to a halftone screen. The latent image of the screen adds to the image projected by the enlarger, creating a fine halftone-dot pattern after development in a high-contrast developer. This pattern is 133 lines per inch, which is much too fine for most silk screen work. Fortunately, it can be enlarged.

Say you wish to make an 8 x 10 screen print with a 65-line dot pattern. Make an initial 4 x 5 enlargement on Autoscreen, which will come out positive. Put the positive in your enlarger and use it to make an 8 x 10 print on Kodalith, which will come out negative. Then contact-print this negative on Kodalith to get the halftone positive needed for exposing the silk screen film. In all cases, use Kodalith Developer. Your positive will have about the right number of dots per inch.

If you don't have a 4 x 5 enlarger, there is another way of doing it. Tape the 4 x 5 Autoscreen positive to a light box and mask off the area around it with black paper. Then photograph it with a 35mm camera loaded with Kodalith. Bracket your exposures to be sure of getting the correct one. Read the light from the light box itself, divide the reading by 5, and set the result on your meter. This should give you the correct exposure, but we can't be too sure. Therefore, make overexposures of one, two, and three stops and underexposures of one, two, and three stops. One of these should come out right on the button, and you can use it for making your 8 x 10 halftone Kodalith positive.

For 35mm Kodalith film use Kodalith Developer at 68F in a rollfilm developing tank, with a $3\frac{1}{2}$-minute developing time. Agitate for 5 seconds every 20 seconds.

Kodalith Autoscreen Ortho should be developed in Kodalith Developer at 68F, the best results being produced by still development, which goes as follows:

1. Before putting the film in the developer tray, agitate the solution vigorously for a few seconds. Then immerse the film, emulsion side up, and agitate by tray tipping for 2 minutes. Then allow the film to lie perfectly still on the bottom of the tray for an additional minute. Any movement of the film or developer during the still period may produce streaks.

2. At the end of the 1-minute still development (total time 3 minutes), drain the film quickly and put it in the stop bath for about 10 seconds.

3. Transfer the film to a regular fixer for about 2-4 minutes, or to a rapid fixer for 1 or 2 minutes. Wash and dry.

DEGREASING THE SILK

Brand-new or used, silk must be degreased, or washed, every time a stencil, or gelatin image, is to be adhered. Wet both sides of the screen with cold water and sprinkle them with Ulano Screen Degreaser. Or you may use powdered trisodium phosphate or an automatic-dishwasher powder, such as Finish, Cascade, or Calgon. These compounds are mixtures of alkaline salts, which are water-soluble and rinse-free. Now, using a soft brush, thoroughly scrub both sides, then rinse the screen very thoroughly with a forceful spray of water. Allow the screen to drain and dry.

EXPOSING THE SILK SCREEN FILM

Use Ulano Super Prep, a presensitized screen process film. If Ulano supplies aren't available locally, write Ulano, 210 East 86th Street, New York, N.Y. 10028. Super Prep is used by both amateurs and professionals and is very dependable. It comes in rolls packed in 41-inch tubes, which means that you have to cut it to get the sizes you want.

Super Prep does not require a darkroom, but the film should be protected from sunlight and ordinary fluorescent tubes. Yellow fluorescent tubes and yellow tungsten "bug lamps" permit very long exposure of the film.

Your film image is contact-printed onto the silk screen film. Good contact is assured by covering them with a heavy plate of glass or a glass sandwich. Better contact can be made with a contact-printing frame, and the best contact with a vacuum frame. For line positives with no fine detail the glass will work fine, but for halftones and finely detailed images the printing frame is advisable.

The silk screen film, often called the "resist," is exposed through the back. That is, the emulsion (dull) side faces away from the film positive. If you should accidentally expose the wrong side, the emulsion will all come off during the washdown in the form of a scum.

For exposing Super Prep it is desirable to have a high-intensity point source of very actinic light. The best light sources are carbon arcs or metal halide lamps, followed by high-pressure mercury vapor, pulsed xenon, and quartz iodide lamps, none of which you are likely to have. If you can't afford a small quartz iodide lamp (the cheapest thing on the list), you will have to settle for a 500-watt photoflood. Though far from being a point light source, it works fairly well.

Assuming that you are restricted to a photoflood, it should be positioned about 3 feet from the printing frame; use it without a reflector. The exposure time should be about 1 hour, which is long. The light is hot, so keep the printing frame cool with an electric fan.

Fig. 22.1 A setup for exposing silk screen film with a Kodalith positive: a rubber mat, a heavy glass plate, and a 500-watt photoflood bulb 3 feet from the film. With Ulano Super Prep film the correct exposure is about 1 hour, which shows that the film is very slow. The bulb is used without a reflector to make it work more like a point (extremely small) light source, which will print very fine detail. In this respect (or in brightness) the photoflood is not nearly as good as a carbon arc, but it works very well for many types of pictures. The black rectangle in the background is merely the darkroom window blacked out with roofing paper.

To get the correct exposure you should make a full-sheet test strip, using a series of 10-minute exposures. Then develop the film and wash it down. In underexposed areas the details will be washed away or weak. In overexposed areas the details will bleed together and the emulsion will be so hardened that it won't adhere well to the screen. As in many photographic processes, the test exposure area that *looks* best will probably *be* best. Once you have learned the correct exposure for the light source and light distance you are using, you can use the same exposure for other pictures.

To get thoroughly sorted out on the exposure problem as quickly as possible it would be a very good idea to adhere your very first test strip to a screen, then go ahead and print it. This means degreasing the screen again before making a final print, which takes some time, but you will find it well worth the bother.

DEVELOPING THE PHOTOSTENCIL FILM

The correct developer for Ulano Super Prep is Ulano "A" and "B" Powder, available in premeasured sets for mixing pints, quarts, and gallons of developer liquid.

You prepare the developer by pouring a foil pouch of powder A into a measured amount of water and stirring it until it is thoroughly dissolved. Then powder B is added and stirred. The water temperature should not be over 75F.

Put the film in the bottom of a tray and quickly pour developer over it, using enough to cover the film. Rock the tray occasionally during the development. The developing time for Super Prep is 90 seconds.

In using this developer, stick to the following rules:

1. Keep the temperature between 64 and 75F.
2. Protect it from strong light, which will decompose it.
3. Mix a fresh developer every day. Do not bottle and save used developer, because it forms a strong gas.
4. If the emulsion wrinkles up or floats off the polyester support during the washdown, it may indicate that the developer was spoiled, too warm, or too cold. Exposing Super Prep through the emulsion side will also cause this.
5. Use a clean developer tray.
6. If the developer turns brown, discard it, for that is a sign of decomposition. It will normally turn yellow when film is put in it, but this is all right.

WASHDOWN

Place the exposed and developed film on an inclined flat surface to allow the wash water to run off. Use water at a temperature from 92 to 100F. Flood the stencil with a gentle spray of water, using lots of it, until all the green color is removed from the unexposed areas—then continue spraying for another 15-30 seconds. Finish by rinsing with cold water.

If lack of sufficient warm water makes tray washing necessary, change the water twice. Then finish up with a running cold water rinse.

Further suggestions:

1. Put an aerator nozzle on your washdown hose. It will break the force of the water and protect fine details.
2. Be sure to wash the whole surface of the film, even where there is no image.
3. Do not underwash, for it can cause scum or traces of emulsion in printing areas. The cold rinse also helps prevent scumming. Overwashing rarely causes a problem.
4. The best way to chill the stencil to prevent scum is to gradually lower the water temperature while continuing the wash.

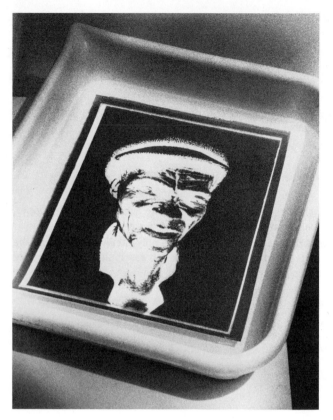

Fig. 22.2 After the silk screen film has been exposed and developed it is cleared, or washed out, with warm water, which dissolves the portions of the gelatin unhardened by light and development and washes them away. At this point the image appears, as we see here. For the washout, or washdown, most people prefer a gentle spray of water, but you can also do it by rocking the film in a tray of warm water, changing the water about three times. After the washdown the film is chilled in cool water.

After sufficient washing the image will look like a colored high-contrast Kodalith negative, with only solidly colored areas or dots and clear areas. It should be very easy for you to see when all the details have been cleared out with the warm water.

ADHERING THE FILM

The chilled, wet stencil is placed emulsion side up on a flat build-up, which is a raised surface, slightly smaller than the inside of the frame, and covered with newsprint or vinyl. Since the build-up should be kept very clean, glass makes a good one. Then you carefully lower the cleaned screen, squeegee side (the side you put the ink on) up, onto the stencil. *Do not use excessive pressure!* In nearly all cases the frame weighs enough to cause complete contact, and the build-up helps in this.

Excess moisture is removed from the stencil by blotting with newsprint. Do this by gently wiping over the newsprint with your fingers. *Do not rub! Blot!* Keep changing the newsprint until a sheet

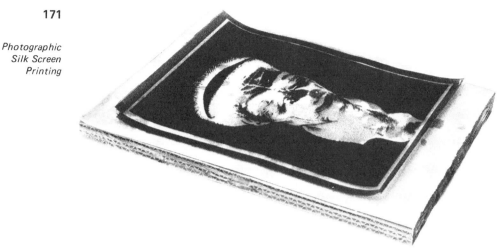

Fig. 22.3 Immediately after washdown and chilling the silk screen film is laid face up (emulsion up) on a sheet of newsprint positioned on a build-up so that it can be adhered to the silk screen. This build-up is made of three sheets of corrugated cardboard covered with plastic food wrap. The splotchiness of the image is due to the water under it.

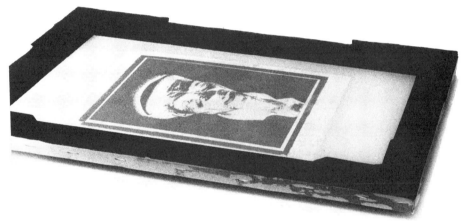

Fig. 22.4 The stretched silk is lowered onto the still-wet image. This should be done without pressure, for the gelatin image is very fragile until dry, and the weight of the frame itself is sufficient to guarantee good adhesion between the image and the silk.

stays dry and picks up little or no green color. This will require four or five sheets.

Avoid dust at all times. Have the screen ready to adhere to the stencil as soon as the stencil is placed on the build-up. The screen should be freshly cleaned just before the stencil is washed down. If

Fig. 22.5 As soon as the stretched silk has been lowered onto the silk screen film the excess water is gently blotted (not rubbed!) with sheets of newsprint. The dark spots in the picture are from water droplets.

this can't be done, rinse the screen and let it drain just before washing down the stencil.

The best adhesion is obtained by adhering right after washdown.

Use only newsprint (unprinted newspaper stock) for blotting. If you use newspapers, the ink may cause problems.

Undue pressure while blotting, either on the frame or on the newsprint, will push the silk threads into the emulsion and cause pinholes, which will print. The displacement of the emulsion by the threads can also cause sawtooth edges.

The washed-down and chilled stencil is preferably adhered to a freshly cleaned damp screen. This avoids contamination of the fabric with airborne dust. It also helps in adhesion.

DRYING THE SCREEN

After adhering, it is best to leave the screen undisturbed on the build-up for at least 5 minutes. After that you can speed up drying with an electric fan, but don't use heat, for it can result in poor adhesion.

When the fabric is dry—but before the emulsion is completely dry—you can fill in the areas of the screen surrounding the picture with Ulano no. 60 Blockout, which will prevent the silk screen ink from getting through and making a mess around your prints. Put the blockout solution on the emulsion side of the screen, going right over the polyester stencil support. The blockout filler will dry along with the stencil.

When the filler and the stencil are completely dry, it is time to pull off the polyester backing sheet. The correct peeling technique is to pick up a corner and pull the polyester back over parallel to the fabric. It should pull up very easily, almost fall off by itself. If there is resistance, dry the screen a while longer.

Part of the adhesive that laminates the emulsion to the polyester support will be left on the emulsion. Remove it by washing the film side with a soft rag wet with naphtha, benzene, xylene, toluene, or carbon tetrachloride.

Fig. 22.6 Right after adhering the film let the screen sit on the build-up for 5 minutes. Then you can turn the frame over and apply blockout solution to the open areas of the silk with a piece of cardboard. You can bring it right up over the polyester backing of the film, for it will be peeled off after the gelatin image has dried. Some blockout solution will go right through the silk and hang in droplets from the other side; this should be scraped up with cardboard.

BLOCKING OUT

As we've seen, blockout can be applied to the emulsion side of the screen before the film support is peeled off. Spread it with the edge of a piece of cardboard. Let it dry thoroughly after the first coat, then apply another. The second coat should be completely dry before the screen is inked, or the ink and blockout will mix together to form a compound very hard to get out of the screen.

RETOUCHING

You should start with a thoroughly retouched film positive, the blacks retouched with opaque and the clear areas with Farmer's reducer or Chlorox. On the gelatin stencil you will probably find pinholes in the green areas due mainly to dust. After the polyester support has been peeled off, fill them in on the emulsion side of the screen with blockout using a small brush.

Small defects in clear areas can be scraped off during washdown with a wooden stylus ("orange stick") such as manicurists use for cuticles. Or you can make your own stylus from a wooden pen holder.

PRINTING

You print an image by using a squeegee to force inks through the areas of the silk mesh that have not been blocked by the gelatin portions of the stencil or by blockout compound. Squeegees come in three degrees of hardness—get the hardest kind. It will make sharper images, require less squeegee pressure, and be best for printing halftones and tone-line conversions. It should be about an inch wider than the narrowest width of the prints you wish to make.

A good grade of drawing paper makes a satisfactory surface to print on. By experimentation, however, you may find a number of papers that work quite well. Just try whatever paper you happen to have.

Before starting to print, work out some system to keep the frame from sliding when you drag the squeegee across the silk. Clamp it to the table edge, butt it against a strip of wood nailed to the table—or something.

To make your print, lower the silk screen onto the printing paper, getting the image centered well. One of the narrow sides of the picture should be closest to you. Above the narrow side opposite you ladle out a line of printing ink that extends beyond both sides of the image. There should be a lot more of it than you think you will need for just one print.

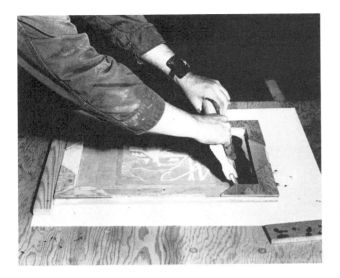

Fig. 22.7 Getting ready to print a picture for the first time by making a pass with the squeegee, which drags the silk screen ink across the image and forces it through the open portions of the silk. This is a very messy business, best done in the garage while wearing old clothes.

Holding the squeegee at an angle of 45 degrees to the screen, put it behind the long puddle of ink. Hold it with both hands and exert firm and steady pressure. Now use it to draw the ink all the way across the image area onto the blockout at the other end with a single sweep. Exert uniform and steady pressure against the rubber edge all the way across.

By making a few test prints you will discover the amount of ink you need and the suitable amount of squeegee pressure. Don't use more pressure than you need.

After you have made quite a few prints you may find that your screen is beginning to block up from dried ink. To prevent this, you can use a commercial antidrying agent called Dri-Kill, which is available in aerosol cans and is simply sprayed on. With it you can open the mesh without damaging the screen or the gelatin image.

DRYING THE PRINTS

Lay your prints out on flat surfaces until dry, which doesn't take very long with most inks. Before stacking them up, test them to make sure they won't smear.

RECLAIMING THE SCREEN

If you clean a screen correctly, you can use it for printing many pictures, for the silk is very strong and durable. But you do have to get it very clean indeed. Scrape up the bulk of the excess ink with a piece of cardboard, then clean off every bit of the rest of it with lacquer thinner. Let the thinner dry.

Clean out the blockout with a stream of cold water.

Fig. 22.8 A silk screen print that originated as a positive color transparency.

Remove the Super Prep gelatin image with Ulano SPC Enzyme. Wet the fabric on both sides and sprinkle the enzyme on them. Next, cover the screen with a squeezed-out wet rag and let it stand for 5 minutes, then hose off the stencil with hot water. After cleaning out the gelatin from the stencil with the enzyme it is necessary to completely inactivate the remaining enzyme so that it won't attack the silk and the next stencil. Do this by wiping the screen with white vinegar or 5 per cent acetic acid. Then rinse the screen thoroughly with cold water. The fabric will then be ready for the next stencil.

Some printers clean their screens with Chlorox, followed by a thorough scrubbing with Ajax cleanser.

COLORS AND SOLUBILITY

There are many silk screen ink colors, so you can print your pictures in just about any color you like. Most inks are not water-soluble, but some are. You'd better stick to the ones that are not: the

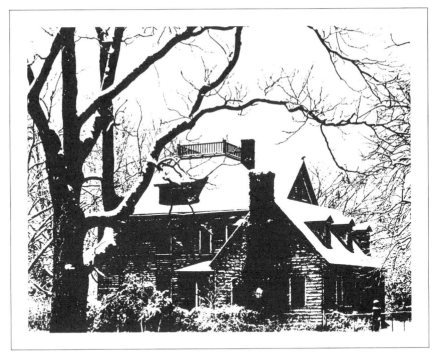

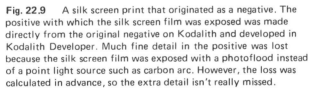

Fig. 22.9 A silk screen print that originated as a negative. The positive with which the silk screen film was exposed was made directly from the original negative on Kodalith and developed in Kodalith Developer. Much fine detail in the positive was lost because the silk screen film was exposed with a photoflood instead of a point light source such as carbon arc. However, the loss was calculated in advance, so the extra detail isn't really missed.

Fig. 22.10 A silk screen print that originated as a color transparency. It was converted into a solarized print, then contact-printed on Kodalith to make it into a tone-line conversion, which was used to expose the silk screen film.

instructions in this chapter assume this. Water-soluble inks require a slightly revised technique.

MULTICOLORED PRINTS

You can print as many different stencils as you like on a given piece of paper, each in a different color, and this is often done. Perhaps the easiest multicolor silk screen print to make is a poster (Chapter 18), using two or three high-contrast Kodalith positives.

You can also make single- or multistencil prints on different colors of paper, and there are numerous colors available.

PRINTING SURFACES

You can make silk screen prints on just about anything that will accept ink—paper, cloth, wood, metal, and so on. However, different surfaces require different kinds of inks, so be sure to tell your supplier what you intend to print on when you buy your materials. He would give you one kind of ink for cloth and quite a different one for paper, and still another kind for metal.

As you have surely seen by now, making a silk screen print is not so very hard to do, though there are a lot of things to keep track of. This chapter should help you in this.

Fig. 22.11 The solarization (on Kodabrome Ultra Hard) used in making the tone-line image for the silk screen print of the girl (Fig. 22.10).

23 Masking

Masking means several things. One of them is to cover part of an image with something in order to protect it from light, developer, bleach, dye, or paint. Another is to superimpose two film images in order to raise or lower the contrast of one of them.

FILM MASKING

Film masking is most often used in color printing and engraving, where one or more black-and-white film images are superimposed on a color transparency in order to lessen its overall contrast, increase its highlight contrast, or both. The overall lessening of contrast is made necessary by the fact that the tonal range of a typical transparency is too great for many printing processes.

In black-and-white work a negative may be flattened to make it fit an available contrast grade of paper. This may be necessary if you have only one grade to work with (some types of paper come in only one grade) or your negative is too contrasty for any paper on the

Figs. 23.1-23.3 A straight print made from a flat negative, another print made on the same contrast grade of paper after the negative was highlight-masked, and the highlight mask itself. The advantage of increasing print contrast by highlight masking is that you don't lose any shadow detail, which would happen if you used a higher contrast of paper instead of masking. Though the original negative had little shadow detail, it is all still there in the masked print. The mask itself is rather heavy, incidentally, and you can see that it really boosted the highlight contrast. Its effect could be lessened by bleaching it in Farmer's reducer.

market, which sometimes happens. Sometimes this flattening is made necessary by the scientific need to make everything in an image as visible as possible, ignoring the pictorial effect.

For everyday masking needs, Kodalith works very well (review Chapter 17 on this film), and it can be used either for continuous-tone masks or high-contrast ones. You can work either with enlarged film images for contact printing or with 4 x 5 images for projection printing.

Though positive film images can be flattened by masking, you will usually work with negatives, so we will stick with them for a while. The procedure is simple enough. Using a contact-printing frame you contact-print your negative on film and develop in D-76 1:1. Ordinarily, what you want is a film positive that is quite a bit lighter than the negative. When the negative and film positive are super-imposed, the drop in contrast will be proportional to the density and contrast of the positive. As you can see in Chapter 19 on tone-line conversions, the contrast can be nearly eliminated entirely, but this is going too far for most purposes.

Now, getting good registration of the negative and the positive may be a problem, but this can be solved by making the positive mask slightly diffused, which you can do while you are exposing it. You merely slip one or two sheets of fine-grain matte acetate (such as a Kodapak Diffusion Sheet) between the negative and the film before you make your contact print. Oddly, the diffuseness of the mask will not affect the apparent sharpness of the prints you make, either enlarged or contact, with the negative-positive sandwich.

Unlike a mask made for reducing contrast, a contrast-increasing mask is negative instead of positive. So is a highlight mask, for it increases contrast in the highlight areas of prints. It is best to make a contrast-increasing mask from a positive transparency that has a bit more density than we would consider just right for a negative. This negative mask can be a bit on the thin side, but it should have quite a bit of contrast, depending on how much additional contrast you need.

You can control the contrast of film images by the developing time and the type of developer used. You can get quite a bit of contrast from Kodalith in D-76 1:1 by developing up to 15 or 20 minutes at 68F, but you can get even more out of Kodalith Developer in 3 or 4 minutes.

Often there is not much point in using masking for a general contrast increase, because it is easier to make a duplicate negative and simply develop it for the degree of contrast desired. But highlight masks are another matter, because they will do things that can't be done in any other way. A highlight mask will increase contrast in only the highlights of a picture, which are often flat, leaving contrast elsewhere unchanged.

A highlight mask is contact-printed on high-contrast film from a film positive, given such a short exposure that only the highlights will

Figs. 23.4-23.6 A straight print, a masked print, and the highlight mask that was used. The masked print was made by posterization, which is essentially a masking technique. It was included to show the effects of a highlight mask of extremely high contrast; as you see, most of the whites (which were highlight-masked) have very sharp edges.

appear on it, and developed in a high-contrast developer. With such a short exposure there would normally be hardly any contrast at all, which makes necessary the high-contrast film and development. Even so, a good highlight mask doesn't look especially contrasty. Indeed, there is so little density on it that it hardly looks like a negative at all. For color work a special masking film is used, but Kodalith works fine for black-and-white.

PENCIL, DYE, SILVER, AND PAPER MASKING

Elsewhere in this book there is information on pencil dodging on printing paper, matte acetate dodging, dye retouching, and contact dodging with paper cutouts, all of which are masking procedures. So is the Emmerman process (Chapter 25), which involves an automatic mask made of silver. Ordinary dodging and chip dodging are masking techniques, too.

LOCAL MASKS

With enlarged negatives made for contact printing it is not too hard to make local masks. Such a mask, usually a diffuse positive, would mask part of a negative and leave the rest unmodified. Part of the mask will have a silver image, while the rest will be clear film.

The usual situation is that you have a picture embodying some kind of an object and a background and you wish to modify the background. Using positive masks, it can be made flatter with a mask of medium density or flatter yet and lighter with a heavier mask. With a very heavy mask it can be made to print white.

Following is one procedure for making a diffuse local mask for a large negative:

1. Put your negative on a light box and make a tracing of the object that is to remain clear on your mask. Draw the lines so that they fall about $\frac{1}{8}$ inch inside the outlines of the object.

2. Turn the tracing over and scribble crosswise over the lines with soft pencil. This will make the paper work like carbon paper. Turn the tracing over again and trace the lines onto thin black paper. With scissors or a very sharp Xacto knife, cut out the object, so that you have a black-paper figure.

3. To the emulsion side of your negative tape a sheet of matte acetate (e.g., Kodapak), with the matte side toward the negative.

4. Register the cutout figure and stick it to the shiny side of that acetate with a length of Scotch tape that has been looped back on itself, sticky side out.

5. Position this assembly, acetate down, on a sheet of unexposed film, emulsion side up, and cover with glass (or better yet, use a printing frame). Then make your exposure—or make a test strip, if you haven't already done so.

6. Develop your mask for continuous tone, not high contrast (see Chapter 17 on Kodalith).

7. When the mask has been developed and fixed, work on it with strong Farmer's reducer, using it to expand the contours of the clear figure into their proper position. Make the bleached contours come out soft, rather than sharp, which is quite easy to do after a short period of experimentation.

8. When your mask has been washed and dried, tape it to your negative, emulsion to emulsion, and make your prints. If the mask is too heavy, bleach it somewhat in a tray of Farmer's reducer. If it is too light, make another one.

Fig. 23.7 A picture contact-masked for bleaching. During exposure the road was blocked out with a black mask, or contact dodger. Thus there is only a small border of tone around the woman in need of bleaching, which has been started around her coat sleeve and right hand. Bleaching the entire roadway would be a very tedious business, whereas the masking was dead easy.

MASKING TAPE AND PAPER

It is sometimes good to work on dry-mounted photographs with one or more colors of spray-can enamel. This is especially good for posters, in which the eye-attracting power of color can be very important. Such a poster should be made on a fine semimatte paper, which takes the paint very well.

Large areas can be masked with paper taped down with ordinary masking tape. The tape should be rubbed down with the thumbnail for a tight seal, but you should remove it with great care so as not to tear the emulsion.

To mask a small or intricate area, cut small bits and pieces of it—curved and straight—with scissors. Take care to rub each bit down tight, or paint will get under it. Put each little bit where it fits best, and you will soon have your figure masked. You can do surprisingly accurate masking this way.

To spray a photograph, shake the spray can very thoroughly and apply two or three thin coats from a distance of about 2 feet, letting the paint dry completely between coats.

FRISKET

There is a thin translucent paper material called frisket, which has a thin coating of rubber cement on one side. It is available in artist's supplies stores, but you can easily make your own with tracing paper, rubber cement, and lighter fluid. Thin the rubber cement with lighter fluid and put two thin coats of it on one side of a piece of tracing paper.

You rub frisket onto a semimatte dry-mounted print, and it will stick quite well, though it can also be pulled up very easily without tearing the emulsion. To remove frisket from areas that aren't supposed to be masked, go around them with the point of a very sharp Xacto knife, cutting only through the frisket and not into the print. Then you put the tip of the blade under the frisket you wish to remove and pull it up. With skilled knife work you can cut around very intricate figures.

Frisket masking is often used for airbrush work, which is an art in itself. An airbrush is a small spray machine that delivers a spray of very finely divided droplets of paint. It takes quite a while to master, so if you want any airbrush work done you had better go to an expert.

If larger, more unevenly divided droplets will serve your purpose well enough, you can use a fixative blower. It is a little device that you can stick in a jar of dye or very thin paint and blow on, and a spray comes out the other end of the tube.

LIQUID FRISKET

There is a commercial product called Maskoid that you can paint on areas of photographs to mask them out for spraying. It is some kind of a rubber cement, with red dye in it so that you can see where you have applied it. When your print is dry, you simply rub the cement off with a clean cloth.

TONE AND TEXTURE SCREENS

At an artist's supply store you can find several brands of plain or textured screens that can be rubbed onto mounted semimatte prints—or portions thereof—and simply left there. A very wide variety of textures and a few tones are available. With every brand I know of you strip a thin filament of plastic sheeting that has a design on it off an oil paper support and smooth it down on your print. With one type, areas where you don't want design are cleared out by rubbing the design off the plastic with an orangewood stick. With another type you cut around an area that you don't want to have masked with a very sharp Xacto knife, then pull up the unwanted plastic with the tip of the knife.

Art store clerks are generally pleased to let you look through the great number of textures they have, because many people won't buy anything until they have done so. Well, it's quite an adventure, so you might try it some time. Stand warned, however: only a small percentage of the textures and tones you will see would look good when stripped onto photographs.

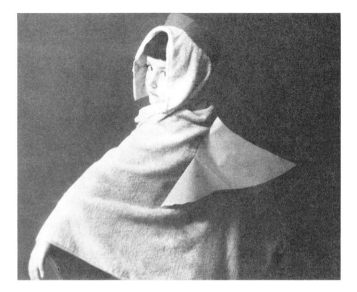

24 The Cyanotype (Blueprint)

Everyone seriously interested in photographic printing should have at least one experience in making his own printing paper. Perhaps the easiest kind to prepare is blueprint paper. There are many other kinds, such as paper for carbro and gum printing, but such processes are now so far from the mainstream of photography that they are mainly of interest to antiquarians and graduate students who want to use them in doing master's theses. They are of little or no value for people interested in photography as a profession. And some of these processes take a great deal of time.

Making and using cyanotype (blueprint) paper takes little time, which is one of its virtues; but the main one is just to see that you can do it. All by yourself you can prepare a paper that will yield beautiful prints of high quality. This is an experience that you will cherish. The paper yields a handsome blue image on a white ground.

PAPER AND SIZING

Use a good grade of typing paper, one that can be soaked in water
187 without falling apart or warping terribly. A paper with a high rag

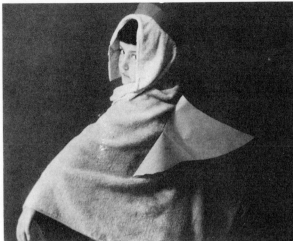

Figs. 24.1-24.3 Black-and-white reproductions made from cyanotypes, which are a handsome rich blue and have a wide tonal range.

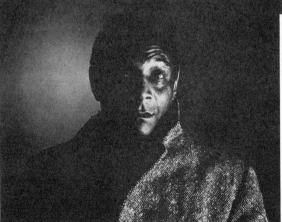

content is most preferable. Watercolor and drawing papers will also work fine.

The paper should be sized (filled, or coated) with a starch solution, spray starch, or albumin (egg white), the last being best. To prepare it, thoroughly beat the whites of four large eggs, using the yolks for cooking. Let the beaten whites sit overnight in the refrigerator. The next day dilute them with water 4:1 (4 parts egg white, 1 water), which will dilute the albumin enough to make it easy to work with. Put it in a clean tray and float the paper on top of it for 1 minute, then hang it up to dry.

To float paper without capturing air bubbles under it, roll it down onto the surface of the solution: hold it by opposite sides and let the middle sag down onto the solution, then let the ends roll down.

MIXING THE EMULSION

Mix the sensitizer in two stock solutions, A and B, using deionized water for both. Store them in dark bottles or in a dark place.

SOLUTION A

Ammonio-citrate of iron 50 grams
Water 250 milliliters

SOLUTION B

Potassium ferricyanide 35 grams
Water 250 milliliters

SENSITIZING THE PAPER

Mix equal parts of solutions A and B and put the mixture in a clean glass or plastic tray. Float the sized dry paper onto the solution and let it stay there for 3 minutes, then hang it up to dry in the dark.

PRINTING

Print the paper as soon as it is dry. Contact-print by inspection with a no. 2 photoflood, using a contact-printing frame. The hinged back of the frame permits you to inspect the paper to see how well the image is printing up without losing registration. As the image darkens it will appear reddish bronze, the unexposed paper yellow-green. When the image is dark enough, wash the print in clean water until all the yellow-green is gone. The image will be blue. For a more intense blue, wash the print in two trays of water, adding a few drops of hydrochloric acid to the first tray.

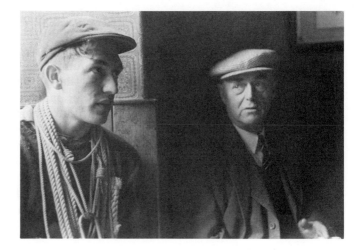

25 The Emmerman Process

Everyone seriously interested in printing ought to make at least one print by the Emmerman process just to see that it actually works as well as it is supposed to. The method is easy to follow and requires no special equipment or solutions. Its purpose is to compress, or flatten, the tonal scale of an extremely contrasty negative. In printing such a negative you usually have to sacrifice either highlight or shadow detail. That is, you must either let the highlights wash out (lighten too much) or the shadows block up and become solid black. With the Emmerman process you can print for both the highlight and shadow detail and preserve the detail in all the print tones in between them.

THE GIST OF IT

You soak a piece of enlarging paper in developer, put it on the enlarger baseboard, and give it two separate exposures, one for the shadows and the other for the highlights. Due to the developer

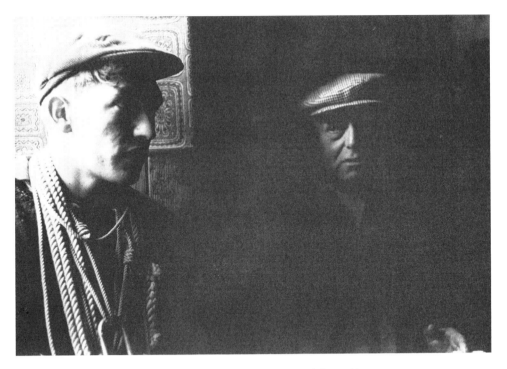

Fig. 25.1 A straight print on a no. 5 paper. Though it would ordinarily be one or two grades too contrasty for this negative, it is just right for the Emmerman process. Also, it shows very well how shadow detail can be lost in a print, the objective of the Emmerman process being to preserve it.

remaining in the emulsion the shadow details will develop up after the first exposure. The black silver in them then acts as an automatic, built-in mask to block off light so that the shadows won't get further exposure while an exposure is being made for the highlights. The paper is then put in the developer tray for the usual amount of time. The highlight exposure brings in the highlight details. Due to the masking, the shadow details are preserved.

THE PRINTING PAPER

Unfortunately, not all papers will work for the Emmerman process. Due to the double-exposure treatment, some will tend to reverse (the Sabattier effect). This can be very interesting, but it is not what you are going for. Two good papers that *will not* solarize are Kodabromide and Polycontrast, though they may give you a problem with fog (which can be counteracted with Kodak Anti-Fog No. 1 in the developer).

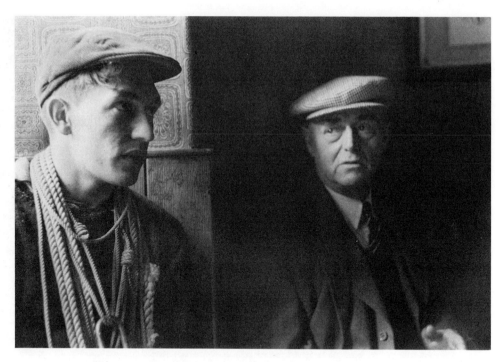

Fig. 25.2 An Emmerman print, of the same negative as used in Fig. 25.1, on another no. 5 paper, in this case Kodabromide. It happens that Kodabromide won't solarize (also true of Polycontrast), which recommends it for the Emmerman process; but it will fog, which isn't so good. Fog or not, we see that the contrast of this image has been considerably lessened and a great deal of shadow detail preserved.

THE DEVELOPER

Any ordinary paper developer such as Dektol will do, but it should be fresh. With a partially exhausted developer you may get staining due to the length of time the damp paper must remain on the enlarger baseboard.

THE NEGATIVE

Choose a negative with a very long tonal scale—for example, one with good shadow detail and excessively dense highlights, a negative with considerable contrast. The contrast may be due to overdevelopment or to a photographic subject with an extreme range of brightnesses. If such a negative were printed in the usual manner, the highlights would have to be burned-in and the shadow areas dodged. With some

negatives this would be easy enough, with others quite difficult. The important thing is that the shadows of the selected negative have preservable detail. If they are clear film, there is nothing to preserve and the Emmerman process won't work.

SAFELIGHT

Since your printing paper will be exposed to your safelight for an unusual amount of time, you should shield the light somewhat with one or two thicknesses of white paper. Otherwise, you may have a problem with safelight fog

THE PROCESS

With your long-scale, contrasty negative make the best enlargement print you can on the grade of paper (low-contrast, usually) that fits it best. Make a note of the exposure time.

Then take a sheet of paper of the next-harder grade and soak it in fresh developer for $1\frac{1}{2}$ minutes. Place the paper on the back of a tray or other flat surface and remove the developer from both sides with a cloth, fine-grain viscose sponge, or rubber squeegee. The developer that will do the masking job is embodied within the emulsion itself.

Then position the paper on the enlarger baseboard, rolling it down so as not to trap air bubbles under it. Work rapidly, because the longer the paper is out of the developer tray the greater are your chances of getting stains.

Now make your first exposure. This masking, or shadow, exposure should receive about half the exposure time given the reference print. Without touching or moving it, let the print develop for $1\frac{1}{2}$ minutes. The shadows will develop up, forming the built-in mask. Then give the highlight exposure, which should be $1\frac{1}{2}$ times the exposure of the reference print. Immediately put the print back in the developer tray and develop it for $1\frac{1}{2}$-2 minutes.

Note that the Emmerman print requires substantially more total exposure time than the reference print. There are two reasons for this. A higher-contrast paper is a little slower; and putting printing paper in developer desensitizes it somewhat.

If your Emmerman print should have streaks in it, it is due to the fact that wiping or squeegeeing makes marks on some papers. With such a paper, remove it from the developer and hold it up by the corner until all the surface liquid has drained off it. Then put it on the enlarger baseboard without touching the emulsion side.

When you compare your Emmerman and reference prints you will see that they differ very little in the highlight and middle-tone areas.

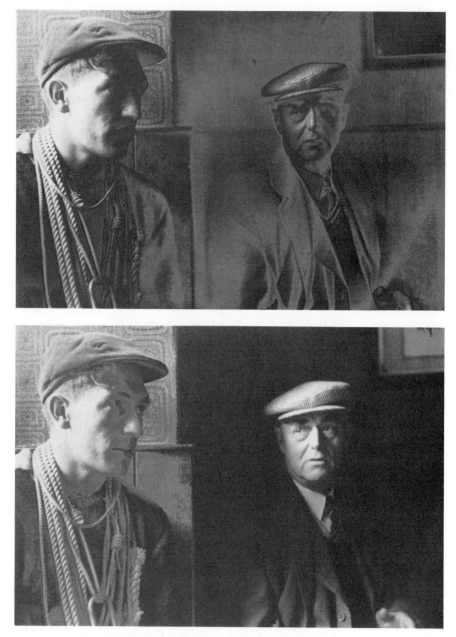

Figs. 25.3, 25.4 Emmerman prints made on Brovira no. 6, which happens to solarize easily. Because of this it shouldn't be good for the Emmerman process, but the results are rather interesting, wouldn't you say? The pictures were solarized in different places because different combinations of first and second exposure were used. And shadow detail *can* be preserved, if that's the most important objective. Where the older man is solarized the shadow detail in his part of the picture was hardly even visible in the original negative, though it stands out clearly here.

However, the reference print will have blocked-up shadows, while the shadows on the Emmerman print will be open and full of detail. And the difference is due to the built-in mask formed by the first exposure and the developer in the emulsion.

The ratios of the Emmerman print exposure times to the total exposure time can be varied, but the ones given are good for a start. This is something you might enjoy experimenting with. The proper ratio depends on the negatives you are printing. A contrasty negative with little shadow detail should receive less total exposure than a contrasty negative with abundant shadow detail.

As you see, there is nothing to making an Emmerman print, though the description given here leaves you a few things to work out for yourself by experimentation—exposure ratios, for example.

When you are through printing be sure to wash and wipe your enlarger baseboard very carefully, because developer left on it could damage the finish and contaminate prints made later. If you are finicky, you can cover the baseboard with plastic sheeting before you make your prints, but that's not usually necessary. If the varnish is still in good shape so that developer can't sink into the wood, washing and wiping is good enough precaution.

26 Photographic Paste-ups

An interesting way to make an unusual photograph is to assemble pieces of two or more prints and paste them together with rubber cement. The results can range from very realistic to extremely improbable, depending mainly on the things you choose to combine and their relative sizes. The technique is frequently used in advertising, less often elsewhere, though it has many creative possibilities.

TWO BASIC APPROACHES

There are two approaches to collecting images for paste-ups. One is to save reject prints, test strips, fogged or stained images, parts of pictures, and so on. To this you can add pictures cut out of magazines, wallpaper samples, and colored craft paper. With such materials you can create a great variety of interesting paste-ups. The main trick is to collect five or six times as much material as you think you will need. With a large enough collection you can try

196

images in many combinations with assurance that some of them will look just right.

This chapter will cover the second approach, though the techniques described will work for both. This method is to shoot a bunch of things (people, objects), then photograph some backgrounds to paste them on. Simple enough, as you will see.

LIGHTINGS

For objects or people that will look well in a variety of backgrounds it is best to avoid dramatic lighting—back or side lighting, or high lighting contrast. Instead, use natural or bounce light (a floodlight pointed at a ceiling or side wall instead of at the subject). Bounce flash is also good. Outdoors, your best lightings are open shade, overcast sky, or hazy-bright sky (direct sunlight is not so good). In paste-up pictures, none of these lightings will draw attention to itself as a lighting, which would not be a good thing. The very same lightings would also be good for the backgrounds themselves.

PRINTING PAPER; FILM DEVELOPMENT

Before developing your film you should consider the printing paper that you will use. The best bet is a single-weight paper with a very smooth semimatte surface such as the Kodak N-type. If you are accustomed to a glossy or semiglossy surface, you will find that your prints on semimatte look one or two paper grades too flat. This is because the surface diffuses the dark areas, making them look much darker than usual. You can compensate by making your negatives more contrasty—just increase the normal developing time about 50 per cent. For example, a normal time of 10 minutes can be extended to 15.

If you use Tri-X, normally exposed negatives will come out a bit heavy and somewhat grainier than usual, but still very printable. There is no particular grain problem with Panatomic-X, but it is best not to overdevelop normally exposed Plus-X.

If the thought of an increase in grain bothers you, don't overdevelop your film as suggested. Instead, buy paper that is two contrast grades higher than you normally use. If the contrast then proves to be a bit too high, which is unlikely, you can reduce it as much as necessary by developing the paper in Dektol diluted 1:20 for 2-5 minutes, 2 minutes giving you the greatest drop in contrast. When using a greatly diluted developer be sure to make a test strip, because it usually calls for more exposure than a normal dilution.

REASONS FOR PAPER CHOICE

One reason for using a single-weight, semimatte paper is that it cuts easily without chipping, whereas glossy and semiglossy papers chip very readily when they are dry. You can solve this problem by cutting out your figures while the paper is still wet, but some people find this difficult. Furthermore, one must use *very* sharp scissors for wet cutting, or the results may be disastrous.

Another factor is that it is easier to take the curl out of figures printed on single-weight paper. Just pull them across a sharp table edge, pulling downward to counteract the curl. Heavier papers give up their curl with more reluctance and can be damaged when given this treatment.

A single-weight print is also a lot easier to cut neatly than a double-weight one, either with scissors or an Xacto knife.

PAPER SIZE

When cutting and pasting up it is very much easier to work large than small, the optimum print size being 11 x 14. At sizes of 8 x 10 and smaller you really have to be an expert with knife and scissors to make your paste-ups look good.

One way of getting 8 x 10s that look well crafted is to make 11 x 14 paste-ups and make copy negatives of them. You can then print them any size you like.

PRINTING

It is best to print your backgrounds and figures during the same printing session. Print a background first, next print the objects that you want to put on it, and then put them together to see what they look like. Matching them up this way makes it easier to get the objects just right in terms of size, exposure, dodging, burning-in, and contrast.

For each object it is good to make a test strip; make it the same size as the object image. You can lay it right on the wet background print to help you in determining the best exposure and contrast. It is even better if you use sharp scissors to trim one or both sides of the object or figure, because the areas on the test strip surrounding it may throw your judgment off somewhat. It's not necessary to be meticulous in your trimming at this point.

For the same reasons it is good to trim your final print of the figure while it is still wet. If you find this difficult, trim just the easy

Fig. 26.1 To check the tone and contrast of a figure it should be partially trimmed while still wet and placed on the wet background print. Then if the figure is too light, too dark, too contrasty, too flat, or the wrong size, you can print another one while the negative is still in the enlarger.

parts and leave an $\frac{1}{8}$-inch margin around the hard ones, which you can final-trim when the figure is dry.

Judge the print quality of a figure only in terms of how it looks on the background print, *not* according to how it looks alone. You will often find that it looks best if it is a little over- or underexposed, whereas normal exposure might not look right at all. Don't worry that the over- or underexposure might seem obvious later. If the object looks right on the background print, the whole paste-up picture will look properly exposed.

PRINT WASHING AND DRYING

Use a washing aid, such as Perma Wash, so that you don't have to
wash your background prints and figures too long. You should

agitate, of course, but not too vigorously, or you may nick the edges of the final-trimmed figures here and there. They would then have to be touched up with dye or retrimmed.

Dry the prints and figures between photographic blotters or in a blotter roll. Though you can air-dry them, too, they will curl quite a bit. You can remove the curl, but it takes a while.

MOUNTING THE BACKGROUND PRINT

It is easiest to work with a background print that has been dry-mounted on heavy cardboard or mounting board. However, taping it to a flat surface will also work fairly well. An unmounted paste-up picture looks best in a picture frame under glass, but there is no need to frame a mounted one.

TRIMMING THE FIGURES OR OBJECTS

A very sharp pair of barber scissors is best for trimming, though some people like the scissors that doctors use for cutting tape. For intricate areas you should have an Xacto knife with a long-pointed blade or its equivalent. A very small scalpel will also work nicely. If you use a knife with replaceable blades, be sure that you use a brand-new blade. If you know how to sharpen knives, try a hard Arkansas whetstone, which will produce razor-sharp edges.

Do your cutting on a piece of mounting board or other tough cardboard, not on a wood surface. Wood grain will deflect your blade in unpredictable directions, thus ruining objects that you are trimming. A piece of tempered Masonite makes an excellent cutting board that will last a long while before it gets too hacked up.

If you find you have little talent for cutting neat edges with scissors or knife, a small piece of fine black sandpaper will help rectify the damaged edges. Fold the sandpaper a couple of times to give it a little stiffness, then work on the edges of your figures in the same manner you would file your fingernails. You will soon see the unwanted bumps and angles disappear.

It is usually a good idea to darken all or part of the edge of an object with a felt-tip marking pen. Otherwise, the edge may show up as an obvious white line on the finished paste-up picture. However, if a part of an object is very light—or if the background behind it is—leave that part of the edge undarkened. If you are uncertain which to do, press the object down flat on the background and look at it from all angles. Then darken the segments that show up as white lines surrounded on both sides by dark.

After trimming a figure, move it around on its background until you have found exactly the right location. Then trace around one of its edges with a sharp pencil, making a line on the background print. It will serve as a guide to help you get the figure properly located when you are gluing it down. Any ordinary pencil will do, but don't use a ballpoint pen.

Give the back of the figure two liberal coats of rubber cement, applied about 20 minutes apart. Do the same thing to the area of the background in which it will be positioned, but let the cement extend quite a way beyond the edge of the area that will actually be filled by the figure.

After coating the figure and background, allow them to dry thoroughly—which means they will be slightly sticky to the touch but no longer slippery. At this point if you touch the object to the background it will instantly stick there, with no possibility of

Fig. 26.2 This picture shows how slip-sheeting is done. You cover the rubber-cemented area of the background print with a piece of paper, so that only the edge of it shows. Then you position the rubber-cemented figure inside the pencil contour and rub it down. Then you pull out the slip sheet and rub down the rest of the figure. With this system you won't accidentally get a figure stuck down in the wrong position, which can be disastrous.

shifting its position. If you are extremely careful you can pull it up again without tearing it, but it will pull all the cement off the background, which will have to be coated again. Therefore, you should get a figure very accurately positioned before it touches, which you can easily do by slip-sheeting.

A tacky-dried rubber-cemented surface sticks vigorously to another such rubber-cemented surface, yet it will hardly stick to paper at all. This is the simple principle behind slip-sheeting. You merely cover up most of the rubber-cemented area on the background print with paper, so that only the penciled contour line for one side of the object is left uncovered. Then you position the edge of the object over the line, lower it into place, and rub it lightly. This makes accurate positioning dead easy. Then you pull out the slip sheet (paper) and smooth down the rest of the figure.

At this point you will probably find yourself surprised and elated. Until the figure is held down perfectly flat by the cement the whole

Fig. 26.3　Kathi and devil fish. Notice the rubbed pencil shadow near her right shoulder. Shadows add authenticity to paste-ups.

assembly never looks like much, but after it is you will feel like celebrating.

Now remove the excess of cement from the background print by rubbing it vigorously with a clean cloth. Rubbing with the fingers instead is not advisable, because they may make smears that can't be removed. To get into little nooks and crannies around the figure, use a pencil eraser that has been cut into a wedge shape. As you are removing the rubber cement it will erase the penciled contour line.

SPOTTING AND RETOUCHING

If the print needs further work, now is a good time to do it. Use liquid spotting dye and/or pencil, which work very well on a semimatte paper. On areas of medium or light tone use a hard pencil

Fig. 26.4 Kathi sitting in a flower pot.

(3H or 4H) with a very sharp, inch-long point. It will make spotting easy and fast, and you can also do retouching with it. Unfortunately, the sheen of pencil heavily applied in a dark area will show up obviously, so you should use dye there. However, dye spotting a semimatte surface is a breeze.

For a look of authenticity it is good to have a figure casting a shadow on the background, which you can do with pencil. Just a hint of a shadow is usually enough, and the main requirement for believability is that it have soft edges that blend imperceptibly into surrounding areas. The shadow takes away the cutout look.

It doesn't matter at all whether shadows would actually fall the way you draw them, because people pay little conscious attention to them in everyday life and don't care what they do in pictures as long as they aren't obtrusive. Rough in the shadow lightly with the point of a no. 2 pencil held nearly parallel to the print. Then rub it smooth and blend its edges with a Q-Tip or small ball of cotton. If you botch a shadow, simply rub it off with clean cotton. If it won't all come off, which is unlikely, use cotton and lighter fluid. You can patch up shadows until the cows come home without damaging your picture.

For very dark shadows it is best to use a piece of artist's black conte crayon that has been sanded to a point. Like pencil, it smoothes out nicely by rubbing. Rubbed crayon has about the same sheen as an N-surface paper, whereas heavily applied pencil is more metallic in an obvious sort of way.

If parts of a figure blend in too much with the background, they can be darkened a bit with either pencil or conte crayon. In fact, you can touch up all over a picture if you like, knowing that you can easily wipe off your mistakes. This is one of the pleasures of a semimatte paper, and you might just as well take advantage of it.

LONGEVITY

One disadvantage in using rubber cement on photographs is that it contains sulfur, which will react with air, especially in hot and humid conditions, and cause bleaching and staining after a couple of years. For picture longevity, therefore, it is necessary to seal out air and humidity. With a dry-mounted print the mounting tissue itself effectively seals the back. The front can be sealed with three coats of spray-can lacquer.

Some lacquers in aerosol cans are mostly solvent and very little lacquer, which doesn't help much. Though it yellows somewhat, Rustoleum clear glossy lacquer is excellent, and there must be other good brands.

To apply lacquer, lay your print on a flat surface so you won't get dribbles, and spray on a coat that is not too heavy. Apply other coats about 30 minutes apart.

Fig. 26.5 The "sculpture" on the left was actually a 10-inch piece of driftwood.

Fig. 26.6 Kathi and Ferdinand the Bullfrog, who seems to have grown somewhat since she first met him.

After the last coat the print should have a glossy surface, which will increase its contrast and brilliance, especially in the dark areas. Remember that semimatte papers tend to look a little dull.

You can also seal the front of a print rather well by framing it under glass, provided it is shoved up tight against the glass.

Another way of solving the longevity problem is to make good copy negatives of your paste-ups. If the paste-ups are 11 x 14, you can count on getting negatives that will make good quality 8 x 10s. The size reduction will cover up many mistakes in cutting out figures and pasting them up. Of course, you can make prints 11 x 14 and larger instead, but there will be a substantial loss in photographic quality.

206

The simplest way to copy a paste-up is to tape it up on the shady side of the house and photograph it with the camera and film that you usually use. A tripod and cable release are advised. Bracket the exposures and develop the film about 50 per cent more than normal for extra contrast. The best negative for printing will be up to one stop heavier than one normally likes negatives to be.

As you have seen, the art of making a paste-up is no great mystery. However, there are good ones and bad ones. You will find it quite a challenge to match up the right figures with the right backgrounds, and trying to get the figures correctly printed will drive you up the wall more than once. After that it's a cup of tea with lemon in it.

27 Negative Retouching

Small negatives, such as 110, 35mm, and 120, are almost impossible to retouch, because it is so very hard to see what you are doing. Experts may occasionally work on 35mm or 120, but the extent of their retouching is usually minimal, and they print the negatives with diffusion enlargers, which minimize retouching defects. For this same purpose they may also use diffusers under their enlarger lenses.

Large negatives, such as those described in Chapter 17, can be retouched much more easily, and an experienced retoucher would find them quite simple to work on. Now, retouching happens to be an art in itself, and there are people who specialize in it. Nearly anyone can learn it, however, if one will apply oneself hard enough. Fortunately, some aspects of the art can be handled rather easily by people with no experience whatever. Though easy to do, these techniques are very effective.

This chapter will be mainly concerned with enlarged continuous-tone negatives (and film positives), though a few things that are mainly repetitive of material from Chapter 17 will be said about line, or high-contrast, negatives. The very few things that you can safely do with smaller negatives will also be described.

LIGHT BOX

For negative retouching you need a light box. The commercially available transparency or slide viewers are just fine, but you can also make a very effective light box for yourself from a cardboard grocery box. Cut a rectangular hole in the top and over it tape a 9 x 11-inch plate of milk glass or opal glass, which will diffuse light very smoothly. Rig a 100-watt frosted lightbulb inside the box; use a porcelain ceiling light fixture—glue it to the bottom of the box. In the back cut a 3-inch hole for ventilation, because the bulb will generate a lot of heat. For this reason many people prefer to use fluorescents, though they are hard on the eyes.

If you put your box on a low coffee table it will be about the right height for working while seated on a chair. Some people like to work in a darkened room, while others prefer to have the room dimly lit. If you are working for long periods of time the dimly lit surroundings will minimize eye strain.

Some people use ground glass in their boxes, but the grain is so coarse that it makes it difficult to see fine detail in negatives. Heavy milk plastic sheeting is available and is good for boxes with a fluorescent tube, but a tungsten bulb may generate enough heat to warp it.

Fig. 27.1 An effective light box (with 35mm negatives on it) made from a cardboard grocery box painted white (for aesthetic reasons).

Red food dye (any kind of red food dye will do) is perhaps the easiest retouching tool to work with. It is used as the equivalent of dodging. That is, if you put some on an area of a negative, it will lighten that area of the final print, just as dodging would.

A *red* dye is used because printing paper (and orthochromatic films like Kodalith) aren't sensitive to red light. Now, the light passing through a dyed portion of an image is changed to red, of course. This means that it doesn't take very much dye to lighten the image in that area. If you wished, you could use a black spotting dye such as Spotone instead, but you would have to use a lot more of it to get the same amount of lightening. This is not so good. The point is that the more dye you put on film, the more irregular the coating becomes. Thus using a thinner coating of red promotes smoother image tones.

As it comes in the bottle, the red food dye is too strong, so dilute it by putting three or four drops into $\frac{1}{4}$ ounce of water. After you have tried it you can adjust its strength to suit your taste.

The dye is put on the back of the film with a Q-Tip or a small ball of cotton. The back has a very thin coating of gelatin on it to counteract curling, and this gelatin accepts dye very readily. Rub the dye on gently, applying as many coats as you need to get the desired degree of redness. Ordinarily, you would want a vigorous pink color, but sometimes either more or less dye is better, depending on how much lightening you want.

The best way to determine the right amount of dye is to make a test print. If treated areas come out too dark, add more dye. If too light, remove some dye. Plain water will remove a little of it, household ammonia a good deal more. It is on account of the ammonia that we put the dye on the back of the film, though it will go on the emulsion side even more easily. Ammonia will sometimes bleach a silver image, so we must keep it away from the emulsion. Strictly confined to the back of the film it does no harm at all, though it may soften the gelatin coating somewhat. If you apply it gently, this will be no problem.

Dye is generally used on areas that print as dark or medium tones in order to lighten them moderately. But you can also lighten areas dramatically, if you wish, even making them come out white, or close to it. However, areas treated this way tend to have a false appearance in prints, so you have to be careful.

The highlight areas in prints sometimes come out looking flat and lifeless. However, if portions of these areas are dyed on the negative, they will pick up contrast and look much more lively.

Though dyeing is the equivalent of dodging in its effect, you can do it with much more accuracy, lightening certain shapes that it

would be impossible to dodge well. In dodging, the basic exposure time limits how much you can do, but there is no such limitation with dyeing. You can treat as many areas as you wish and lighten them as much as you find necessary.

LIPSTICK

You will recall that you print enlarged negatives by contact-printing and that you assure good contact by pressing the negative against the printing paper with a heavy sheet of glass or a glass sandwich. Now, you can tape your negative to the glass and do lipstick retouching on the back of the glass.

Use dark red lipstick, and it will give you the same lightening effects as red dye, though it is hard to get it on as smoothly. First, put some lipstick on your little fingertip, then tap it onto the glass. Or you can put it on the glass first, then tap it. The point is that you smooth it out by tapping, because rubbing doesn't work very well.

You can trim up the edges of a lipsticked area with a Q-Tip or a piece of cloth.

The advantages of lipstick on glass are that it is fast, easily removed, and involves no risk whatever of damaging the negative. At first you will find it aggravating to get even coats, but you will soon work out a patting technique that does the job.

DYEING AND LIPSTICKING POSITIVES

If you dye or lipstick areas on an intermediate film positive, they will come out lighter on a negative made from it and darker on a final positive print. Thus treating an area on the film positive is the equivalent of burning-in on the final positive print.

LINE NEGATIVES AND POSITIVES

Remember from Chapter 17 that line images have only blacks and clear areas, no middle tones; thus they are very easy to retouch.

Unwanted clear spots in black areas are removed by filling them with black opaque applied with a brush. Unwanted black spots in clear areas can be removed with strong Farmer's reducer or Chlorox.

Remember that Chlorox takes the emulsion right off, which doesn't matter a bit if you want the clear areas to print up dead black. However, if you want them to print up gray, the edges of the

dissolved emulsion will show. In that case, use Farmer's reducer, even though it takes more time to work.

Other types of household chlorine bleach will work just as well as Chlorox. Use them undiluted.

BLEACHING CONTINUOUS-TONE NEGATIVES

Except for the necessity of a light box, you bleach negatives in exactly the same way that you bleach prints (Chapter 5), so it is not necessary to repeat detailed instructions.

Bleaching areas of a negative is equivalent to burning them in on the final print, but you can bleach areas that are too intricate or small for good burning in. Areas can be bleached clear, so that they will print black, or bleached moderately for moderate darkening. Generally, it is good not to be too bold in your bleaching.

Sometimes highlights are badly overexposed and blocked up so that no detail will print through them, and if you burn them in you get muddy-looking grays. Often a little local bleaching will make a substantial improvement. Be careful not to carry it too far, because most highlights need quite a bit of density.

The only way to tell for sure if bleaching has gone far enough is to make a test print, which can be done while the negative is still wet. For a large negative: rinse it in water, wipe it off thoroughly, put it between two sheets of acetate, and contact-print this sandwich. To avoid air bubbles, roll the negative down on the first sheet of acetate, then roll the second sheet down on the negative.

A smaller negative can be put between two pieces of glass and then put in the enlarger. To avoid bubbles, put the negative and the glass in a tray and make the sandwich under water, then wipe off the outside carefully. You can also use a glassless negative carrier, which is even better, but be sure to wash it carefully afterward.

You should work fairly fast in printing wet negatives, so that they don't start to dry. There is a good chance that a partly dried negative will stick to its sandwich, which could lead to damage when you try to remove it.

ABRASIVE REDUCER

Overly dense areas on film negatives and positives can also be lightened with an abrasive reducer, a heavy, oily paste saturated with a very fine abrasive, probably pumice. Put the reducer on a Q-Tip and rub it (not too hard!) on the offending area until sufficient silver

has been removed. It is a naturally slow technique, so don't get in a rush—or you will surely scratch your negative.

You can also make your own abrasive reducer with "technical" pumice (from a printer's supply store) and Vaseline, and it seems to work as well as the stuff you buy.

When you are through reducing, wipe the grease off the negative with cotton. It will do the negative no harm.

OPAQUE

Opaque is a thick tempera with something in it to make it adhere well to film, which ordinary tempera won't do. Kodak makes both red and black types, but there are more uses for the black.

As you read earlier (Chapter 17), opaque is used on line negatives to block out unwanted clear spots in dark areas. It can be used on both line and continuous-tone images to block out backgrounds and other areas so that they will print white. If it is used on an intermediate film positive, the opaqued areas will come out black on the final positive print.

It is practically impossible to do neat opaquing on small images, so you should restrict yourself to large ones. Though intended for work on film, opaque also works well on paper negatives and positives made on resin-coated (RC) paper.

You can use thinned opaque with a small spotting brush to retouch pinholes and scratches in continuous-tone film positives and negatives. It adheres very readily, whereas regular spotting dye does not. It also adheres well to glossy prints, which can be agony to spot with dye, though it has a dull sheen which will show up when viewed at an angle. However, if the print is intended only for reproduction, the dullness won't matter.

ETCHING

Small dark areas on film can be lightened or removed by etching them with a small knife, though this technique is most definitely not recommended for beginners. Even so, one can learn it. There are special etching knives, but a small Xacto blade with a curved edge will work fairly well. The edge should be very carefully sharpened and polished with a hard Arkansas whetstone, so that when you run it lightly across the edge of your thumbnail you can't feel any serrations or rough spots.

The film should be very dry, or the knife will dig up the emulsion in little chunks. You can get a dry negative superdry by holding it up to a lightbulb for a minute or two. Professional retouchers sometimes

use infrared bulbs for this, but these will permanently warp the film if the exposure is too long.

To etch your film, lay it on your light box and lift up the side farthest from you. Then when you touch the image with the knife it will be pushing against the spring in the film and not against the hardness of the glass on the box. This makes for lighter, more delicate pressure, which you very definitely need.

Hold the side of the blade vertical to the image and delicately scratch it back and forth until it has worked its way into the gelatin and removed sufficient silver. The blade should make a barely audible whispering sound. Though the technique is essentially one of scratching, the treated area shouldn't look scratched but smoothly eroded. As you might imagine, this is easier said than done.

It is usually good to polish the surface of an etched area with abrasive reducer. Etched negatives are generally printed in diffusion enlargers, which tend to minimize defects. Only an expert should do etching for condenser enlargers.

SMALL NEGATIVES

You shouldn't try to retouch negatives as small as 110, but there are a few things you can do with 35mm and 120.

With a round toothpick and a tiny bit of cotton you can make a miniature Q-Tip and do a certain amount of work with red food dye. The dye is very smooth and grainless and won't show up in the final

Fig. 27.2 A white line drawn on a print to show how a backing scratch on a small negative will usually print up.

Fig. 27.3 A scratch on the back of a negative can be filled with a minute quantity of Vaseline applied in circular strokes with the tip of the little finger.

print—unless you put too much on. If you do, lighten it a bit with ammonia, which works smoothly.

Scratches on the back of a negative will print up as white lines, but they can be filled with a very thin coating of Vaseline. Apply enough of it to the tip of your little finger to make it just slightly greasy, then rub it on the back of the negative in a circular pattern. The scratches, which usually have slightly rough edges, will pick up enough Vaseline to get filled in. The rest of the negative should have hardly any Vaseline at all on it. When you are through printing, wipe off the Vaseline with cotton; it will do your negative no harm.

You can fill tiny pinholes with diluted opaque on a round toothpick used as if it were a brush. Sharpen it to a needle point on sandpaper, then suck on it for about 10 minutes to soften it somewhat. Then dip it in slightly thinned opaque and fill the pinholes before the opaque can start drying out. The point of a sharpened toothpick is quite a bit more controllable than the point of a spotting brush, which is too flexible.

You can darken portions of a small negative by rubbing very fine pencil dust on the emulsion side with a small ball of cotton or a Q-Tip. Make the dust by rubbing a no. 2 pencil on crocus cloth, which is like an extremely fine sandpaper. You can trim up treated

areas, or remove the dust altogether, with cotton dampened with lighter fluid. Rubbed pencil dust makes a very smooth tone and does no harm to negatives.

PENCIL-RETOUCHING

Most negative retouching is done with pencils, but it's not easy to do it well. One uses pencils ranging in hardness from about 2H to 4H, sharpened with a knife and sandpaper to inch-long needle points. Negatives are usually prepared by coating them with retouching dope, which is like a slightly thickened turpentine. The dope, applied to the emulsion side, gives negatives an even "tooth" that will accept pencil.

With many films the emulsion already has a tooth, quite a bit of it in dense areas and little or none in thin ones; the dope evens it out. Certain films such as Kodalith have an almost mirrorlike emulsion side, so that even when coated with retouching dope they don't develop a very satisfactory tooth. Some films with which you can make enlarged negatives are manufactured specially with matte surfaces for retouching, and they don't have to be doped at all.

To dope a negative, lay it emulsion up on a clean piece of paper and put two or three drops of the dope on the area you wish to retouch. Immediately rub it all off with a flat wad of cotton about the size of your palm, rubbing in a broad circular pattern. Stop rubbing as soon as the dope is all gone, or you will polish the tooth so that it won't accept pencil.

A properly doped negative shouldn't be even slightly sticky, and you shouldn't be able to see a line of demarcation between doped and undoped areas, for that would print up. If a negative comes out sticky, simply dope it again, using twice as much dope this time and rubbing faster with the cotton. Not harder—faster.

Since most of the dope is picked up by the cotton, you can understand that the coating on the emulsion is very thin indeed, as it should be. Coatings that are too thick pick up cotton lint and dust and make the graphite come off your pencils in tiny chunks.

You need a light box for pencil-retouching, of course. To retouch a negative, lift up the far side of it so that your pencil will be pushing against the spring of the film, helping you to maintain a light touch. The graphite is usually applied in short straight strokes, small circular ones, or in figure eights. Build up the pencil density gradually, but don't work on a given area too long, for that will polish the tooth. If you botch a retouching job, simply redope your negative and start over again.

Penciling is most often done on portrait negatives, which are printed with diffusion enlargers. It is used mainly for lightening the

215

Fig. 27.4 Pencil-retouching a negative, which is lifted up
somewhat so that the pencil point pushes against the spring of the
film. This prevents digs in the negative and broken pencil points. The
bottom of the negative is covered with paper to protect it from
abrasions and fingerprints.

bags under eyes, lightening or removing other facial lines, and
clearing up skin blemishes.

Strokes made with needle-sharp pencils usually show up rather
badly with condenser enlargers and contact printers, but it is not so
bad if the pencil points are a little dull—long but dull. With a
condenser enlarger you can also use cellophane diffusion (Chapter 7),
which will blend pencil strokes together. You can also blend pencil
strokes by brushing them lightly with a Q-Tip, which unfortunately
also removes some of the pencil.

Pencil-retouching is a profession in itself and not at all easy for
beginners. However, you can learn it if you practice long enough,
even working only with the information given here. The main tricks
are to have long enough points on your pencils, to dope your
negatives properly, and to work against the spring of your film.

Of the techniques discussed in this chapter, only etching and
penciling are really difficult at first. With the others you can start
right out with reasonable assurance of success. You have to use them
with good sense, of course, but all photographic techniques call for
that.

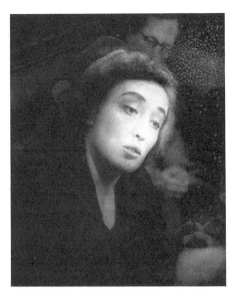

28 Print Retouching and Coloring

Almost any photographic print surface can be retouched or colored, though some are much easier to work on than others. Glossy and semiglossy surfaces are true agony to work with, as if they had been invented by the devil to punish sinners. Though they can be spotted, bleached, or dyed, they are no good at all for such things as pencil work, oil coloring, or chalking. And spotting them is a good way to go crazy. In contrast, matte and semimatte papers are often so easy to work on that it seems that they were made specially for that purpose. Among these surfaces the Kodak N-type—a fine-grained semi-matte—is especially good.

One purpose of retouching is to remove image defects, another to change the appearance of things for pictorial purposes. Retouching can be used to remove unwanted objects from pictures, lighten or darken tones, mask out backgrounds, strengthen or weaken centers of interest, add objects to pictures, simplify overcomplicated environments, and so on. It is often used for "pictorial cosmetic surgery" in portraiture, where bags are removed from under eyes, wrinkles are lightened or removed, noses are straightened or cropped, and skin blemishes are eliminated.

All in all, retouching is very interesting to do, though you must struggle with some techniques before mastering them. On the other hand, some techniques are easy from the beginning.

The purpose of coloring is simply to make things look prettier. Though this requires a knowledge of which colors look well together, this can be learned through direct experience.

SPOTTING

One of the easiest kinds of retouching is simple spotting, which you do with a fine sable spotting brush and a black liquid spotting dye. It consists of using the brush and dye to fill in white specks, squiggles, and lines on prints that are caused by dust, lint, and scratches on negatives.

It is convenient to put about a dozen drops of dye on a small white dish and let it dry there, picking it up as needed with a damp brush. With the dried dye it is easy to get any concentration you want, from very black to a light gray, using the dish as a palette. The dye goes on more smoothly if you use water containing about five drops per ounce of Photo-Flo or a diswashing detergent. Control the load of dye in your brush by stroking it on a paper napkin: light loads work best.

Fig. 28.1 Materials for print spotting: water with Photo-Flo in it, eyedropper, spotting dye (black, brown, and blue), magnifier, white dish, spotting brush, white watercolor, and paper napkin.

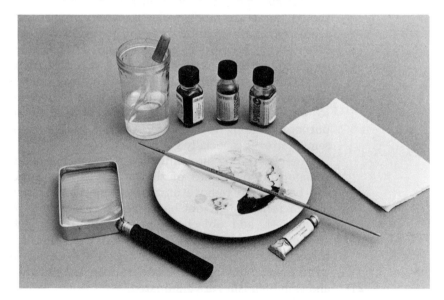

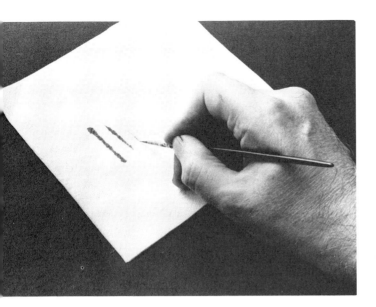

Fig. 28.2 One of the main tricks to print spotting is to control the amount of dye in the brush (very little), which you can do by stroking it on a paper napkin.

Apply the dye to white defects in small dots or short strokes, gradually building up the amount until the defects disappear. If you put it on too heavy, it will get into the surrounding areas and make a mess of your print. However, most of it can be removed with household ammonia. But don't use ammonia if your print was underdeveloped, for it may bleach the silver. Work under a strong light so that you can see what you are doing. A reading glass is also a help.

For areas up to $\frac{1}{2}$ inch in size you can apply diluted dye in washes, using your brush or a Q-Tip. It helps if you first dampen the area with water. Dye washes tend to go on gelatin surfaces unevenly, so in larger areas they would tend to show up in a distracting way. Also, the dye often changes color when it gets into the emulsion, and this would show up too, whereas in small areas it doesn't really matter.

For black spots, squiggles, and lines you can use either white watercolor or gouache, which come in tubes from an art supply store. Dry $\frac{1}{2}$ inch of pigment on your plate and wet it when needed. The problem with these pigments is that they show up as dull spots against the shinier print surface. However, you may prefer the spots to the dark defects.

Dye can be used to tone down things that should have been burned-in. And white watercolor can be used to add more brightness to highlights. With both you can draw lines and sharpen up edges that are out of focus. On a print destined for reproduction you can use as much white as you please, but keep it to a minimum on a **219** picture intended for viewing.

VARNISHING RC PRINTS

Kodak glossy-surface resin-coated (RC) papers are extremely resistant to dye, and the blacks look rather dull and lifeless. Both problems can be remedied with a coating of marine spar varnish diluted 1:20 with turpentine. A coated print accepts dye easily, the dye washes right off if you get it in the wrong place, and the blacks look rich and deep.

First wash off the print surface with a cloth soaked in turpentine, then put it in a tray of diluted varnish. Then hang the print on a line in a dust-free area to drain and dry. You can make nifty little hangers by bending large common pins into S-shapes. Even with such a thin coat, spar varnish dries rather slowly, so you should let your print dry overnight.

BLEACHING

Bleaching is a form of print retouching, but we already have a chapter on it (Chapter 5). All I'll add here is that with a small brush you can do very fine detail work, such as removing a straggling hair in a portrait. It can also be used for removing dark blemishes, softening shadows under eyes, and so on.

WAXING

Some matte and semimatte print surfaces tend to be a little too dull, and prints made on them seem to lack contrast. They can be brightened up, and their contrast somewhat restored, with wax. Paste waxes made for bowling alleys or cars work very well. Give your print a thin coating of wax, let it dry, then buff it thoroughly with a soft cloth. Nothing to it.

Wax also helps protect a print from atmospheric smog, which often contains sulfides that bleach or discolor silver images. It also protects against fingerprints, which may be contaminated with Lord-knows-what.

FOOD COLORS

Many people have joyously taken to coloring their prints with food colors, so you might enjoy it, too. It is usually best to color just part of a print, rather than the whole thing. The colored part generally **220** looks quite well with the black and white of the rest of the image.

The range of food colors (red, yellow, blue, green) is very limited, but that doesn't seem to bother anyone. You can extend it somewhat with medicinal dyes, such as Merthiolate (shocking pink) or gentian violet (a gorgeous purple). With a little searching you can probably find others, but don't use iodine (it bleaches silver). The dyes and medicinals can be mixed together two at a time to get some in-between colors, including a good brown, a fair orange, and an excellent magenta. Try it and see what you get.

The food dyes and the gentian violet are so strong that they should be diluted quite a bit, but not the Merthiolate. Apply them to dampened areas of your print with a Q-Tip or brush. They go on most smoothly if you dilute them with water containing five drops of Photo-Flo per ounce. Dye used with no Photo-Flo gathers into droplets, which make dark spots, whereas treated dye lies nice and flat.

On black-and-white prints you won't get pure colors except in very light or white areas. Elsewhere you get a mixture of the print color (a shade of gray or black) and the dye color. For example, in a very light area a yellow will come out yellow, but on a medium or dark gray it will be green. On gray tones, reds tend toward the brownish side, though it can be a very rich brown. Blue and green are merely grayed by darker print tones.

If you put the colors on prints that have been toned brown (see Chapter 29), the yellow and red won't be changed so much, though the blue and green will be grayed a bit. Gentian violet and Merthiolate won't be changed much either. Professional colorists nearly always work with toned prints, usually portraits or landscapes.

The dyes will go on both glossy and matte prints, though matte ones are easier to work with. As a surface for retouching of almost any kind, glossy is both a challenge to patience and a pain in the neck. However, one can improve it considerably by using a non-hardening fixer and by dampening areas before coloring them.

Dye put on too heavily can be lightened a lot, but not totally removed, with household ammonia—but remember that ammonia will bleach underdeveloped prints. To minimize bleaching, dilute it. Use about ten drops in an ounce of water. You needn't wash a print after using ammonia on it.

TRANSPARENT OILS

You can buy oil-coloring kits for working on matte or semimatte prints, either toned or untoned. Oil colors won't adhere to glossy or semiglossy papers, because they have no "tooth." Print coloring is a very popular hobby, so you might find it interesting. Many people do it as a profession, nearly always working for professional portrait photographers.

Oil color can be applied directly to an unprepared print surface, rubbing it in with a Q-Tip or a ball of cotton—but you have to rub hard to get it on smoothly. You get very bright color this way, though it is hard work.

In the Marshall's color kit, which is in widespread use, there is a bottle of preparation medium, an oily substance that is rubbed over the entire print surface. The color will then go on very smoothly, but not as brightly as on an unprepared surface. Indeed, coloring a prepared surface is so easy that nearly anyone can do it well on the first try.

The edge of a colored area can be trimmed up with a Q-Tip dampened with the solvent included in the kit, though lighter fluid works just as well. Areas can be lightened by merely rubbing them hard with clean cotton, but it is often best to clean out the brightest highlights with solvent. Or you can use solvent to totally remove color. Indeed, you can color the same print again and again until you get it exactly the way you want it. However, the color should be removed while it is still wet, within an hour or so after application. Dried color is very difficult to remove.

To prevent fingerprints in freshly colored areas, cover your print with clean paper, leaving only the area you are working on uncovered. You can rest your hand on the paper. The paper won't pick up enough color from the print to make any difference, nor will it smear it.

Sometimes matte and semimatte prints are a little flat. You can add contrast by lightening the light areas and darkening the darks. Clean out the highlights with solvent and apply a modest amount of white oil color. Darken a medium tone or dark area by adding black to its color.

After a print has dried for a few days you can coat it with the spar varnish mixture already described, though this isn't usually done. If you have applied color in light tints, the usual way, the print simply doesn't need it. With more heavily applied color the sheen of the print surface may vary from area to area, making varnish advisable. If you let it dry thoroughly between coats, you can varnish a print as many times as you like, even bringing a matte or semimatte surface up to a high gloss. This will increase print brightness and contrast considerably.

Professional oil colorists usually work on brown-toned portrait prints, but many people are now using oils on black-and-white pictures of every subject imaginable.

MEDIOBROME

There is a technique called "mediobrome" that is most often used on black-and-white portraits and landscapes, though it will work on

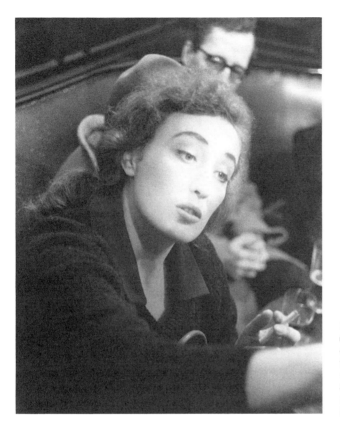

Fig. 28.3 A good basic print for mediobrome, which is done with black oil paint and is approximately equivalent to burning-in. Notice that the print is rather flat and light; the black paint will add contrast and density where they are needed. It will also be used to make the background less confusing.

almost any subject. Actually, it is a form of print coloring, but only black oil color is used. You cover a print with preparatory medium, then give the whole surface a thin, even coating of black, rubbing it on with cotton. Then you selectively lighten certain areas, leaving others dark.

You can lighten an area quite a bit by rubbing it with clean cotton, or clean it out entirely with solvent. You can leave darker areas as is, or make them even darker with additional black paint. However, if the application is heavy, you may need to varnish your print to even out the sheen. Or you could give it several light coats of clear spray-can lacquer.

This technique will permit you to change an image around very considerably. If you are artistically inclined, you can use homemade Q-Tips of various sizes to rub out designs in the overall black coating. You can also apply black oil color with a small sable brush, making lines and small shapes with it. If you like, you can touch up the highlights with modest amounts of white paint.

A somewhat underexposed print is best to work on, because the overall black coating will darken it quite a bit and make it look 223 properly exposed. For deeper blacks you can dispense with the

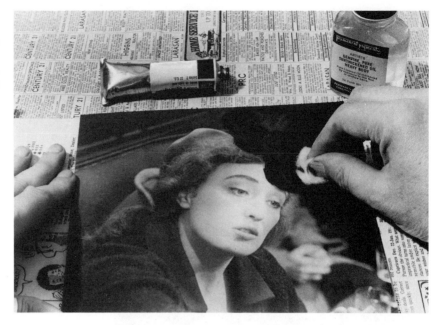

Fig. 28.4 The mediobrome print is first covered with a medium—in this case, linseed oil—then with black oil paint applied with cotton in circular strokes. Most of it is then removed with clean cotton, so that the coating is very thin and some areas are cleaned out entirely.

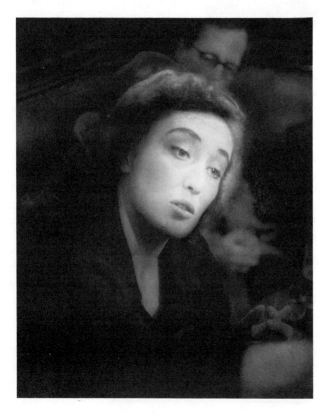

Fig. 28.5 The finished print after mediobrome treatment, which was done in a most simple and straightforward way: a thin, flat coating of oil paint applied and a little rubbed off here and there. The background figure could have been eliminated entirely, but I wanted him to show up a little bit. The print was varnished after it was colored.

preparatory coating, thinning the oil with solvent if necessary. This technique embodies the virtues of both dodging and burning-in. You dodge by rubbing off color, possibly adding white, and burn-in by applying more black.

You can also use the mediobrome method on a picture that has been toned brown, covering it with a mixture of brown and black paint, which makes a dark brown. Or you can use brown straight from the tube. You can vary its color by adding orange, yellow, or red to it.

OIL COLOR BURNING-IN

Instead of doing a full mediobrome you may just wish to do local darkening, the equivalent of burning-in. If you rub black oil color on a matte surface, it will often have an unwanted visible texture to it, but this is not true with a fine semimatte such as the Kodak N-type surface. If you work neatly, the oil won't be evident at all, except for a possible difference in surface sheen, which varnish or lacquer will correct.

It is best to do regular burning-in whenever you can, but sometimes you forget or don't do enough of it. Then black oil paint may do the job, though it would be easier to make another print. Sometimes, however, an area may be so complex that it is impossible to burn it in without messing up surrounding areas. You can darken such an area with dye if it isn't large enough to show up the dye's unevenness and shift in color. But for a larger complex area that has to be very smoothly darkened, using black paint may be the very best thing.

For moderate local darkening cover the whole print with preparatory medium, but for dramatic darkening use an unprepared print. For a toned print use a mixture of brown and black.

HEAVY OILS

The hand-colored prints that you see in commercial portrait studios that look almost like oil paintings are done with so-called heavy oils, which are opaque instead of transparent. Though used mainly for portraits, heavy oils can be used on almost any subject. Done with a skilled hand, the results can sometimes be very beautiful.

These heavy oils are actually regular artists' oil colors, sold in tubes at any art supply store. Since they are opaque, they will completely cover up an area that is being worked on, though you can rub some off to let the underlying photographic image show through.

In general, however, you will find yourself making a finished oil painting right on top of a photograph, using the photograph as a very

precisely delineated guide or preliminary sketch. This might sound very easy to do, but it isn't. Indeed, it takes a lot of experience and a natural flair for art in order to become a good heavy-oil colorist. Even so, the beginner often finds heavy oils very interesting to experiment with, provided he can overcome his disappointment with initial failures.

With heavy oils you don't have to limit yourself to painting complete paintings on top of photographs. You will find it easier to merely paint backgrounds various colors, vignette things, paint over things you wish to eliminate, and so on. Fortunately, you can wipe out your mistakes with a rag soaked in turpentine and work over an area as often as need be.

We sometimes see portraits done with transparent oils, with backgrounds done with the heavy oils. Sometimes it looks good, sometimes not, depending on the colorist. Perhaps the important thing to understand is that it is all right to put oil paint on photographs. You can put it on with a brush, spray can, roller, cotton swab, or your fingers, and it does your picture no harm. You can even use it for spotting and print retouching.

You can also combine heavy and transparent oils with dye coloring, the dye being put on the print first. One might do this to take advantage of the extreme brilliance of heavily applied dye.

The tools for heavy-oil coloring are Q-Tips, cotton balls, your fingertips, and soft sable brushes, both pointed and square. Brushes must be cared for properly or they won't last. Immediately after use, rinse them in turpentine and wash them very thoroughly with soap and warm water. Leaving paint to dry in a brush even once will ruin it.

INKING

A Kodak N-type print surface will take ink readily, though you should first rid it of fingerprints with lighter fluid and cotton. You can use india ink (in a pen, ruling pen, or brush), a felt- or nylon-tip marker, or opaque.

People most often draw on prints to make greeting cards, though some limit themselves to drawing decorative black lines around pictures with wide white borders.

Perhaps the easiest way to make a card is to remove a color slide from its mount and use it to make an enlargement print, the right size for the card, on Kodabrome Medium RC paper, N-Surface. Leave white borders wide enough to draw on. After the print is processed and dried, draw your designs on the emulsion side with Kodak black opaque or india ink, both of which are good and black. Then use the print as a negative for contact-printing your greeting cards. The lines

will come out white. The photographic quality of the picture should
be excellent.

It used to be popular to use a straight pen and waterproof india
ink to make a drawing right on top of a photograph, following the
image exactly, but translating it into ink lines. Try it. When you are
finished, put the picture in a tray of strong Farmer's reducer until
the photographic image disappears, taking care not to remove the ink
by touching it. Hypo the print, wash it, and hang it up to dry. You
end up with an ink drawing, its quality dependent on how well you
can draw. A 4 x 5 drawing is usually enough for a starter.

This technique is used commercially to turn continuous-tone
material into line copy, which costs less to reproduce by photo-
mechanical means. The people who do it are usually experienced
commercial artists, but you ought to try it at least once just for
kicks.

PRINT ETCHING

Professional print retouchers often do a lot of etching on dry-
mounted prints made for reproduction, using brand-new razor
blades. Essentially, it is a scratching process, and the main problem is
to prevent the scratches from looking like scratches. Etching is done
only on small areas.

Use a two-edge razor blade made of ordinary steel, not stainless.
Break the blade in two lengthwise to get rid of one of the edges, so
you won't cut yourself with it. Then break the remaining edge in two
crosswise to give yourself a short etching blade. Use the end with the
rounded corner. If you prefer having something larger to hold onto,
don't break the blade at all. Just wrap two or three turns of masking
tape around one edge. This will give the blade more stiffness and
protect your fingers.

Your print must be very dry, or the blade will make digs in it. The
side of the blade is held vertical to the print surface in a very firm
grip, while the edge is at such an angle that about $\frac{1}{16}$ inch of it near
the rounded corner does the etching. You move the blade back and
forth across an area, barely touching it, until sufficient gelatin and
silver have been removed. The delicate scraping should make a barely
audible whisper, one that you feel rather than hear.

At first you will find that print etching really tries your patience,
because it is so easy to make obvious digs and scratches, and for a
beginner it is a very slow business. Furthermore, it is hard to see
what part of the blade is doing the etching, so one tends to do it in
the wrong place. However, with practice you will develop a touch
and build up accuracy and speed. Real pros move along at a great
rate.

Etching leaves dull spots, which of course isn't good for display prints—unless the spots are very small. With reproduction prints the size doesn't matter.

CHEMICAL ETCHING

Small gray and black spots can be removed from prints with ordinary household sodium hypochlorite bleach, such as Chlorox. Apply it with a sharpened round toothpick that has been softened somewhat with water or saliva. Don't use a spotting brush, for the bleach will damage the sable fibers.

The bleach can be used right out of the bottle, but to slow down the bleaching action you can dilute it with an equal amount of water. Don't rub the spot, for the emulsion gets very soft. Just let the bleach stand on it in a small droplet, then blot it when the spot is light enough. By carefully watching the action it is possible to bleach a spot to match exactly the surrounding areas. If the bleaching goes too far, you can simply put spotting dye on it later.

When all spots have been taken care of, wash the print for a few minutes in running water to remove the bleach remaining in the emulsion.

PRINT CHALKING

A matte or semimatte print with areas that need darkening can be treated with a mixture of chalk dust and pumice, which can be applied so smoothly that large areas can be handled with success. For black-and-white prints you need black chalk (or conte crayon) from an artist's supply store. For toned prints you also need blue, brown, and yellow. Use dental pumice, from a drugstore, or technical pumice from a printers' supply house. In a pinch you can use an abrasive cleanser, such as Ajax or Comet, if you can't find pumice.

The chalk is inexpensive and will last indefinitely, and one stick will go a long way in treating prints. Buy plain chalk, not pastel, for the latter is a little oily. You also need the finest black sandpaper, Q-Tips, surgical cotton, lighter fluid, and an artists' kneaded rubber eraser.

Remove all fingerprints from your picture with lighter fluid and cotton and thereafter avoid touching the surface with your fingers (lay clean paper across the print to rest your hand on). Make chalk dust by rubbing a chalk stick on the sandpaper. When you have a little pile, add an equal amount of pumice and mix them together. Then pick up some of the mixture on a ball of cotton and rub it with circular strokes into the areas of your print that you wish to darken.

Figs. 28-6, 28.7 A straight print and one that has been chalked.
Chalking is roughly equivalent to burning-in, but you can control
it a little better in some respects.

For smaller areas you can rub with a Q-Tip. As you will see, the mixture goes on easily, though you may have to rub a while to get a smooth tone.

The pumice in the chalk mixture delicately abrades the print surface, giving it a fine tooth to which the chalk will stick. It also helps to smooth out the chalk tones. On some papers you can do chalking without the pumice, but it is harder to get smooth tones that way.

A chalked area can be lightened or freed entirely of chalk by rubbing it with cotton and straight pumice. The artists' kneaded rubber eraser will usually do an equally neat removal job.

Chalked areas readily pick up fingerprints, so keep your fingers off of them. When you have finished chalking, blow off the excess chalk. If some of the excess still sticks to the print, pick it off with the eraser.

If you want a really black area, apply chalk with the chalk stick and don't rub it very much.

To prevent a chalked print from smearing or picking up finger-prints you can immediately frame it under glass or cover it with a sheet of clear plastic. Or you can steam it, which usually works very well. You just hold the print emulsion down over a steaming teakettle, treating each chalked area for about 15 seconds or so. Then immediately put the print in a tray of cold water for about 30 seconds and hang it up to dry without wiping it. Putting Photo-Flo in the water will prevent water spots.

The steam softens the emulsion enough to allow the chalk dust to sink into the print surface, and the cold water firmly sets the gelatin around the chalk particles, making them a part of the emulsion so that they won't rub off. Though steam usually does a good job, don't count on it. Handle your chalked print by the edges anyway.

Print chalking is most often used on formal portraits and romantic landscapes, but it has many potentials. To visualize what they might be, consider chalking as the equivalent of highly precise burning-in.

To chalk toned prints you make mixtures of the black chalk and other colors until you get a color that goes with the print tones—very easy to do by experiment.

If you wish, you can use pencil dust instead of chalk with your pumice; the mixtures are made and applied in the same way. Pencil tones can be very smooth, but if they are too dark the graphite sheen may show up against the print surface. This doesn't matter with a reproduction print, of course. Penciled areas may be trimmed up with either the kneaded rubber eraser or cotton and lighter fluid.

This chapter has covered some of the most basic and classical print retouching and coloring techniques, with the accent on the how-to-do-it side. It is now up to you to decide what you will use these tried and true techniques for.

29 Print Toning

Developing a black-and-white paper normally produces a silver image that is black or gray, but the color can be modified somewhat by changes in the developer to produce tones ranging from blue-black to brown-black or yellow-brown. But the color range is not great. For more pronounced changes you must use a chemical toner. With such a chemical the silver image is converted to or covered by other metals or inorganic compounds. Silver sulfide is one such compound.

Toning is very easy to do, but there are certain rules that you must follow, starting when you are printing your pictures. For example, you should use a fresh hypo bath and wash your prints very thoroughly with the help of a washing aid such as Kodak Hypo Clearing Agent or Heico Perma Wash. Otherwise, stains may result. Such thorough hypo elimination is necessary for most toners, but not all.

WARM- AND COLD-TONE PAPERS

Warm- and cold-tone papers require different kinds of toners, so toners and papers must be carefully matched up. A toner designed

for, say, a warm-tone paper may have no effect whatever on a cold-tone emulsion, or it may produce a disagreeable color.

To say that a paper is cold means that it has a *very* slight bluish cast, something you feel more than see. Contact papers are often cold in this sense, but enlarging papers are not. However, enlarging papers that produce very neutral image tones, such as Kodabromide and Brovira, are usually called cold-tone, too.

Warm-tone papers such as Medalist or Polycontrast also have a color cast ranging from very slightly brownish to quite obviously brown. The degree of brownness can be controlled somewhat by development.

MATCHING UP TONERS AND PAPERS

The information sheet included in a package of printing paper will usually tell you which toners are recommended for it. For information on Kodak toners, which are generally the best bet, refer to the *Kodak Darkroom Dataguide* and Kodak Data Book J-1, *Processing Chemicals and Formulas for Black-and-White Photography*. For more complete information on toning as such, write for Kodak Pamphlet G-23, *ABC's of Toning*, which is available free on request (Eastman Kodak, State Street, Rochester, New York 14650).

WARM-TONE DEVELOPMENT AND DEVELOPERS

Though it is designed to produce neutral-toned prints, a standard print developer such as Dektol will produce slightly warm images with warm-tone papers, the degree of warmth depending much on the developing time—shorter times producing warmer tones. With developing times of 2 minutes or more the image may come out quite neutral. You can add Kodak Anti Fog No. 1 (benzotriazole) to Dektol and safely develop 3 minutes or more; with a paper like Medalist you get purple-black tones.

With Versitol, a developer designed for both films and papers, you tend to get bluish tones with some papers.

You can use special portrait developers such as Selectol and Selectol-Soft with warm-tone papers and get prints that are very definitely brown, the degree of brownness depending on which paper you choose. Selectol-Soft is a low-contrast version of Selectol. Prints developed in such developers can later be treated with brown toners, which usually isn't necessary, and come out with more obvious brown colors than other prints. They also blue-tone very well.

TONING PROCEDURES

With all of the commonly used toners the toning procedures are very simple. For most of them you need only a clean tray and a clean print. You simply put a print in a toner until it has toned sufficiently, then wash and dry it.

Almost as easy to use is a bleach and sulfide redevelopment formula (Kodak Sepia Toner), with which you first bleach a print, then redevelop it in a toner, the whole process taking about 5 minutes.

PREPARATORY WASHING

Before using most toners you should wash your prints very thoroughly, using a washing aid such as GAF Quix, Heico Perma Wash, or Kodak Hypo Clearing Agent. However, these are not necessary for prints to be toned with Kodak Gold Toner T-21 or Kodak Hypo Alum Sepia Toner T-1a, because complete hypo elimination prior to toning is not required with these toners.

I suggest that you use Perma Wash and the following washing procedure, which extends the recommended washing times considerably. Wash six to ten prints in a large tray under rapidly running water. Put them all in face up, then immediately start pulling them out from the bottom one at a time and laying them on top face down. Dump the tray when they are all face down, but keep on pulling and flipping them as the tray fills up again. Dump it again when they are all reversed again. Keep this up for the entire time of the first wash: 5 minutes.

Then put the prints in a Perma Wash bath for 2 minutes, continually pulling them up from the bottom, flipping them, and putting them on top.

For the final wash—15 minutes—use the same system employed with the first wash: pull out, flip, and dump.

When your prints are washed, dry them between clean photographic blotters, in a blotter roll, or on a drying rack. When dry, handle them only by the edges to avoid fingerprints, which often make a mess of a toning job.

PREPARATION FOR WASHING

The above washing system is very effective, but only if prints have been properly prepared for washing. This preparation consists of

233

proper fixation, with agitation in the fixing bath(s), for the time recommended for a given paper. Your best bet is a two-bath hypo system, with the second hypo freshly mixed. Neither too long nor too short a time in the hypo is good.

PREPACKAGED AND MIX-IT-YOURSELF TONERS

Many toners are available ready-prepared, usually in the form of liquid concentrates, but some of the most popular toners are not available in package form because of various packaging problems. Thus you must mix them yourself, though this is easily done.

HYPO-ALUM

The following is the formula for Kodak's Hypo Alum Sepia Toner T-1a, which is very popular in the portrait photography trade for Medalist, Polycontrast, and Panalure papers:

Cold water . 2.8 liters
Sodium thiosulfate (pentahydrated) . 480. grams
Dissolve thoroughly, and add the following solution:
Water, about 160F . 640 milliliters
Potassium alum (dodecahydrated) . 120 grams
Then add the following solution (including the precipitate) slowly to the hypo-alum solution while stirring the latter rapidly:
Cold water . 64 milliliters
Silver nitrate crystals . 4 grams
Sodium chloride . 4 grams
After combining the above solutions
add water to make . 4 liters

Note: Be sure the silver nitrate is completely dissolved before you add the sodium chloride. You will get a milky white precipitate. Immediately add it to the rest of the formula, pouring slowly while stirring rapidly. The black precipitate that forms will not affect toning if the proper technique is used. The chemicals can be obtained from Eastman Kodak.

Use the toning solution at 120F, bringing it to temperature by floating the toner tray in a hot water bath. Prints will tone in 15 to 20 minutes. Do not tone longer than 20 minutes. A temperature higher than 120F may result in blisters and stains.

A really thorough washing is not required for this toner, though a wash from 5 to 15 minutes is advisable. Prints should be thoroughly

soaked in water before toning. Prints should be occasionally separated in the toning bath, especially during the first few minutes.

Losses in both density and contrast occur. They can be counteracted in advance by increasing print exposure up to 15 per cent and developing time up to 50 per cent.

After toning, wipe off prints with a sponge and warm water, then wash them for 1 hour, or treat them with Kodak Hypo Clearing Agent and use a shorter time.

BLEACH AND SULFIDE REDEVELOPMENT

Bleach and sulfide redevelopment is the principle behind Kodak Sepia Toner, a packaged formula and one of the very few toners that will work well with Kodabromide. Any paper will tone with this formula, though some will produce better effects than others. It generally gives the best results with cold-tone papers, warmer papers tending to turn rather yellowish brown. However, many print colorists like to work with this color.

This is a two-solution toner, the print being treated first with a bleach, which should not come in contact with iron in any form. It contains potassium ferricyanide which combines with iron, even tiny bits from old rusty waterpipes, to cause blue stains.

Prints to be toned should be thoroughly washed.

The bleach works fast, taking only about 1 minute to reduce the image to a faint yellowish brown.

After bleaching, rinse the print thoroughly in cold running water for at least 2 minutes.

Then treat the print in the toning bath until all the image detail returns, which should take about 30 seconds. The whole toning process, including the rinse, should take less than 5 minutes. Immediately after toning, give the print a thorough water rinse. Then treat it for 2-5 minutes in a hardening bath composed of Kodak Liquid Hardener diluted 1:13 (1 part hardener, 13 parts water).

Finally, wash the print for at least 30 minutes in running water between 65 and 70F. Dry it in the usual way.

Since there is a definite bleaching effect with the sepia toner, prints should be given 10 to 20 per cent more than normal exposure in order to compensate for it in advance.

Small traces of hypo left in the print due to insufficient washing will cause the bleach to act like Farmer's reducer, possibly causing excessive or irregular bleaching.

A sulfide redeveloper should be used only in a well-ventilated place, because the fumes given off are both disagreeable and poisonous. Since the solution is also strongly alkaline, you should wear rubber gloves or use print tongs.

POLYSULFIDE

One standard polysulfide toner is the Kodak Brown Toner, which is sold in prepackaged form. It is a single-solution toner that works directly with silver images to form silver sulfide, the toning action being complete in 5 minutes at 100F or 20 minutes at 68F.

The toning should be carried to completion, because partial toning is not satisfactory. This is because the toning action is not uniform. Thus a partly toned print will have irregular tones. However, there is no problem whatever if toning reaches completion.

Warm-tone papers should be developed in cold-tone developers (e.g., Dektol) if they are to be treated with a polysulfide toner. A warm-tone developer (e.g., Selectol) will make them come out yellowish brown, welcomed by oil colorists, but not usually pleasing by itself.

Prints destined for toning should be very thoroughly washed, using the washing system described earlier. Otherwise, they have a tendency to develop highlight stains.

After toning, rinse the print a few seconds and bathe it for about 1 minute in a Kodak Hypo Clearing Agent bath, freshly mixed and used only for this purpose. Then treat it for 2-5 minutes in a bath made with Kodak Liquid Hardener diluted 1:13. If the print has sediment on it, wipe it off with a sponge, then wash it for at least 30 minutes at 65-70F before drying.

A polysulfide toner should be used only in a very-well-ventilated place, because the hydrogen sulfide fumes given off are both disagreeable and poisonous. Since the solution is very alkaline, you should wear rubber gloves or use print tongs.

SELENIUM

Packaged Kodak Rapid Selenium Toner is recommended for warm-tone papers but is also used on cold-tone papers, though it tones the latter very little. The principle toning agent is sodium selenite, which oxidizes the silver image to a reddish brown silver selenide.

The toning action proceeds smoothly, so a print can be removed from the toning bath at any time. For full toning use a dilution of 1:3, for partial toning 1:9. At both dilutions the image is made very permanent with both warm- and cold-tone papers. The working solution has no marked odor and works rapidly at room temperature.

POLY-TONER

You can produce any of a series of hues by varying the dilution and toning times of Kodak Poly-Toner, a single-solution toner. The tones

range from a reddish brown similar to that produced by selenium toning to a very warm brown such as produced by Kodak Brown Toner. Poly-Toner is designed primarily for use with Portralure and Ektalure papers.

Poly-Toner can be thought of as two toners in one, the selenium type being most active at low dilutions (say, 1:4) and the brown type most active at high dilutions (1:50). At 70F the toning times range from 1 minute at 1:4 to 7 minutes at 1:50. In most cases a 1:24 dilution (3 minutes) will produce the most pleasing tones.

BLUE TONER

Kodak Blue Toner is a packaged toner, once known as thiourea gold toner, that contains thiourea and gold chloride as the principal reacting agents. Apparently the silver image is etched slightly by the thiourea, and finely divided metallic gold is deposited on the silver grains. Used with warm-tone papers, this toner produces a bluish color cast that is very lovely. The toned image is very stable.

Both the contrast and density of a print are increased by this toner, but the increases are negligible. Very thorough washing before toning is important, because traces of hypo may cause uneven toning and colored spots.

The toner works slowly but uniformly at room temperature, the time varying from 10 seconds to 1 minute. You can get any desired intermediate tone by simply removing the print from the toner at the appropriate time.

Prints should be washed 30 minutes after toning. A white precipitate may form in a blue toner kept overnight, but this doesn't affect the toning action.

TONING FOR ARCHIVAL PERMANENCE

Many serious photographers today are concerned with securing for their prints as much longevity as possible and are envisioning print survival times as long as 2,000 or 3,000 years. They are consciously working for future generations, we might say. In their quest for such "archival permanence" they turn to toners, especially selenium toner and gold toner.

The following system, used by many serious photographers, involves the use of Kodak Rapid Selenium Toner for both warm- and cold-tone papers. Though they tone very little, cold-tone papers are adequately protected. The developer and stop bath should be fresh. Use a two-bath hypo system, with the second bath fresh. Some workers use a three-bath system, the third consisting of plain hypo (sodium thiosulfate).

Coarse-grain papers such as Agfa Brovira 111 and Kodabromide appear to be more stable than papers such as Medalist and Polycontrast, though the latter types (warm-tone) can also be treated for longevity.

1. Expose the print normally, but leave a 1-inch white border on all sides of the image. The border protects the image from stains creeping in from the side of the paper.

2. Use the developing time and temperature recommended by the manufacturer of the paper.

3. The stop bath should be fresh and accurately mixed, not mixed with the "dump acid system." After development, drain the print 10 seconds and transfer it to the stop bath for 20-30 seconds, agitating constantly. Then drain it for 30 seconds and transfer it to the first hypo. Do not store prints in the stop bath.

4. Leave the print in each hypo bath for exactly 4 minutes, with constant agitation, then put it directly into the toner-washing aid bath (formula follows in a moment.)

5. In the toning bath the print's color change and intensification of the blacks should become apparent in 3 to 5 minutes, but it is a subtle change and can often be seen only in strong light and by comparison with an untoned print. When the print has toned enough for your taste, put it in the wash tray.

6. Let this first wash go on for 30 minutes, then put the print in a tray of Kodak Hypo Eliminator HE-1.

7. Leave the print in the HE-1 for about 6 minutes at 68F, then put it into the wash again.

8. The second wash should be for 20 minutes at 65-70F.

9. Finally, wipe the print on both sides and lay it, emulsion up, on a rack to dry.

The formula for the toner-washing aid bath follows. If you wish, you can substitute either Heico Perma Wash or GAF Quix for Kodak Hypo Clearing Agent.

TONER-WASHING AID BATH

Kodak Hypo Clearing Agent working solution 1 gallon
Kodak Rapid Selenium Toner concentrate 7 ounces
Kodak Balanced Alkali . $2\frac{1}{2}$ ounces

This toner will give a perceptible toning effect and an intensification of the blacks with papers such as Agfa Brovira 111 and Kodabromide. If you wish to have print protection but no toning, reduce the amount of selenium toner concentrate to $1\frac{1}{2}$ ounces. Then limit the time in the toner-washing aid bath from 3 to 5 minutes.

Some papers, including Polycontrast, will show little or no change in the toner, even if it is mixed full strength. Even so, they are protected by the bath.

Some people use the toner-washing aid bath primarily to intensify and increase the contrast of prints and are not greatly concerned with archival permanence. They are especially interested in getting richer, deeper blacks than papers such as Brovira 111 and Kodabromide normally produce, though these papers do have quite good blacks already. Incidentally, resin-coated papers are not good for archival work.

You may have noted that even with the use of two different washing aids the total wash time for an archival print is quite long. With tray washing and constant hand rotation this could be very tedious, of course. Instead, many serious photographers buy the special archival washers manufactured by East Street Gallery (1408 East Street, Grinnel, Iowa 50112), which lessens the work considerably.

Many archivists have maintained that fiber glass drying screens are the *only* satisfactory method for drying archival prints. These can be made with the fiber glass screen material sold in lumberyards and hardware stores.

Though screen-dried prints tend to curl, you should never use a print-flattening solution on a print processed for maximum permanence. Such compounds usually contain hygroscopic substances very detrimental to print longevity.

Now, the second washing aid, Kodak Hypo Eliminator HE-1, works in quite a different way than the first one. It actually reduces hypo all the way to sodium sulfate, which is very water-soluble (thus easy to wash out) and relatively harmless to silver photographic images.

KODAK HYPO ELIMINATOR HE-1

Water	16 ounces
Hydrogen peroxide (3% solution)	4 ounces
Ammonia solution*	$3\frac{1}{4}$ ounces
Water to make	32 ounces

*Prepared by adding 1 part of 28 per cent ammonia to 9 parts of water.
Caution: prepare HE-1 immediately before use and keep it in an open container. In a stoppered bottle, the gas that it generates might break it.

Use HE-1 at 68F, immersing each print for about 6 minutes. The useful capacity of the formula is about thirteen 8 x 10 prints or the equivalent per quart. Wash prints for 20 minutes after treatment.

Archival prints should be stored in polyethylene sleeves or containers, or in boxes made of special cardboard free of acid and other contaminants. They should be handled only by the edges, because the fingers are a major cause of print contamination.

Though gold and selenium toners are most favored by archivists, certain other toners also produce very stable image tones. Among

Kodak products these include the sepia, polsulyfide, hypo-alum, and blue toners. Toned prints are not appreciably affected by gases and sulfurous matter in the atmosphere, which helps them survive a lot longer.

DOUBLE-TONING

To produce certain color effects a print can sometimes be treated in more than one toner. However, there is only one case in which this is generally recommended—the production of handsome red image tones by toning a print first in Kodak Brown Toner or Kodak Sepia Toner, then treating it with Kodak Blue Toner.

With the five Edwal toners (discussed below) you can make as many combinations as you please, even to the point of treating a print in all five of them (blue, red, yellow, green, brown). The toners themselves can be mixed together, except for the blue, which should be used alone. They mix so well because they are essentially dye baths, not toners in the usual meaning of the word; the exception seems to be blue. At any rate, you can get quite a few different colors with Edwal mixtures, either by mixing the dyes or by transferring a print from one bath to another.

RUBBER CEMENT MASKING

If you want certain areas of a print not to change color in a toner, you can coat them with rubber cement, using two coats to make sure of effective coverage. Since the brush that comes in a cement bottle is rather large and crude, you should use a smaller sable brush for fine detail work, cleaning it out later with a solvent. You will probably not be able to get all the cement out of it, so you may have to use this brush only for masking.

Apply the rubber cement to a clean, dry print, then soak it in clean water for 10 minutes before toning. After the print has been toned, washed, and dried, the rubber cement can be rubbed off.

With a regular paper the toner may soak through the paper's back and work underneath the rubber cement, possibly toning in an irregular or splotchy fashion. Therefore, use a resin-coated (RC) paper. The resin coating on the paper base seals off the emulsion from behind so that toner can't seep through the back and start to work beneath the rubber cement.

A good paper for this purpose is Kodabrome RC, a paper with very neutral image tones. Thus it would be classified as a cold-tone paper, except for the fact that it will tone well in many toners, including Kodak Blue Toner, Kodak Brown Toner, Kodak Sepia

Toner, Kodak Sulfide Sepia Toner T-7a, and Kodak Polysulfide Toner T-8.

With the exception of the Kodak Blue Toner, the above toners will also work on Polycontrast Rapid RC, another excellent paper, which will also tone in Kodak Hypo Alum Sepia Toner T-1a.

EDWAL TONERS

Edwal Scientific Products Corporation manufactures five photographic toners: red, yellow, blue, green, and brown. They are not so much toners in the usual sense as dye baths with a silver bleach in them, though the blue is more like a traditional toner. These dyes will produce very pretty colors in the lighter midtone and highlight areas, though they have little effect on dark areas until they have been considerably lightened by the bleach components.

The idea of an Edwal toner is very simple: darken a print with dye and simultaneously counteract the darkening by bleaching the silver image. The darkness of the dye, which is not affected by the bleach, can be controlled by the washing time.

Light print tones show the influence of the dye most obviously, and they also bleach fastest—so you have to watch them. If a print is left in a dye bath long enough, the silver image will bleach out entirely, so that there is no sign of it, and the dye itself doesn't form a substitute image. That is, you end up with a smooth, undifferentiated dye tone. No picture. This doesn't have to happen accidentally, however, for it is very easy to see when a print has picked up enough color. Then you simply take it out of the toning bath and wash it.

Quite a few people have been doing local coloring on prints with Edwal toners, which is akin to coloring them with food dye, except for the compensatory bleaching action. A toner can be used right out of the bottle and applied with a sable brush. Apply it to a print that has been thoroughly soaked and then wiped off.

Prints should be thoroughly washed before toning, preferably with the help of a washing aid such as Perma Wash or Edwal Hypo Eliminator. After toning they should be washed for 5 minutes or longer in running water to remove excess color.

Though I have no figures on the subject, I have strong suspicions concerning the permanency of prints treated with Edwal toners, but permanency isn't everything, so don't let that stop you from using them.

As you might guess from this chapter, print toning is quite an extensive subject, one that photographers have traditionally been interested in. Its objective is simple: to make pictures prettier and more permanent.

30 Mural Prints

Big prints are made in the same way as small ones, though the equipment required is on a larger scale. Exposure techniques, including test strips, are exactly the same, but handling large sheets of wet paper is naturally more difficult than working with small ones. If a very large mount press for mounting murals is not available, murals must be wet-mounted, which is somewhat more difficult than dry-mounting.

To make photomurals commercially requires a lot of floor space, special enlargers and lenses, large sinks, large trays, large mounting tables, and large drying racks. Some mural houses now use automated processing machines, which are expensive and huge. However, a few large prints—up to, say, 4 by 6 feet—can be made by improvised methods in a medium-size printing room.

NEGATIVE QUALITY

An original negative is usually preferable to a copy negative for mural printing. However, if an original negative is too dense, too flat, too contrasty, or of the wrong size, a fine-grain duplicate negative should

be made (Chapters 17 and 21). A fairly thin, sharp negative that will make a good print on contrast grade no. 3 paper is excellent for big enlargements. If you make a duplicate negative, aim for this quality.

Dense negatives require excessively long exposures at high degrees of enlargement and often produce images that aren't very sharp due to diffusion by the heavy density of silver particles. If you can afford to buy rolls of paper in grades 1 through 6, negative contrast is not so much of a problem, but if you can afford only one roll (say a no. 3), you must match the negative to it. This may be a good reason for making a duplicate negative, in which you can get any desired degree of contrast.

THE ENLARGER

To make a mural-size print you need an enlarger with a light source sufficiently bright to permit reasonably short printing exposures—for example, a machine that will take a G.E. 212 or 213 bulb. A 1-minute exposure is reasonable, but burning-in exposures can be much longer than that, making the operation very tedious. If possible, choose a negative that needs little or no burning-in.

Quite large prints can be made by twisting the enlarger standard on the baseboard and projecting onto the floor. However, it is better to have a machine with a head that will rotate into the horizontal position so that it will project onto a wall. Lacking such a machine, it is possible with some enlargers to remove the baseboard and fit the head and standard into a jury-rigged wooden jig on a movable table for horizontal projection. It isn't usually much of a problem to construct such a jig.

Whatever type of enlarger you have, you may have trouble with the lens at higher magnifications—or you may not. The thing is that lenses are designed for optimum sharpness within the range of magnifications normally used for making enlargements. Outside this range—for example, at mural magnifications—they may "fall apart," or get quite unsharp. Fortunately, there are lenses that don't fall apart, and you may be lucky enough to have one.

You could have trouble with the results of misalignment of enlarger parts, poor lens quality, and uneven illumination, all of which will be greatly accentuated at large magnifications. Owners of the largest Besseler and Omega enlargers seem to get along pretty well, provided their lenses hold up. But people with cheap enlargers run the risk that they won't work out very well.

MURAL PAPER

The recommended mural papers are Agfa Brovira 111 (50 inches wide, grades 1 through 6) and Kodak Mural Paper (42 inches wide,

grades 1 through 5). Mural paper is made with a very tough single-weight base to withstand the repeated folding, rolling, and squeegeeing which may be necessary in making very large prints.

The rough surface is very easy to retouch, is excellent for coloring, and tends to disguise objectionable grain, which is emphasized by high degrees of enlargement.

Mural prints can be toned, but toning should be preceded by adequate washing, which is a problem.

Mural papers are very fast, the speed being necessary to cut down exposure times that might grow interminably long.

FOCUSING

For focusing, turn off the safelights and wait until your eyes are dark-adapted—you will then be able to see the image well enough for focusing. With a grain magnifier, check the center and all four sides to see if the enlarger has the proper vertical alignment to the printing paper. If not, swing or tilt it into alignment. Now focus on the center of the image, then check the top. If the focus falls off toward the top it should fall off to an equal degree toward the bottom; check to see. If you get this focus falloff, refocus the image one-third of the way down from the top. When the lens is stopped down two or three stops from the full aperture, the overall sharpness will usually be satisfactory. Some lenses suffer from "focus travel," which means that they shift out of focus when they are stopped down. With such a lens you should focus at the aperture you intend to use. If your enlarger will accept a G.E. 212 bulb, you might substitute a much brighter G.E. 213 to get a brighter image to focus on. You can also use it for exposing if you wish.

EXPOSING MURALS

You should make a test strip, of course. Use a sizable strip of paper—say, 10 x 30 inches—because smaller strips won't give you much of an idea of what a large print should look like. Make as many strips as necessary to get the correct exposure, which is very important.

Now, with strips of masking tape frame the corners of the image on the wall (or floor), so that you can get the mural paper accurately positioned. Then position the paper, tape it down, and make the exposure.

When paper is wet-mounted it expands, and the mounting procedure guarantees that it won't contract again. If you make a print to fit on a board of predetermined size and don't take this expansion into account, the print will overlap the board somewhat and you will

lose some of your image. Wet paper expands more in width than length. For example, a sheet 40 x 100 inches will stretch to 41 x $100\frac{1}{2}$. This amount of expansion can be considered a constant. For practical purposes you can allow for 1 inch of stretch for every 40 inches of paper width, disregarding the lesser expansion in length.

PROCESSING A MURAL

The best way to process a mural is in a machine or in very large trays, which you probably don't have. In an institutional darkroom, such as in a school, that has several sinks, you can use the sinks themselves as processing trays. Clean them out, plug them, and fill them with chemicals to a depth of about 3 inches. You can then roll your exposed mural prints through the chemicals. Two sinks are enough— one for developer and one for fixer. After you have developed and fixed your murals you can dump one sink and use it for washing.

Another system is to wash the concrete floor of the garage and cover it with plastic material, such as old shower curtains or tablecloths. You can then swab or brush the solutions over the print until processing is complete. You should do this at night, of course, and should rig a safelight to work under. After processing you can wash your print with a hose right there on the garage floor, turning the print over from time to time until both sides are clean. If you are a boatsman, you can take the print out on the lake and drag it behind you until thoroughly washed, or even float it out from the beach.

A less messy system is to build wooden troughs somewhat longer than the width of the paper and about 4 inches deep and 10 inches wide. Waterproof them with epoxy paint or line them with plastic sheeting. Build three troughs—for water, developer, and fixer. Roll your mural through the water until it is thoroughly wet, then through the developer and hypo. It does no harm to the print not to use stop bath, although the hypo wears out a lot faster that way. We abandon stop bath primarily to cut down on the number of troughs laying around.

Rolling a mural through a solution takes a bit of a knack, which takes a while to learn. This is why it is good to put it in water first. However, an experienced mural printer can roll a mural directly into the developer rapidly enough to get even development.

You can develop a mural in Dektol, but it is better to use a developer that will permit longer developing times without fogging, the longer times promoting more even development with roll-through processing. Hunt's H-7 is very good for this. The normal developing time range is $1\frac{1}{2}$-3 minutes, though one can safely go longer. It is best to expose for a 3-minute time rather than, say, $1\frac{1}{2}$ minutes.

If necessary, you can slow down Dektol by diluting it 1:10 and developing 3-5 minutes. This also cuts down on the amount of

developer stock solution required to fill a sizable developing trough. For the best quality, however, it is best to use developers at their normal dilutions.

Any standard fixing bath will do very well.

WASHING

Washing is the main bugaboo of processing murals with makeshift equipment, for it is quite a job to get them free of hypo. You should surely use a washing aid such as Kodak Hypo Clearing Agent, GAF Quix, or Heico Perma Wash.

For trough-washing you can do only one mural at a time, dumping and refilling the trough after every two or three roll-throughs. Even with a washing aid you should wash about 30 minutes.

As already suggested, a print can be washed on a flat surface with a hose, provided it is frequently turned over; taking murals to the beach and herding them around in the water (fresh) is also effective. Salt-water washing is effective, too, but you have to wash the salt out, which fortunately takes little time. Some people have effectively rigged up stall showers for mural washing, and others have hung them on clotheslines and washed them with lawn sprinklers.

DRYING

In professional photographic mural houses the murals are dried on large twin-belt matte drying machines, but you surely don't have one of those. Some mural houses use lightweight wooden racks covered with muslin, again a procedure that may not be available to you.

But you can drape a mural over parallel clotheslines and dry it well, or wipe it off on both sides and drape it over the bedspread. You can even lay it out on a freshly mopped or waxed floor. Even better, lay it out on sheets of photographic blotter paper.

The best bet is not to dry a mural at all but to wet-mount it immediately after washing.

Well, doing the mural bit is certainly a hassle, but most red-blooded photographers want to try it at least once in their lives. There is something tremendously thrilling in making one of those great big prints.

Note: There is a section on wet-mounting murals in the next chapter.

31 Print Mounting and Framing

Since unmounted prints tend to curl and look rather nondescript, their appearance can be improved considerably by mounting them on tough cardboard or other sturdy supports. This also makes it possible to use prints for wall display. For this purpose a technique called dry mounting is usually employed, though there are others.

For mounting prints in albums one can use "photo corners," a chemically inert glue, or rubber cement. As you will see, rubber cement has definite shortcomings, but they can be overcome to a degree.

For very large prints there is a technique called wet-mounting, which produces very durable and handsome results.

Prints can also be well displayed in portfolios in plastic sleeves. Put in the sleeves back to back they stay flat without any trouble.

Finally, we have picture frames, some of which suit photographs very well.

MOUNTING CEMENT

Kodak Rapid Mounting Cement is a chemically inert glue made specially for mounting photographs, one of the very few cements

that will not cause deterioration of silver images in the course of time. It is usually used for small prints or snapshots. To use, touch the nozzle to the back of the print, squeeze the tube gently, and draw a line around all four sides, about $\frac{1}{8}$ inch from the edge. Then put a dot of cement in the center. After the cement has set slightly, mount the print and rub it down with moderate pressure.

To remove a mounted print, cover it with a sheet of paper and heat it with a warm (not hot!) electric iron for about 15 seconds. Then immediately pull it up.

RUBBER CEMENT

For mounting with rubber cement, give the back of the print and the mount card two coats each, letting both coats dry. Then cover the cemented area on the mount card with a sheet of paper, leaving uncovered only the narrow strip onto which the edge of the print will fit. Position the edge of the print, rub it down, and remove the paper. Then roll down the rest of the print onto the mount board and rub it lightly. Rub off the excess of cement from around the print with a clean cloth.

Because rubber cement contains sulfur, it will eventually bleach or stain silver images, perhaps in two or three years. Thus it is usually used only on prints made for reproduction, which don't have to hold up very long. However, the longevity of a rubber-cemented picture can be increased considerably by sealing both the print and the cement against air with a clear spray-can lacquer such as Rustoleum. Give both the print and the back of the mount three coats. This will effectively seal the picture in all directions. Even so, one cannot expect archival permanence, for lacquers will break down and change color with the passage of sufficient time.

SELF-ADHESIVE TISSUE

You can now buy very sticky adhesive tissues for cold-mounting prints, such as Perma/Mount 2. When you get such a tissue it is backed on both sides with a heavy, slick paper that will readily peel off. You peel off one paper and stick the tissue to the mount board, then peel off the other paper, lay the print down on the tissue, and rub it for tight contact.

The tissue is so extremely sticky that if you get your print down in the wrong place you may have to kiss it goodbye, though there may be a chance of pulling it up again. To lessen the possible danger, don't remove the backing papers all at once. Pull the first paper back

Fig. 31.1 Mounting a print with Falcon Perma/Mount 2, a self-adhesive mounting tissue. The tissue has already been adhered to the mount board. Here we see that one edge of the protective paper covering has been pulled back and folded down, so that only a narrow strip of the adhesive is exposed. The edge of the print will be laid onto this strip and rubbed down. Then the protective covering will be pulled all the way off and the rest of the print rubbed down.

about $\frac{1}{2}$ inch and fold it over. Then position the exposed strip of adhesive above the mount board, lower it, and rub it down. Then pull the backing paper the rest of the way off and roll the tissue onto the mount board.

Now, with a sharp knife and straightedge cut a line along one edge of the top backing sheet, so that you get a strip about $\frac{1}{4}$ inch wide, then pull off the strip of paper (the adhesive under it won't pull up). Position the edge of the print above the adhesive strip and rub it down. Then pull off the rest of the backing paper, roll the print down, and rub it with a cloth.

Though tissues of this sort are very convenient, especially if one doesn't own a mounting press, the adhesives used in them are usually not very good for print longevity, which may or may not matter to you. However, they should be just fine for resin-coated (RC) papers, in which the emulsion is sealed off from the adhesive.

Dry-mounting involves using heat and pressure to weld together a print, a sheet of glue-impregnated paper (dry-mount tissue), and a support, usually a mount board. The heat and pressure are supplied with either a household electric iron or a photographic mounting press, the latter being much more convenient. In this section I will assume that you have a press available but give instructions on the use of an iron anyway.

The first step is to drive all the moisture out of both your prints and mount boards, which you do by putting them one at a time in a hot mounting press. Each should be covered with a large sheet of clean white paper so that dirt and vestiges of mounting tissue on the heat platen won't be transferred to them. Drying is to prevent prints and mounts from warping later.

The next step is called "tacking," which simply means to use heat to stick mounting tissue to the back of a print so that the tissue won't slide out of place. It also means to temporarily stick the tissue and print to a mounting board so that they won't slide. For tacking one uses a photographic tacking iron, although a cheap electric soldering iron or the tip of a household electric iron work just as well.

Fig. 31.2 Tacking dry-mounting tissue to the back of a print with a cheap electric soldering iron, which works very well if you don't let it get too hot (at full heat it will scorch a print). The next step is to trim the print.

But one shouldn't let a soldering iron get too hot, or it will scorch both tissue and print.

The best way to tack tissue onto a print is to make four "melt marks" with the iron in the shape of a cross, starting each mark in the center of the print and extending it all the way out to the center of one side. Press lightly with the iron, for too much pressure may make indentations that won't go away. This part of the tacking can be done before you have trimmed your print.

You trim a tacked print just as you would trim one without the tissue—with a paper trimmer or with a straightedge and very sharp wallboard knife. However, there is a refinement worth considering. Trim the print *before* tacking. Then tack on the mounting tissue so that it doesn't come quite up to the edge of the print, leaving a border of $\frac{1}{32}$ inch. Using a straightedge and sharp wallboard knife, trim the other edges so that they have the same width border, cutting only through the tissue but not into the print. The reason for the border is that when mounting tissue melts in the press it sometimes seeps out from under the edge of the print, which is unsightly. Even with such a narrow border it never spreads far enough to do this.

Now, position the trimmed print and tissue on the mount board for tacking, which you do by curling back two corners of the picture along one side and melting the tissue underneath to the board. Tacking down more than two corners is not advisable, for it may lead to creases or folds in the print when it is pressed.

The temperature of the mounting press should be between 200 and 275F. When there is no print in the press keep it closed, for only the top platten has a heating element, so it must heat the bottom half. Cover the print and the mount with clean white paper (which has previously dried thoroughly in the hot press), place in the press, and close the top platten for at least 10 seconds, or longer in the case of a thick mount. When you remove a mounted print from the press, put it under a heavy weight until it has cooled off. This inhibits print warping and also helps in the adhesion process when a print has come out of a very hot press (say, 275F) with the mounting tissue still in the melted state. At high temperatures, 10 seconds is enough press time, but around 200F you may have to use 30 or 45 seconds. At even longer times you can use temperatures somewhat below 200F.

When mounting color prints use a lower temperature range (200-220F). The thermostat on a household automatic electric iron must be set for "synthetic fibers."

If you have no mounting press, an electric iron will work quite well on double-weight prints up to 8 x 10 inches. However, it is hard to avoid creases in double-weight prints larger than 8 x 10 and single-weight prints larger than 5 x 7.

The iron should be set between "silk" and "wool," though you should test it to make sure it will be hot enough to melt the mount-

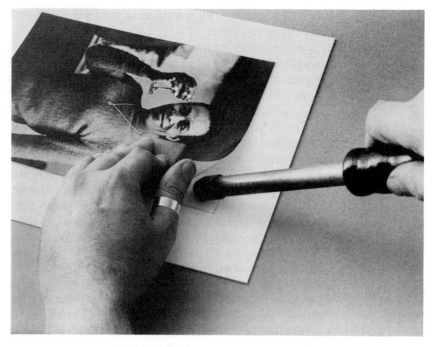

Fig. 31.3 Tacking a print to a mount board by melting a corner of the tissue to the surface. Only two corners (adjacent ones) should be tacked. If you tack three or four, the print may wrinkle in the dry mounting press.

ing tissue but not so hot as to scorch the print. You can do tacking with the point of the iron, but should then remove the glue from it by rubbing it vigorously on a coarse cloth while it is still hot.

Center the print on the mount, tack it down, and cover it with a sheet of white paper for protection. Then start pressing it down from one of the long sides, moving the iron along it in a circular movement and gradually moving it to the other side. Starting in the middle of the print and gradually moving outward may also work, but it is not usually recommended.

The recommended mounting tissues are Seal MT-5, and Kodak Dry Mounting Tissue. The most popular press nowadays is the Seal-Mount.

DRY-MOUNTING RC PRINTS

Resin-coated (RC) prints are handled in exactly the same way as other prints, except that one may employ a special mounting tissue, use a lower mounting press temperature, and use heavier weights on prints just removed from the press.

The acceptable press temperature range with RC prints is 180-210F. Higher temperatures may melt the resin in the print base. Various workers have reported that Seal MT-5 tissue and Kodak Dry Mounting Tissue will work fine with an RC print at 200F, though others claim to have had less success.

Kodak now makes a special material for RC prints called Kodak Dry Mounting Tissue, Type 2, a waxy tissue that is very aggravating to work with. The problem is that when prints come out of the press they may be hot enough—and not too hot—yet not stuck down. Thus they should immediately be put under heavy cold pressure to promote adhesion. Kodak claims that the correct press time is 30 seconds (or a little longer for thick mounts) and that excessive time and temperature account for the lack of adhesion. The fact that manufacturers are beginning to produce presses with very accurate temperature gauges indicates that temperature has been recognized as a problem with RC papers.

Unless you have such a press you will probably have trouble drymounting RC prints, unless the older type tissues work for you, or you develop for yourself a workable system with the new.

DRY-MOUNTING ARCHIVAL PRINTS

The only really safe way to dry-mount an archival print is to mount it back to back with a cleared and archivally processed sheet of paper of the same brand that the print was made on. Mount boards, even the very expensive ones, are suspected to contain contaminants that will shorten the lives of silver images to much less than the 2,000 or 3,000 years that archivists dream of.

The backup print can be of fogged or out-of-date paper; these things don't matter. You can contact-print your name on it, or even your face, if you like that kind of an ego trip. This would require processing it all the way through, of course. Or you can simply put the paper through the first and second hypos and archivally wash and dry it (see Chapter 29). For mounting tissue use Seal MT-5 or Kodak Dry Mounting Tissue (not Type 2).

Prints mounted back to back will stay very flat, which is a good thing, without having much weight or thickness. Ordinarily, it takes a fairly heavy board to keep a print flat, and even then it might not work. If you want a print that is mounted in the usual way to stay really flat, use heavy bookbinders' board, but hold your ears against the affronted screams of the archivists (it isn't as chemically pure as it might be).

The true archivist will never mount a print at all unless he absolutely has to, and then he will turn to very expensive 100-per-cent-rag-content acid-free mount boards such as Strathmore Drawing Board or Bainbridge Museum Board. He suspects that even these will

eventually deteriorate his images, but they are the best he can do. Only the years will tell whether his suspicions are well founded.

Being a print-mounting archivist is an expensive proposition when you consider the high cost of Strathmore and Bainbridge boards. It would probably cost no more to clear and archivally wash fresh printing paper for back-to-back mounting, and one just knows that's an expensive trip.

SUBMOUNTS

You can mount a print on a sheet of black or colored craft paper, leaving a narrow craft paper border around the image, then mount the craft paper in turn on a mounting board. The border can be any width you like—though narrow ones usually look best—and almost any color. Almost any paper available in an art supply store, including toned charcoal and pastel papers, will work very well for submounts. It's best to stay away from strongly chromatic papers, because they detract too much from photographic images.

WET-MOUNTING

People who make very large prints usually have to do wet-mounting, though there are special dry-mounting presses that will handle prints up to 4 by 8 feet. A mural-size print is wet-mounted on tempered hardboard (e.g., Masonite Dulux) with an adhesive (e.g., Borden's GR-7, distributed by Arobol). Printer's padding compound, from a printers' supply house, is also excellent. Ordinary wallpaper paste is satisfactory, though not as good as the others. To prevent warping the mural is backed up with brown craft paper, which is glued to the reverse side of the hardboard. The shrinkage of the print and the paper equalize one another.

The print and backing paper should be mounted so that their grains run in the same direction; otherwise there will be warping. To get this orientation, mount them so that their direction of maximum stretch is the same (these papers stretch when wet, the maximum stretch being across the width). If necessary, you can empirically determine the direction of maximum stretch of a paper by cutting off a sizable piece, measuring it, then wetting it and measuring it again.

You should put the backing paper on the hardboard first, after the paper has been thoroughly soaked in water. While it is soaking, apply adhesive to the board with a paint roller. Immediately hold up the paper and drain it until all the surface water is gone, then lay it on the board. Smooth it down and remove air bubbles and excess water with a blade squeegee.

In the meantime, the print should have been soaking in water. As soon as the backing paper has been adhered, turn the board over and apply adhesive with the roller. Immediately drain the print of all surface water and lay it on the adhesive, smoothing it down with the squeegee.

You can then trim the edges of the mural with a single-edge razor blade or other sharp edge. Alternatively, you can make a wraparound mount by sticking the overlap to the back of the board, making a neat job of it by mitering the corners of the print with a sharp blade.

Now you should remove all traces of glue from the print with a damp sponge, especially if you have used printers' padding compound, which is practically impervious to water when dry.

Dry the mural horizontally on a rack (which can be makeshift) made of sticks, so that the air will circulate equally well on both sides of the hardboard. Unless both sides dry at about the same rate you will have a warping problem, even if the print and backing paper are properly mounted with the grain running in the same direction.

The best hardboard-adhesive combination is surely Masonite Dulux (which has a very hard finish) with Borden's GR-7. If you have a more porous hardboard, combine it with printers' padding compound, sizing both sides of it before mounting your print with compound diluted 1:1. This compound must be washed off paint rollers, squeegees, tabletops, and print surfaces while still wet. For this reason it is a very good adhesive to use for a mural that will be hung in a very humid environment. No matter what kind of adhesive you choose, wallpaper paste or whatever, use only hardboards that are finished on both sides.

Mural prints can be mounted on many surfaces—for example, plastered walls—provided they are properly sized. When it comes to sizing porous surfaces, an extra sizing coat or two is always a good thing—just to be sure.

Though it is single-weight, mural paper is made especially tough so that it will take the rolling, squeegeeing, folding, hanging, and so on that may be involved in mounting it in various ways on different surfaces.

The surfaces of mural papers are very well adapted for spotting and retouching, which should be done after a mural has been mounted and dried. Perhaps the best materials to use are dye, pencil, and oil color. Mounted murals can also be lacquered—for protection and increased tonal brilliance.

PICTURE FRAMES

The main idea of picture frames is to protect and enhance pictures, those with glass in them providing the most protection. Though most available frames will protect photographs to one degree or another, very few will enchance them. This has troubled photographers for

years. The problem with most frames is that they visually overwhelm photographs; you find yourself looking at the frames and hardly seeing the pictures at all, which certainly does nothing for the pictures.

Fortunately, there is a kind of narrow black frame (with glass), sold in many department stores, that enhances most photographs, especially if they are mounted with fairly wide white borders. You can frame unmounted prints, too, but they tend to wrinkle a bit. Mounted or unmounted, prints usually look good in these inexpensive, very commonly available frames. With a few simple tools you could make them for yourself, but you would probably save little or no money that way.

At picture frame shops and art supply stores you can now buy do-it-yourself frames, either in metal or plastic, that often look good with photographs, though not always. All you have to do with such frames is assemble them, a job easy enough for the average idiot. They cost a good deal more than the black dime-store numbers, but they can give your pictures that expensive look that makes them appear to actually be worth something. If you intend to be a professional photographer, or even a respected amateur, you should always do everything possible to make your pictures look valuable. Which includes framing them well.

Curators of photography in various galleries and museums have been beating their brains out for years, trying to figure out how to frame photographs properly. Now most of them have settled on metal frames, especially those made by Kulicke (Kulicke Frames, Inc., 43 East 10th Street, New York, N.Y.). There is also a low-cost version made by Contract Products Corporation of New York.

If you use a metal frame, buy glass for it, not plastic. Acrylic plastics such as Plexiglas may release compounds that will damage silver images and have an even worse effect on colored ones. You can use plastic in a frame if you use glass, too—next to the picture. Thus if you wished to protect a wall display color photograph from ultraviolet light you could use Plexiglas II UVA or Plexiglas UF sheets in the frame in front of the glass. These sheets will greatly increase the life of color photographs displayed in the home or at the office.

While we are on the subject of no-noes, you should also avoid nonglare glass, which will damage color photographs that come in contact with it. This being so, it seems likely that it might not be especially good for black-and-white pictures, either. Also be very sure to avoid bleached wood frames, as they are very harmful to photographs because of contaminants left in the wood by the bleaching.

Regular picture glass is probably best for photographs, though ordinary single-strength window glass is quite all right, too. Many photographers don't want their pictures to contact glass at all, so they use cutout mounts that keep the images at a distance from it.

Fig. 31.4 A partly finished passe-partout—a mounted print
bound to a plate of picture glass with tape. The cardboard strip
at the bottom is a guide to help get the tape border even. Making
a passe-partout is a cheap and simple way to dress up a photograph.

You can cut such a mount with a wallboard knife and straightedge,
or get a cutter from an art supply store that will give you beveled
edges. The available cutters are a little tricky to use, but one masters
the knack after a while.

Most available frames seem specially designed to consign photo-
graphs to oblivion, because they were made for pictures done in
bolder graphic media, such as oil painting, silk screen printing, lithog-
raphy, and so on. However, if you make really bold photographic
prints, as a few people do, you can safely use such frames. Even so,
you must select them with care, or they just won't look right with
your photographs.

If you are mechanically inclined, you can make frames for your-
self, buying your frame material at a rather good savings from a
picture frame shop. All you need is a meter box, backsaw, hammer,
nails, sandpaper, screweyes, paper, glue, picture wire, and a few
other odds and ends. But if you are mechanically adept, I don't have
to tell you what to do with these things—so I won't.

Now, for people who aren't mechanical there is a very nifty kind
of frame that they can make by merely being alive and in close prox-
imity to the materials. It is called a passe-partout and is simply a
sandwich consisting of a plate of glass, a mounted print, and a back-

258

ing cardboard, with colored cloth tape around all the edges to hold them together and a stick-on picture hanger in the back. Have the glass (picture glass, preferably) cut to size at the glass store. If you get the tape on straight, a passe-partout looks just about as great as a Kulicke frame.

CONCLUSION

In this book are most of the things you *really* need to know about photographic printing and a few things you *may* need to know just once in your life. On the basis of what is here you should be able to figure many other things out for yourself without too much difficulty. I hope you have enjoyed the book. Writing it for you has certainly been a pleasure.

Index